IMAGES
of America

HAMILTON COUNTY'S
GREEN TOWNSHIP

IMAGES
of America

HAMILTON COUNTY'S GREEN TOWNSHIP

Jeff Lueders
Introduction by Paul Ruffing

ARCADIA
PUBLISHING

Published by Arcadia Publishing
Charleston, South Carolina

Library of Congress Catalog Card Number: 2006930906

For all general information contact Arcadia Publishing at:
Telephone 843-853-2070
Fax 843-853-0044
E-mail sales@arcadiapublishing.com
For customer service and orders:
Toll-Free 1-888-313-2665

Visit us on the Internet at www.arcadiapublishing.com

This book is dedicated to my wife, Debbie, whose love and encouragement are a constant inspiration. In addition, her editorial assistance was invaluable.

CONTENTS

ACKNOWLEDGMENTS

Many thanks to Paul Ruffing, president of the Green Township Historical Association for his dedication, energy, time, and effort in helping to select photographs for *Hamilton County's Green Township*. The job was a smooth transition from start to finish. Thanks also go to the many members of the Green Township Historical Association, especially Les Brenner, Tom Wernke, Ray Hollmeyer, and Ken and Caroline Scheidt.

A book is always a labor of love, and this one proved to be a great educational experience. To the residents of Green Township, past and present, they have made the community a thriving and prosperous place to live.

INTRODUCTION

A drive through Green Township in 2006 would look much different from a drive along the same roads in 1850 or even 1900, when the township was mostly farmland. Just 50 years ago, the township was in the midst of a post–World War II population explosion, typical of suburbs throughout America. Little of the township's 29 square miles has been left untouched by development of new houses, stores, churches, offices, parks, and roads. In the 2000 census, Green Township had a population of 55,660, which made it Ohio's second largest township. Recent census estimates for 2005 indicate it might now be the largest.

Green Township includes the communities of Bridgetown, Covedale, Dent, Mack, Monfort Heights, and White Oak. The township is located in west-central Hamilton County—west of the city suburbs of Cheviot, Westwood, West Price Hill/Covedale, and Mount Airy/north of Delhi Township/east of Miami Township/south of Colerain Township. The township was established in 1809 and named after Revolutionary War general Nathanael Greene.

Hamilton County's Green Township gives readers a glimpse of scenes of Green Township, mostly from the mid-20th century and earlier. Readers will get a feel for what it was like in Green Township when earlier generations lived here. For longtime residents, it might bring back a memory or two.

Farming dominated everyday life through the 1800s and into the 1900s. Local farmers, many of German heritage, worked hundreds of small and midsized farms that dotted the township landscape. If you lived in Green Township in the 1800s, you likely were a farmer or in some related occupation such as blacksmith, wagon maker, carpenter, or general store proprietor. Scenes of township farm life are featured in Chapter 1. One notable example is Charles Reemelin, a township farmer, lawyer, and Ohio State legislator, who in the 1860s wrote a popular book on grape growing and wine making. When streetcars and automobiles made living in Green Township and commuting to a job in the city possible, the farms became much more valuable as land for houses than as land for farms. Farming is mostly a memory today—few Green Township farms remain.

An annual agricultural fair dating from the 1860s called the Harvest Home Fair is still held today. Until the 1930s, it was organized by the Green Township Harvest Home Association. It is currently under the leadership of the Cheviot-Westwood Kiwanis Club and is located in the city of Cheviot, no longer a part of Green Township. However, it still retains a bit of its Green Township agricultural flavor. Today it is known as the "Biggest Little Fair in Ohio." Chapter 2 features some scenes of the fair over the years.

Transportation was key to the development of Green Township. In horse-and-buggy days, the distance to Cincinnati and the steep hillsides leading to the hilltop suburbs such as Green Township meant farming would thrive since commuting to the city for a job was not practical.

Scenes of dirt roads, a turnpike tollgate, and horse-drawn vehicles give the reader a flavor of these days. Pictures of other transportation modes such as the Cincinnati and Westwood Railroad, the Chesapeake and Ohio (C&O) Railroad running through the township, and the small Western Hills (Frank) Airport show a different side of transportation. The C&O Railroad trestle was a township landmark for many years until razed in 1984. By the end of the 1960s, the airport was gone, covered with new subdivisions. The arrival of electric streetcars around 1900 and widespread ownership of automobiles a few decades later were major catalysts that completely changed the landscape of Green Township from rural to suburban by 2000. Chapter 3 includes some scenes from the days of streetcars and early automobiles and businesses that supported them.

Several inns and taverns were built along township roads. In addition to serving the locals, they were stopover places for farmers driving livestock to the stockyards and meatpacking plants in Cincinnati. Chapter 4 features photographs of several old inns and taverns, along with a few 1900s taverns and eateries of interest. Two 1940s vintage roadside motels, now just memories, are also pictured.

Nothing seems to peak people's historic interest as much as old schools. Twelve small Green Township district schools educated township children for many years, until they were gradually consolidated into today's larger regional school districts by the 1960s. Chapter 5 includes pictures of old township school buildings, class photographs, a commencement program, and a report card. Scenes of two older Catholic schools dating from the 1800s are also included.

A variety of churches has served township residents since its early days. Today there are many places of worship in Green Township, most starting as the population grew rapidly in the 1900s. Several churches dating from the 1800s are still active, some under newer names. Photographs of the old church buildings and congregations are featured in Chapter 6.

Green Township was named for Gen. Nathanael Greene, a Revolutionary War hero. This is briefly explored. Chapter 7 features some historic photographs from the township's communities— Bridgetown, Covedale, Dent, Mack, Monfort Heights, and White Oak. Also shown are some current township scenes including fire stations, libraries, and the German Heritage Museum.

The Green Township Historical Association welcomed the opportunity to assist Jeff Lueders in assembling the historic sights and scenes in *Hamilton County's Green Township*. The book is not a complete history of Green Township, but rather a collection of historic photographs, many featuring people and places that are now only memories. The accompanying captions give some of the history associated with the photographs. Enjoy this trip back to earlier days and times in Green Township.

Paul J. Ruffing
Green Township Historical Association

One

LIFE ON THE FARM

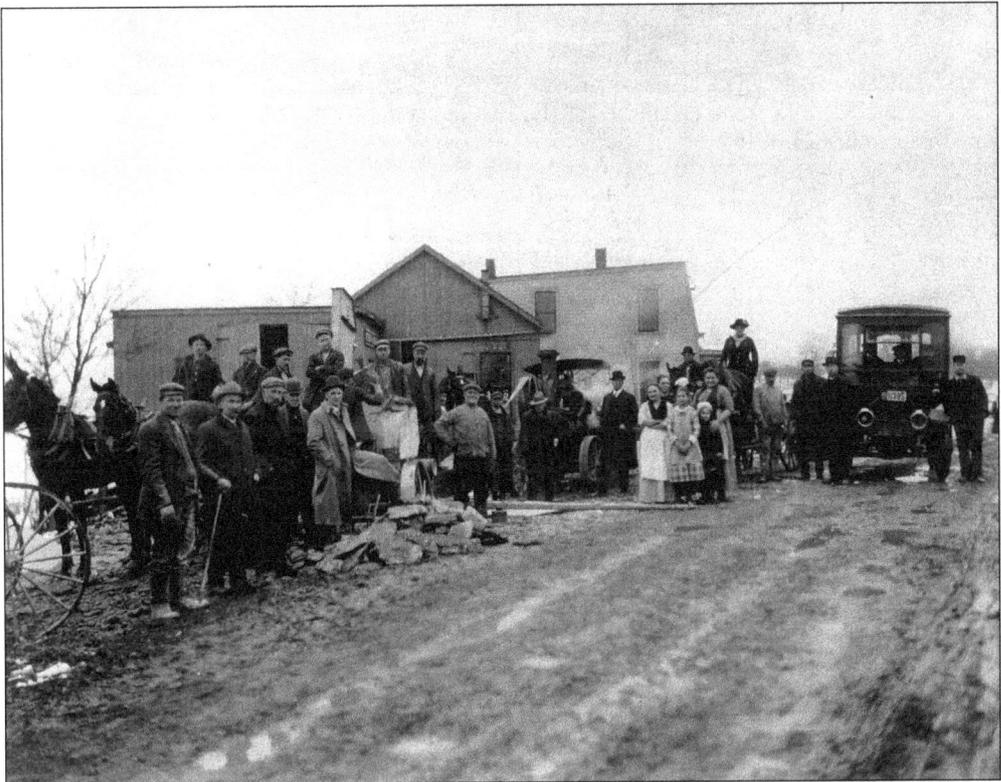

This is the Farmers' Union Co-operative Supply Company in Monfort Heights in the early 1900s. Farmers bought commodities such as coffee, sugar, flour, and even coal at wholesale prices. It was located on North Bend Road about where the Monfort Heights Shopping Center is today. The members met in a wagon maker's shop belonging to Harry Frondorf. Dances were also held at the hall with music that featured fiddles and guitars.

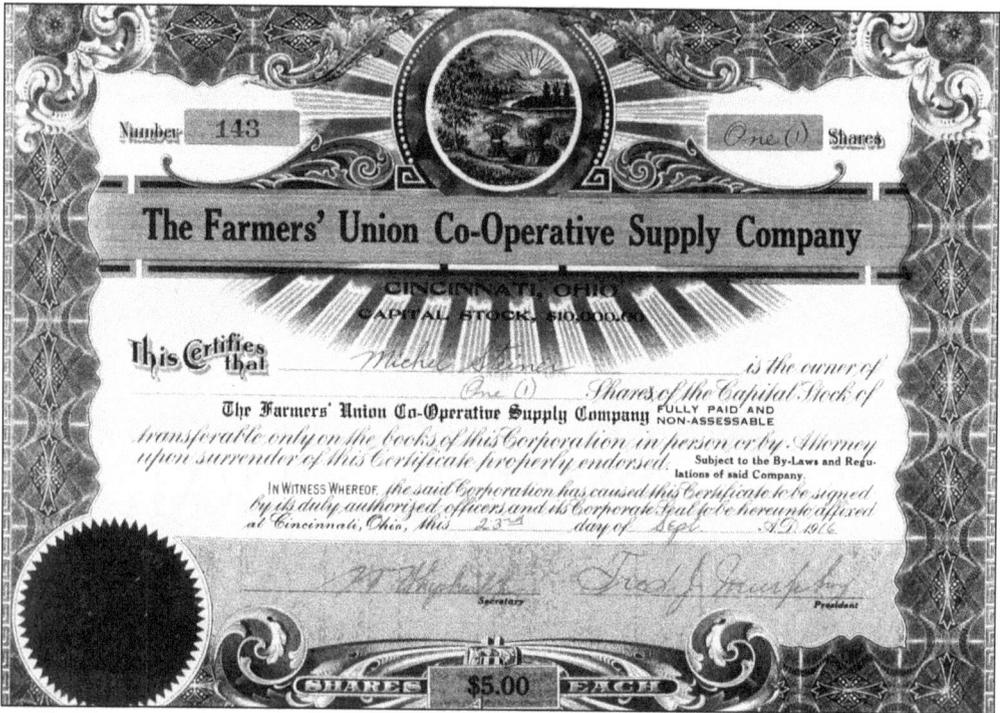

This is a picture of a stock certificate of the Farmers' Union Co-Operative Supply Company dated September 23, 1916.

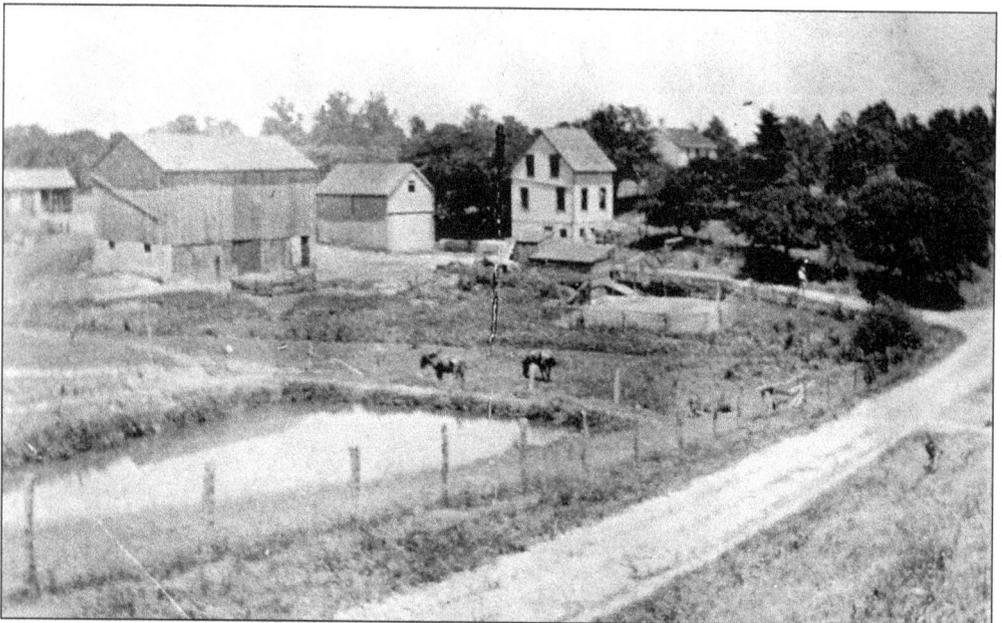

The Hollmeyer Farm is shown here in the early 1920s with Fiddlers Green Road in the foreground. Some of the buildings still stand today. The farm was settled by Thomas Markland in 1803, called the "Chestnut Farm," and was sold to the Hollmeyer family in the early 1900s. The farm has been in the Hollmeyer family for several generations and is one of the few farms left in Green Township—where farming dominated life into the 1900s.

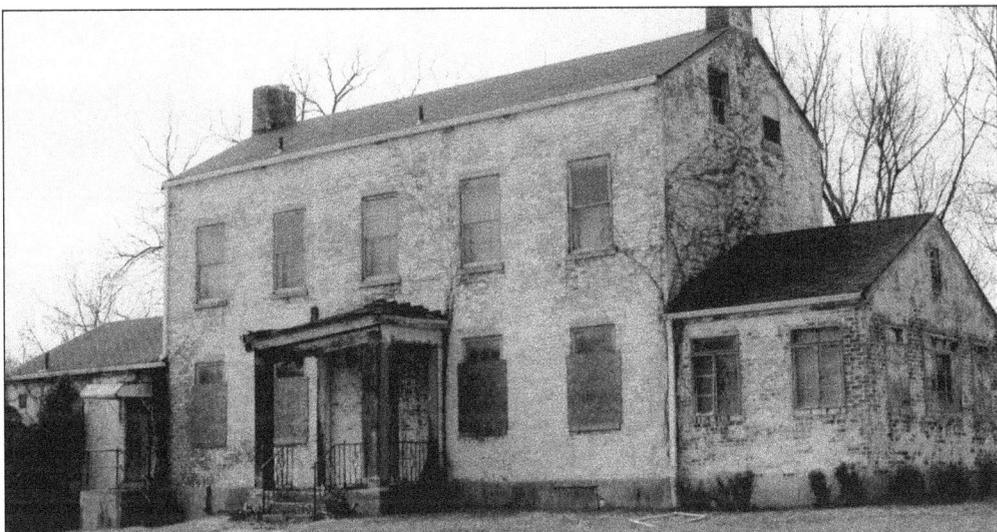

The Diehl House still stands today at 2885 Diehl Road, known in the 1800s as Swine Road because huge numbers of hogs were driven to the stockyards by the farmers. The main part of the house was built in 1835 by Peter Diehl on his 160-acre farm. The Diehl house and its remaining 50 acres were recently purchased by Green Township as parkland from the late Marge Unnewehr Schott estate. (Courtesy of David Bushle.)

Cheviot Business Directory.

Town and Township Officers.

John Gaines...Attorney and Mayor of Westwood.
John Craig...Township Treasurer.
Thomas Wills...Postmaster and Justice of the Peace.
E. L. Agin...Post Master and Justice of the Peace, at Dent P. O.
Philip Bayer, of Bridgetown.... } Township Trustees.
John Goshorn, of Sec. 4...
Geo. Rabenstein...Township Clerk.
C. H. Moore...Ex-Township Clerk.
John Ritt...Township Assessor.
James Epley...Justice of the Peace, 2½ miles North of town.

Ministers and Teachers.

Rev. W. G. Pratt...Baptist Minister and Professional School Teacher.
A. I. Applegate...Professional School Teacher.
G. A. Clause...Professional School Teacher.
E. L. Agin...Professional School Teacher, at Dent P. O.
Rev. G. Catt...Christian Minister. Residence 1 mile N. W. of town.

Physicians and Surgeons.

P. M. Williams...Physician and Surgeon.
B. Agin...Physician and Surgeon, at Dent P. O.
G. H. W. Musecamp...Physician and Surgeon, ½ mile West of town.
E. D. Crookshank...Retired Physician and Surgeon.

Dry Goods, Groceries, &c.

S. B. Goble...Dealer in Dry Goods, Groceries, Hardware, Notions, &c.
I. W. & D. T. Stathem...Dealers in Groceries, Hardware, Crockery, Notions, &c., ½ mile S. E. Westwood.
Fayette M. Wood...Dealer in Dry Goods, Groceries, Boots and Shoes, Family Medicines, &c., at Dent P. O.
E. L. Agin...Dealer in Dry Goods, Groceries, Boots & Shoes, and a General Assortment of Goods, at Dent P. O.
W. H. Markland...Dealer in Dry Goods, Groceries, Queen

Hotels and Saloons.

Geo. Rabenstein...Proprietor of Cheviot Exchange Hotel.
Martin Barwick...Proprietor of Union Hotel, at Bridgetown.
G. A. Stammel...Proprietor of Seven Mile House, on Harrison Pike.
F. Hess...Proprietor of Eleven Mile House, on Cleves Pike, P. O., at Dry Ridge.
V. Adam...Proprietor of Nine Mile House, on Harrison Pike.
Fredrick Yaisle...Proprietor of Five Mile House on Muddy Creek Pike.
John Bleh...Proprietor of Coffee House, at Dent P. O.
Phillip Oehler...Proprietor of Bridgetown Saloon.

Nurserymen, Florists and Gardeners.

Charles Miller...Florist, at Bridgetown.
James Epley...Proprietor of Nursery, 2½ miles North of town.
Louis Schafer...Gardener, 1½ miles West of town, on Harrison Pike.

Blacksmiths, Wagon Makers, Carpenters and Painters.

Philip Bayer...General Blacksmith, at Bridgetown.
Chas. Steinmann...Blacksmith and Wagon Maker. Buggies and Spring Wagons a Specialty.
J. D. Ashley...Blacksmith and Wagon Maker. Horse Shoeing a Specialty.
John Schwarz...Painter and Manufacturer of Wagons and all kinds of Farming Implements, at Bridgetown.
Phillip Oehler...Carpenter and Builder, at Bridgetown.

Butchers and Dairymen.

Wolf Meyerfeld...Butcher and Drover.
Schulte & Koch...Dairymen, S. W. of town.

Miscellaneous.

A. I. Applegate...Agent for Etna and Enterprise Insurance Companies.

This Cheviot Business Directory from the 1869 Hamilton County Atlas is a comprehensive directory. Most businesses supported local farmers.

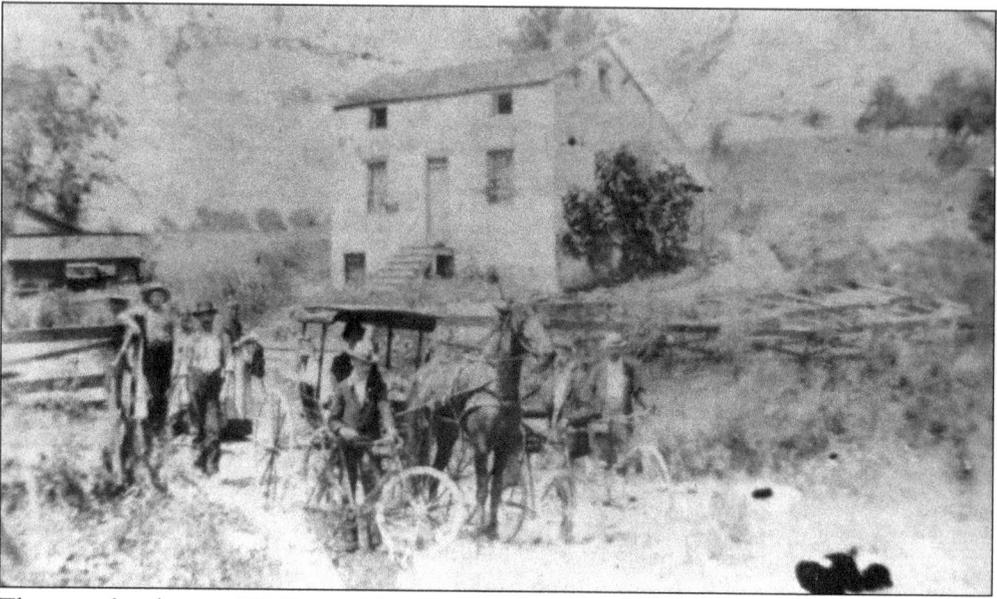

The stone farmhouse of Phillip and Catherine Herrmann was located on Shepherd Creek Road, Green Township, just north of the present Mount Airy Forest Park entrance. This photograph was taken around 1870. Later after a new frame house was built on the hill across the road, the house was torn down and the stone used for the Shepard Creek roadbed. In the background is the barn along Shepherd Creek Road. Some years later, children burned the barn as a prank.

The Andrew Herrmann Family is pictured at their farmhouse along Shepherd Creek Road, now Mount Airy Forest. Seen here, from left to right, are the following: (first row) Barbara Herrmann, Carie Herrmann, Andrew Herrmann (1885—1924), son of Phillip Herrmann (1819—1912), William Palmer, and Dewit Palmer; (second row) August Herrmann, Elsie Herrmann Steigleder, John A. Herrmann, and Emma Herrmann Palmer.

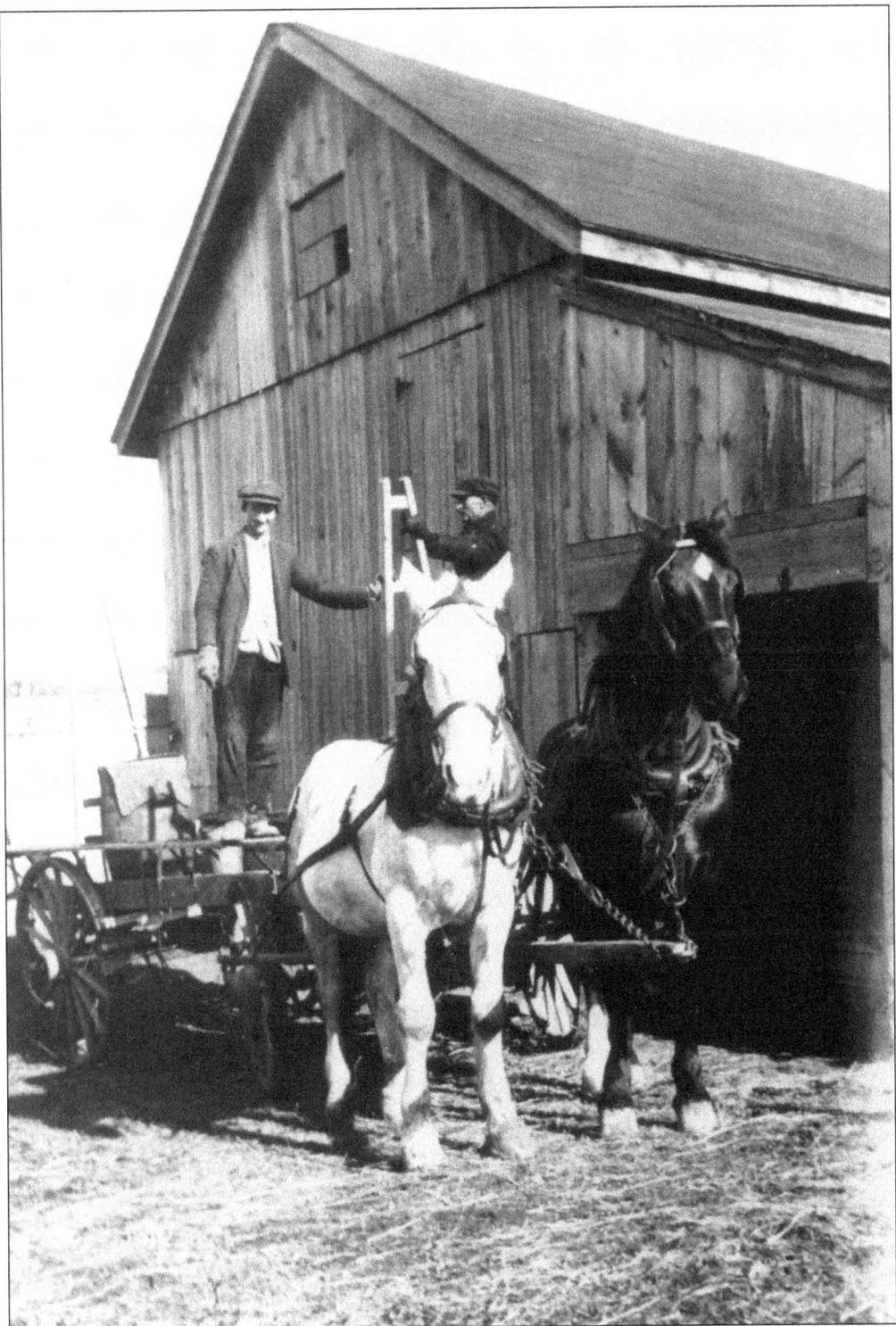

Pictured here are Andrew Herrmann (right), and his son, August Herrmann, about 1923 with their horses. The building was demolished for Mount Airy Forest in 1933.

Bridgetown O Feb 2nd 1889

*The Green Township Anti-Horse thieving Associatⁿ
met on this day. George Frondorf Presiding,
Richard Powell as Secy*

Minutes of previous meeting were read and approved

*It was moved and Carried, that the present
Officers be Elected by Viva Voce*

*Moved and Carried that the Secretary get
the proceedings published in Two newspapers. One
English and One German.*

*Meeting then adjourned Subject to Call of the
President*

Officers

George Frondorf — President

Richard Powell · Secretary

Jacob P Neiheisel Treasurer

*Geo. W. Hay, Mathias Honert
Joseph Skeible, Frank Bertram
& M Anton Rack* } Directors

This is a page from the minute book of the Green Township Anti-Thieving Association from a February 2, 1889, meeting. Officers elected represented well-established family names in the township.

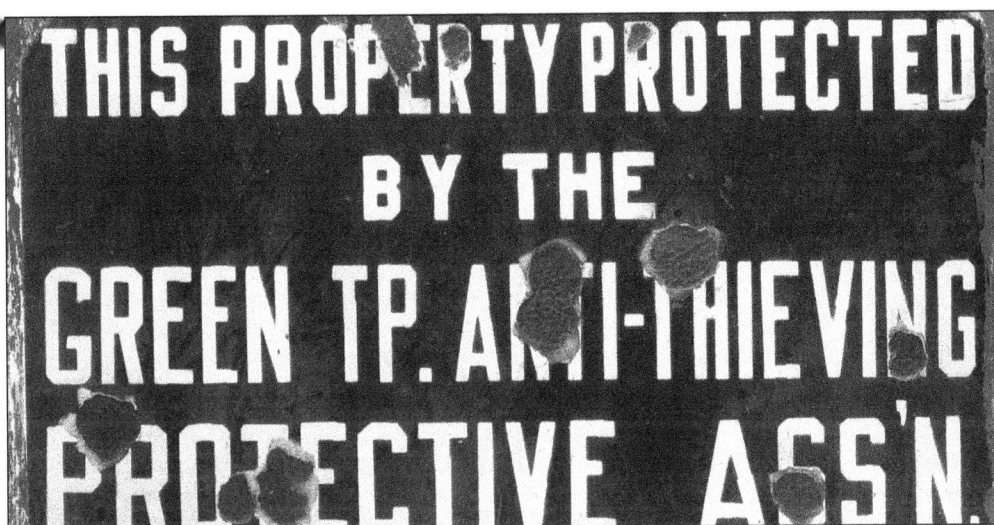

This plaque was placed on Markland's barn at Bridgetown and Ebenezer Roads. Township farmers helping to protect farms and other properties were known as the Green Township Anti-Thieving Protective Association. In the 1880s, township farms and other property suffered from a number of horse thefts. County sheriff's deputies rarely patrolled the outlying townships. The first meeting was held in 1885 with 77 members. When a theft occurred, word spread and members mobilized to catch the thief. They used roadblocks and were sometimes armed. Members displayed a plaque on their barns to warn potential thieves. Note that with this plaque someone used it as target practice. In the early years, the group met in Focke's Tavern at Bridgetown Road and Church Lane. In later years, it became more of a social club.

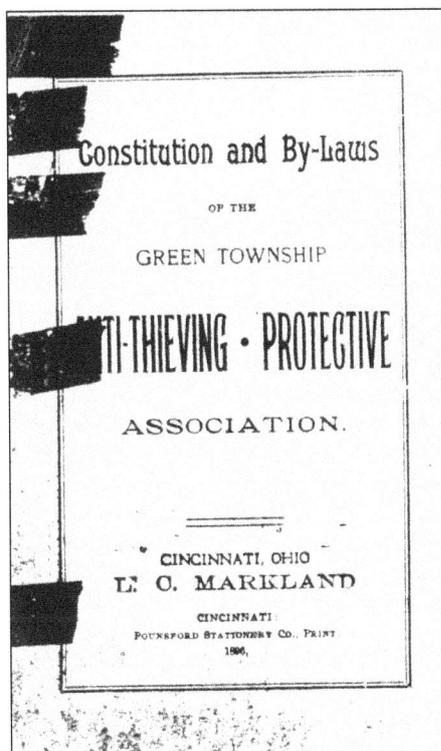

The Anti-Thieving Protective Association had its own constitution and by-laws. The cover is shown here.

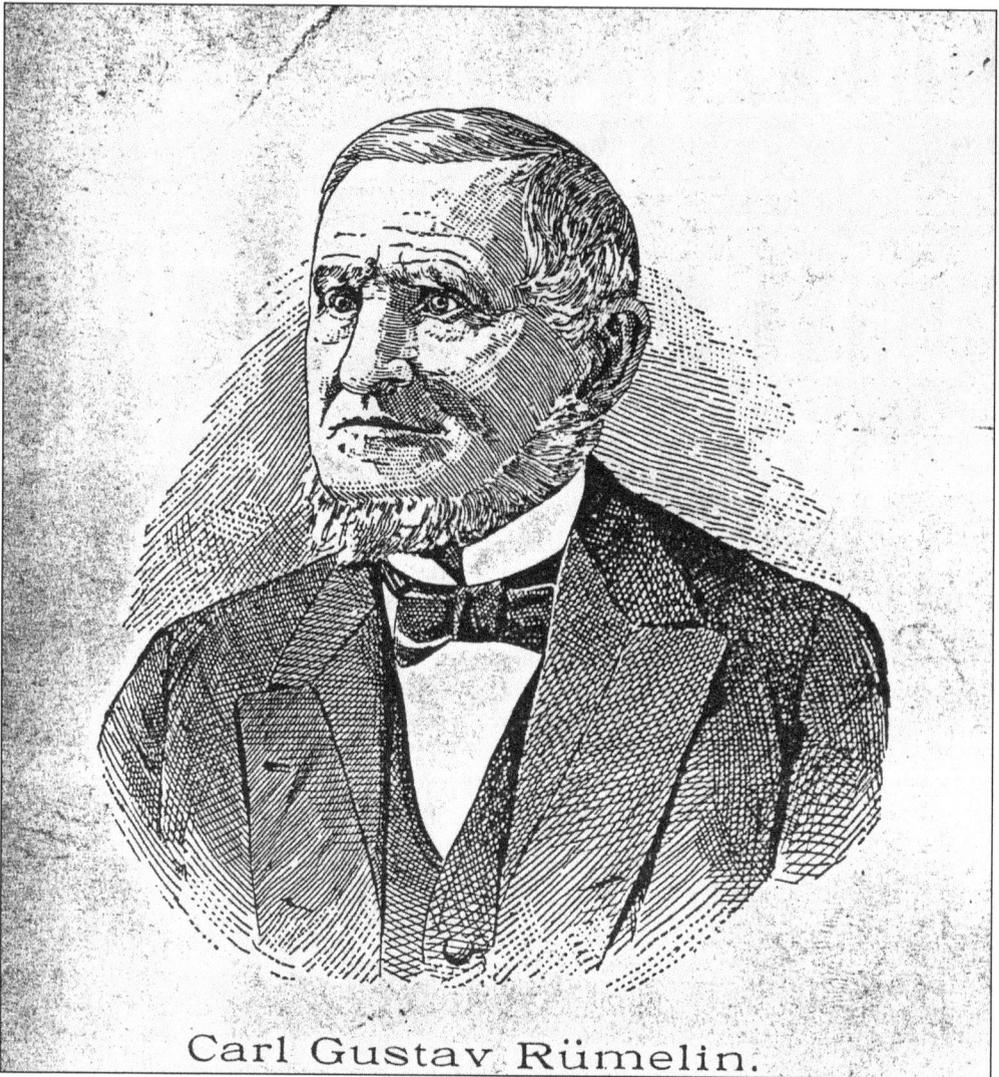

Carl Gustav Rümelin.

Carl Gustav (Charles) Reemelin was a businessman, lawyer, public servant, farmer, author, husband, and father. Born in 1814 in Heilbronn, Wurtemburg, Germany, he sailed to America in 1832 and traveled to Cincinnati in 1833, prospering in the grocery business. He married Louise Mark in 1837 and raised a family of seven children. In 1843, he sold his grocery business and purchased a 160-acre farm in Green Township (Dent). He actively worked his orchards and vineyards, regularly traveling to Cincinnati on horseback. He became an expert on methods of grape cultivation for wine production. In 1851, his wine production topped 450 gallons. Gradually he sold all but 32 acres of his farm. He became a lawyer in 1848. Elected to the Ohio House of Representatives in 1844 and the Senate in 1846, his political career flourished. Reemelin also served as a banking commissioner, state reform school commissioner, and commissioner of mines. He was a founder of the German newspaper *Volksblatt* and wrote numerous literary, agricultural, and political journals, along with several books, including one on wine production. Reemelin was elected to the Green Township board of education, attended the Harvest Home Festival for over 20 years as a local farmer, gave Dent its name for the steep, hilly depression in the area, and completed his autobiography in 1892. He died on January 16, 1896, and is buried in Spring Grove Cemetery.

Reemelin wrote this book on wine production in 1860. He contributed to numerous literary, agricultural, and political journals and wrote several other books.

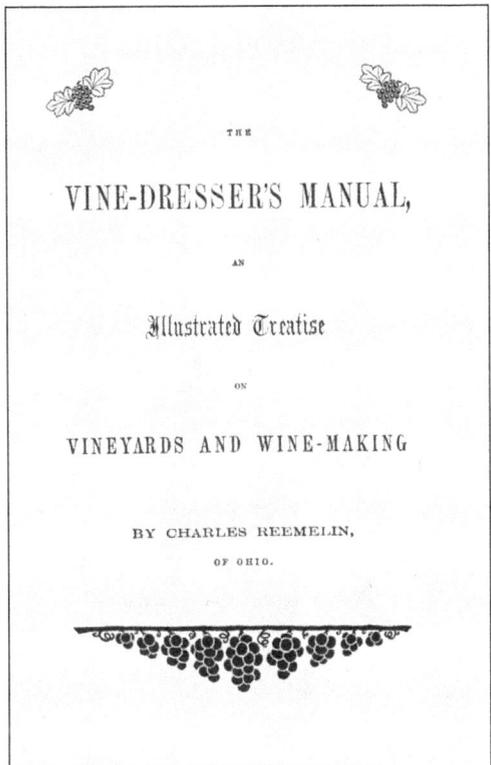

THE

VINE-DRESSER'S MANUAL,

AN

Illustrated Treatise

ON

VINEYARDS AND WINE-MAKING

BY CHARLES REEMELIN,
OF OHIO.

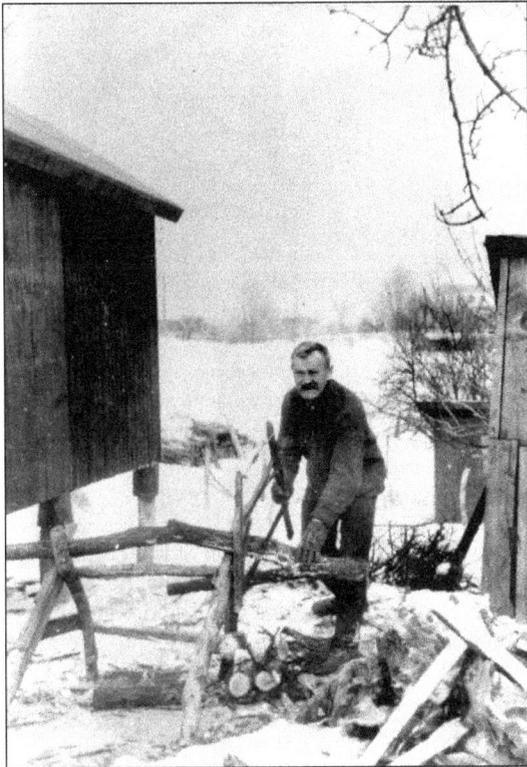

John Fischer saws wood at home on West Fork Road in Monfort Heights. The view looks north along North Bend Road. In the background are the homes of the Heids and the Thurings, open fields then, now the site of a major grocery chain and fast-food restaurants.

17

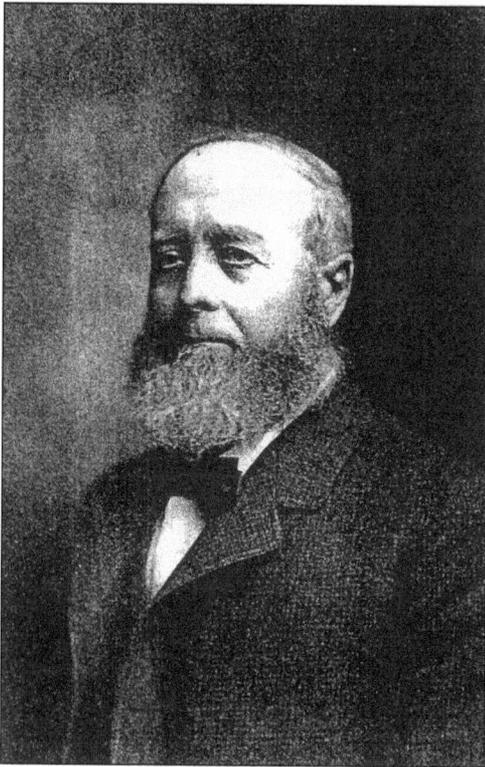

Philipp Neufarth, born in Germany in 1835, came to the United States in 1845 with his father, Heinrich, and two brothers and a sister. They settled along Diehl Road. Philipp and his wife, Elizabeth, raised eight children on their Diehl Road farm.

The Neufarth Farm overlooked today's Mount Airy Forest. The construction of I-74 cut into the hillside and bisected Diehl Road. The site where the house was located is now at the dead end of old Diehl Road. The house was built by Philipp Neufarth to replace the original farmhouse property. Philipp died in 1913, and his wife, Elizabeth Zimmer Neufarth, continued to live there until her death in 1916. At that time, the farm and house were sold to the Cincinnati Park Commission to become part of Mount Airy Forest. One of Philipp's sons, Charles, worked for the park board, renting the family homestead. In the 1930s, the property around the home was used to house the Civil Conservation Corps, a federal program.

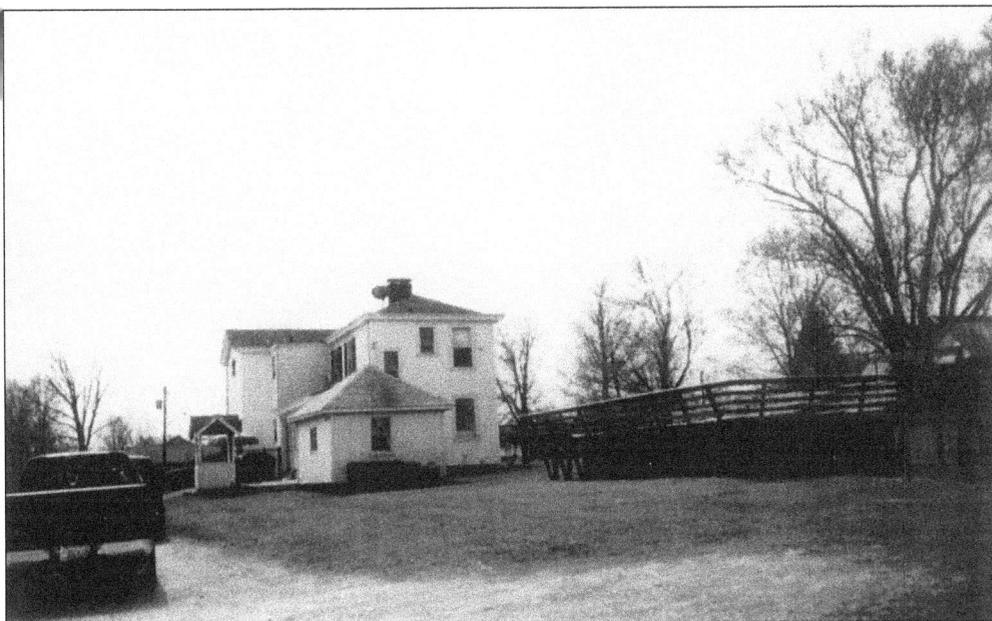

Frederick Brockhoff was the original owner of the Brockhoff Farm in the 1880s. The farmhouse was on Bridgetown Road just east of Virginia Court. Son Edward and his wife, Louise, subsequently farmed the land, along with Edward's brothers Albert, Walter, Henry, daughter Carrie, and their families. The farm raised crops and also had cattle and boarded horses. The farmhouse was demolished in 2005 for development.

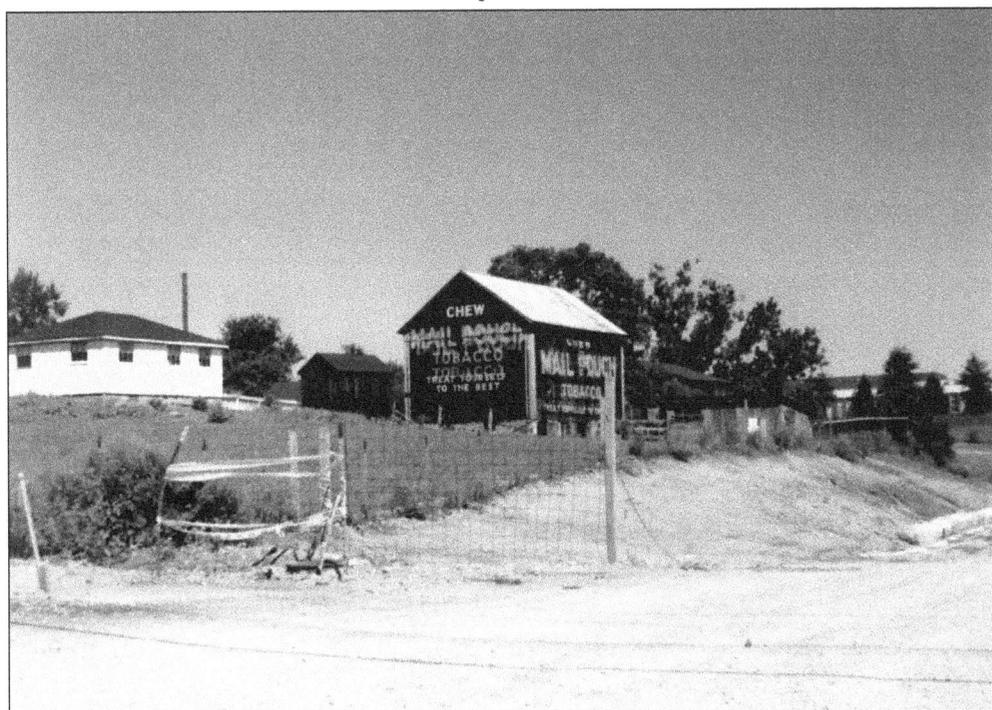

In the 1930s or earlier, Mail Pouch Tobacco signs were painted on the barn as advertisements. The barn was also demolished for the development.

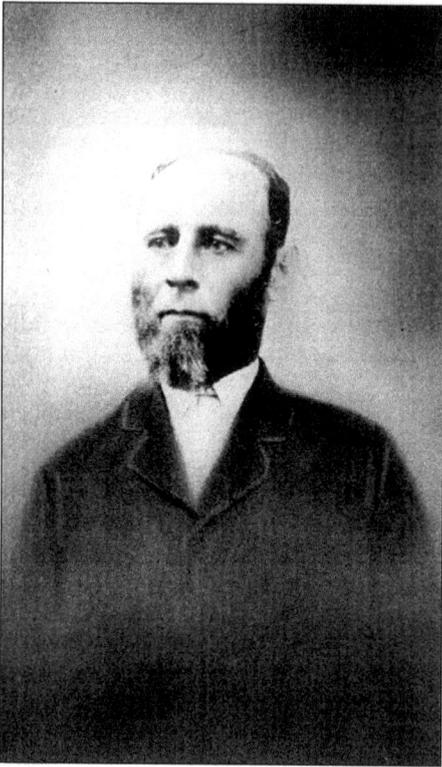

Michael Schaible settled on his farm with his wife, Louisa Von Laer Schaible, after their honeymoon in 1869.

Louisa Von Laer Schaible and husband Michael lived on a 28-acre farm that Louisa's parents (the Von Laers) purchased in 1863. Both Michael and Louisa's parents came from Germany, typical of many Green Township farmers.

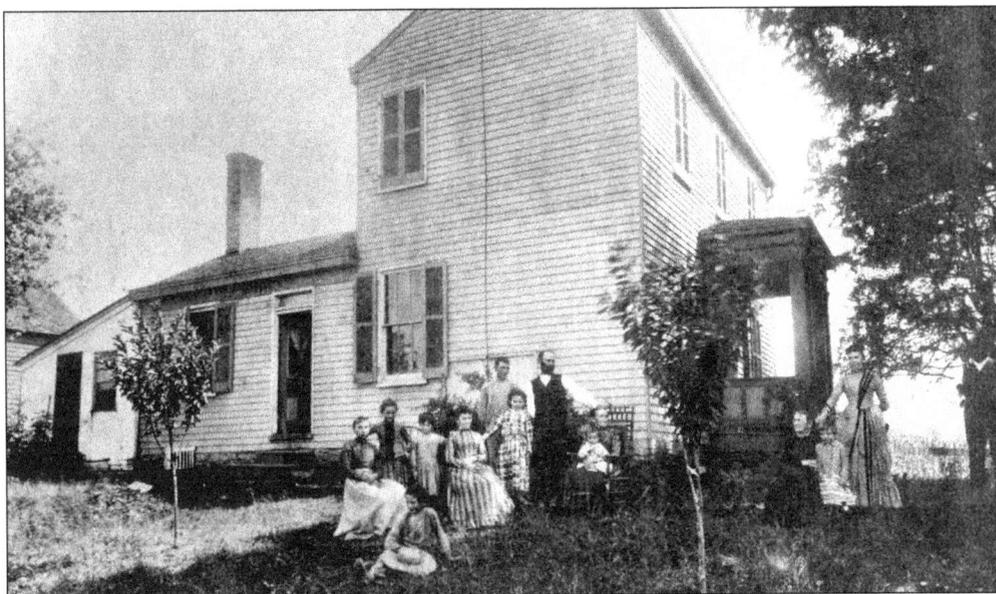

Michael and Louisa Schaible's 28-acre farm is shown here in the 1880s, located along and east of today's Westbourne Drive, just north of Muddy Creek. Michael and Louisa had nine children, six girls and three boys. In his early 20s, Michael was on the organizing committee that began St. Aloysius Parish in 1866. He even used his team of horses to help dig the church's cellar for the first parish. Michael and Louisa's wedding was one of the first at St. Aloysius in November 1869.

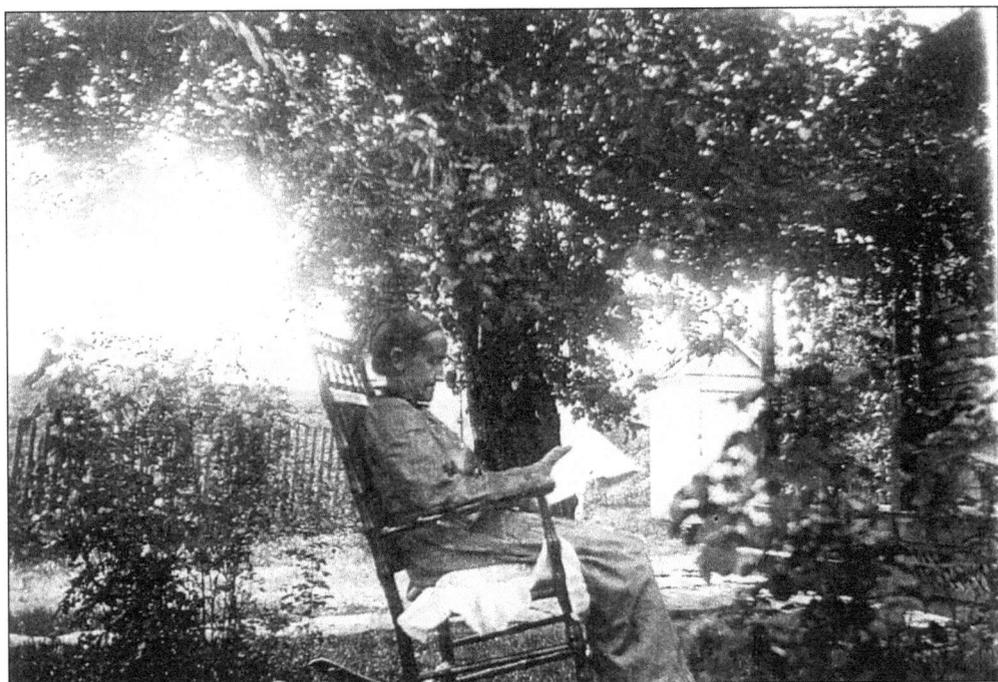

Louisa Von Laer Schaible sits in a rocking chair under the shade of an old apple tree. The building in the background is the smokehouse. The corncrib, used to store corn, is hidden by the apple tree.

According to an 1881 Hamilton County history book, Sidney S. Jackson was a well-respected horticulturist, not only in Green Township but also around the country. His father, Isaac, purchased 480 acres for $7.35 per acre in Green Township in 1813.

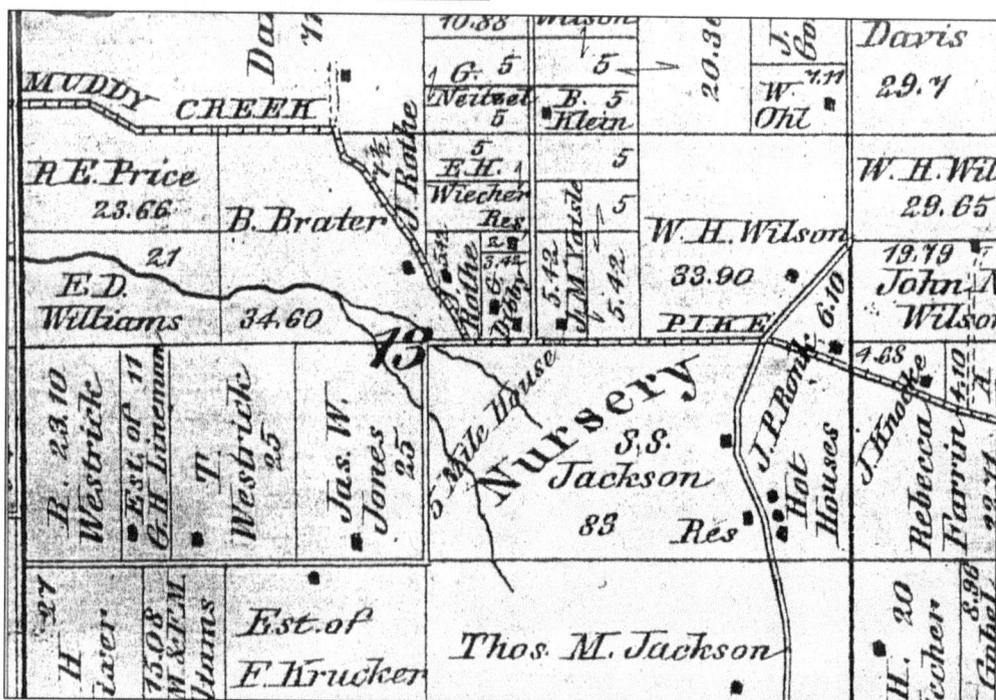

Jackson's property is outlined on the 1869 Hamilton County Atlas map. The road is Muddy Creek Pike, today's Sydney Road. The Jackson Nursery was south of Sydney Road, roughly from today's Linneman Road on the west to a little east of Anderson Ferry Road. As early as 1830, Jackson dealt extensively with exotic and rare plants and was one of the founders of the Horticultural Society of Cincinnati. His farm contained three greenhouses.

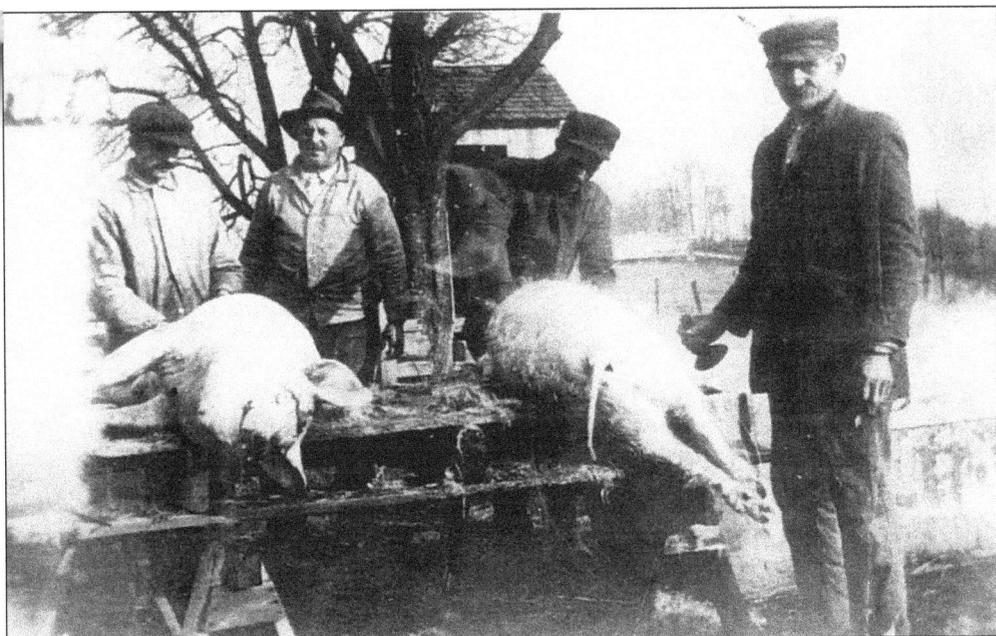

The Frondorf Farm on Bridgetown Road is shown here in the 1920s on what is now Eyrich Road. The farmers are butchering hogs, a family operation in which many members participated.

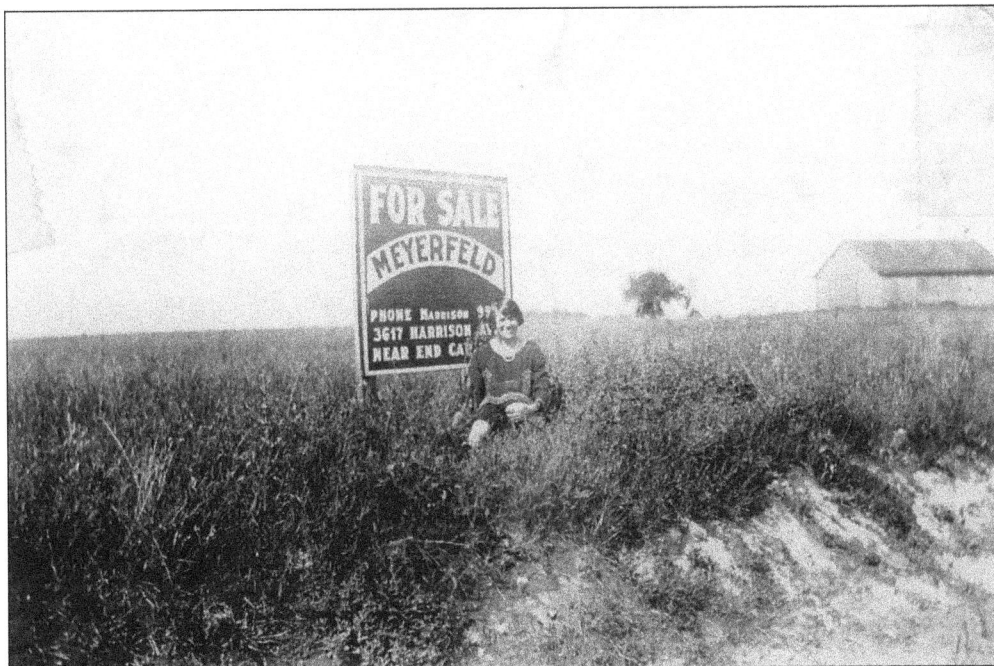

The Kramer Farm, for sale, on Bridgetown Road was located on the site of what today is St. Jude Parish. The date is September 13, 1926.

Bill and Stan Neiheisel are gathering hay for fodder in their fields on the Neiheisel Farm on Bridgetown Road in Mack. The date is June 21, 1922.

John Shey is seen here with workhorses on the Neiheisel Farm around 1922.

Two

EARLY HARVEST HOME

Here is the Harvest Home Dance Barn in 1890. The Harvest Home Festival/Fair had its roots in farming and still does to this day, with animals, horse shows, flower shows, crafts, baking contests, fruits, and vegetables. Green Township pioneers, the Carson family began the farm community gathering to celebrate the bountiful farm harvests in the early 1800s, and it became an annual event. The grounds became known as Carson's Grove.

The Green Township Harvest Home
ASSOCIATION.

This Certifies, That *Maggie Rodler*

is entitled to *one* Shares, of ten dollars each, of the Capital Stock

THE GREEN TOWNSHIP HARVEST HOME ASSOCIATION,

transferable only on the books of the Company, in person or by Attorney

surrender of this Certificate.

Witness, the seal of the Company and the signatures of the Presider

and Recording Secretary, at the Company's office,

Cheviot, Hamilton County, Ohio, this *Ninth* da

of *May* 1895

D W Craig ———— Recording Sec'y.

Peter M. Williams President

This stock certificate is from the Green Township Harvest Home Association from May 1895. The Green Township Harvest Home Association organized and ran the fair from 1860 until 1939, when the Cheviot-Westwood Kiwanis Club took it over as its major fund-raiser for the community. Today the Harvest Home Fair is called "the Biggest Little Fair in Ohio." While Carson's Grove (Harvest Home) is now in Cheviot, which owns the park and grounds, its ties to Green Township remain. Admittance tickets still have "Annual Green Township Harvest Home Fair" written on them. The Harvest Home Fair still attracts thousands of visitors and participants on the weekend after Labor Day.

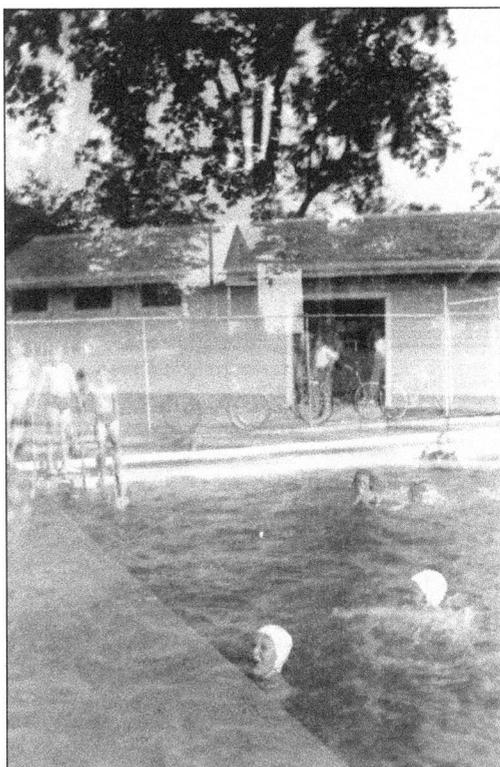

Swimmers enjoy cooling off in the Harvest Home Swimming Pool on a summer day around 1937 or 1938.

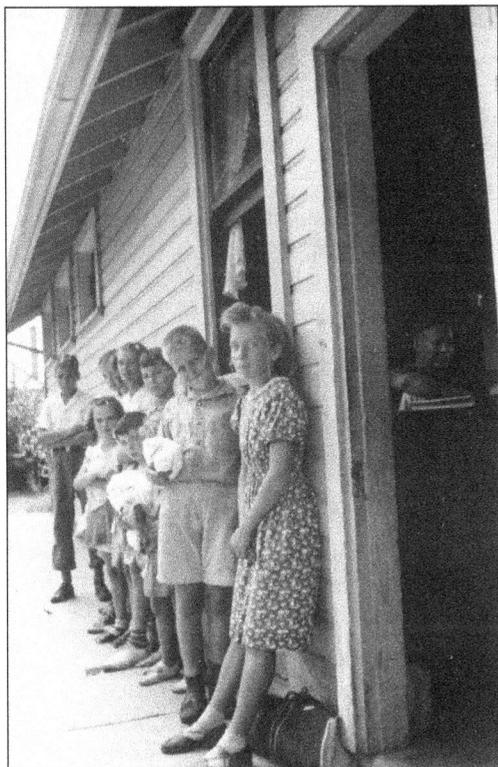

Eager kids wait to change in the locker room to go swimming in the Harvest Home Swimming Pool about 1937 or 1938.

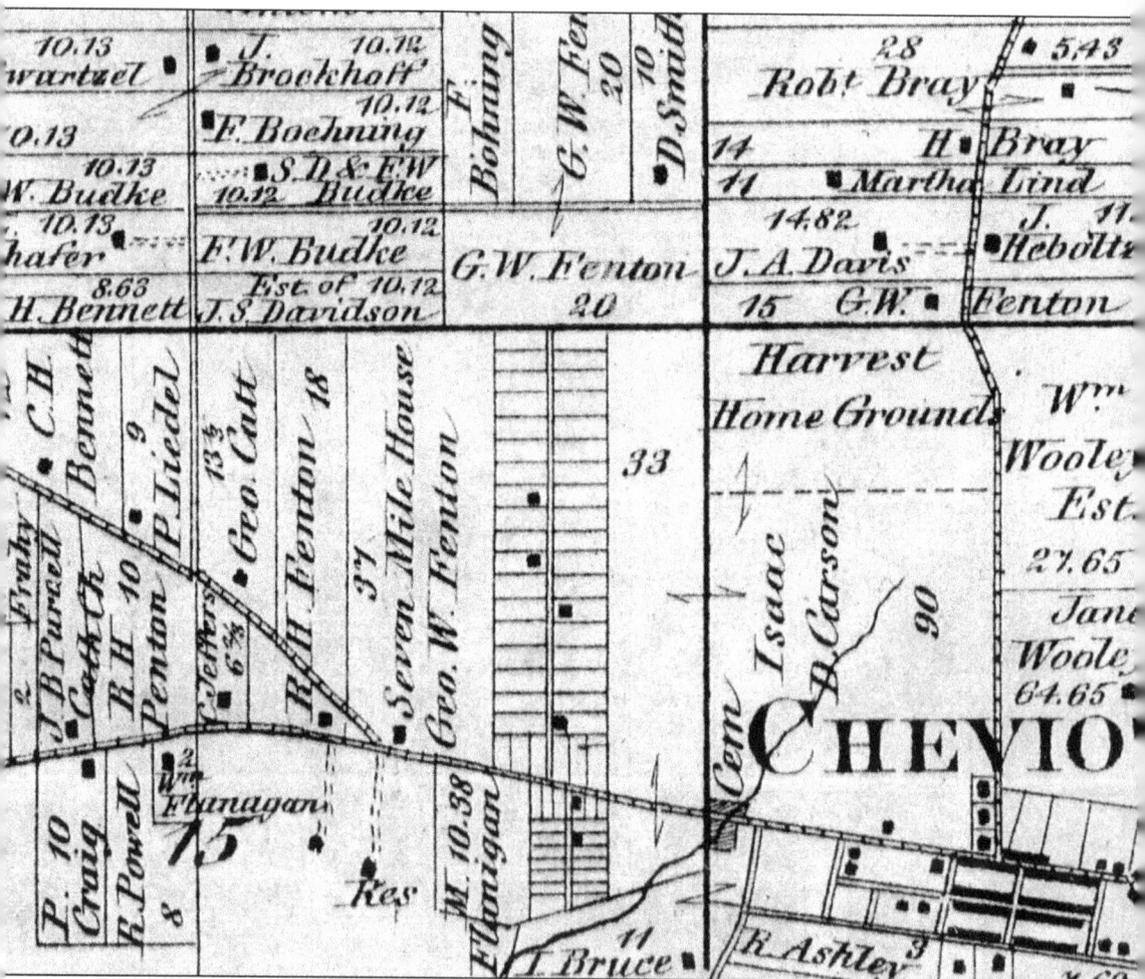

This map from 1869 shows the Harvest Home grounds. According to Dr. Reese P. Kendall, in the *Pioneer Annals of Greene Township*, published in 1905, "The interior of Green Township was noted for its density of its beech forests; and in our youth large areas of soil never were touched by the rays of the sun in summer months. Hence, they were very attractive to impromptu picnics called going to the woods. A fair sample of the continuous shade feature can be seen on the grounds of the Harvest Home Association, the surface of which is nearly dead level."

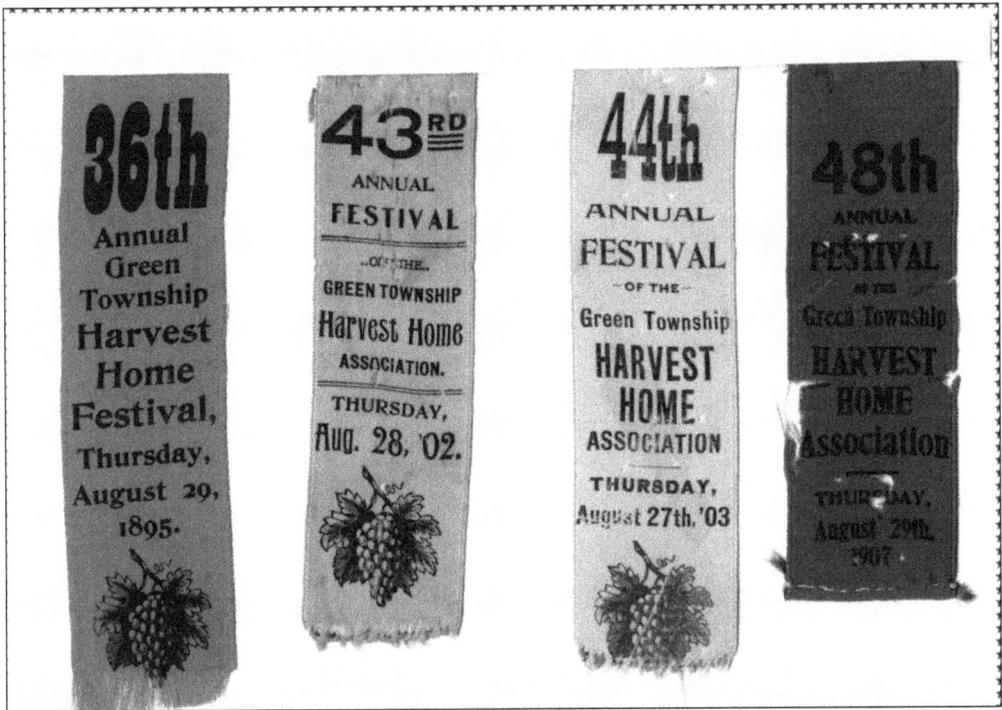

These Green Township Harvest Home badges are from August 20, 1895; August 28, 1902; August 27, 1903; and August 29, 1907.

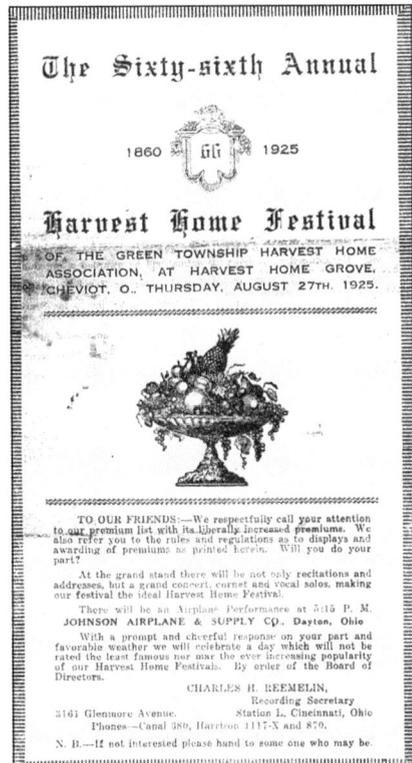

Here is the program cover from the 66th Annual (1860—1925) Green Township Harvest Home Festival. The date is August 27, 1925.

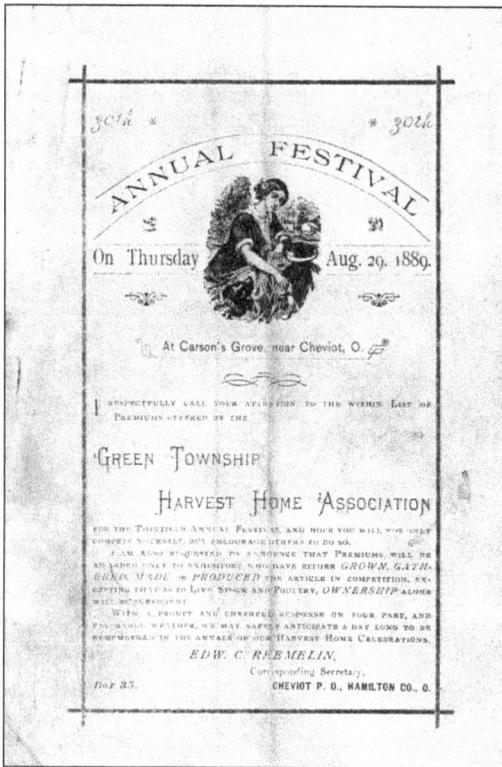

Here is a Green Township Harvest Home Festival program cover from August 29, 1889.

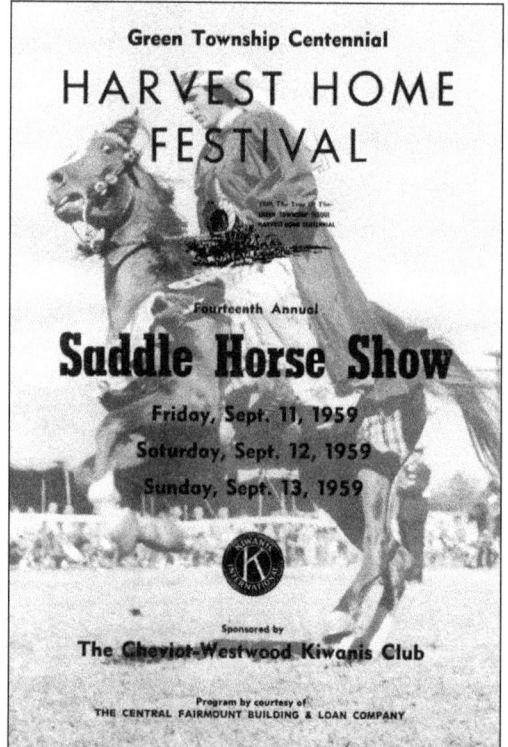

This program cover features the 14th Annual Saddle Horse Show at Green Township's Harvest Home Festival's Centennial September 11, 12, and 13, 1959. Note that the sponsor is the Cheviot-Westwood Kiwanis Club.

These are Green Township Harvest Home Festival park entry tickets from August 28, 1919; September 7, 1958; and September 11, 12, and 13, 2004.

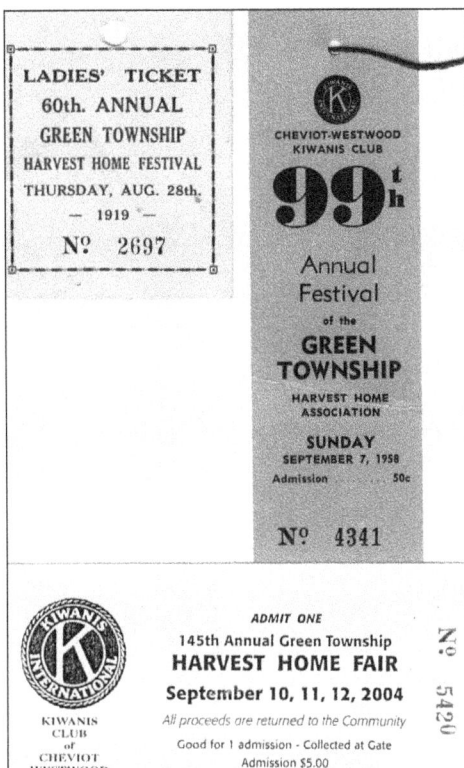

LADIES' TICKET
60th. ANNUAL
GREEN TOWNSHIP
HARVEST HOME FESTIVAL
THURSDAY, AUG. 28th.
— 1919 —
N? 2697

CHEVIOT-WESTWOOD
KIWANIS CLUB

99th

Annual
Festival
of the
GREEN
TOWNSHIP
HARVEST HOME
ASSOCIATION

SUNDAY
SEPTEMBER 7, 1958
Admission 50c

N? 4341

ADMIT ONE
145th Annual Green Township
HARVEST HOME FAIR
September 10, 11, 12, 2004
All proceeds are returned to the Community
Good for 1 admission - Collected at Gate
Admission $5.00

KIWANIS
CLUB
of
CHEVIOT
WESTWOOD

N? 5420

Pictured here is the entrance gate to Harvest Home from the 1930s.

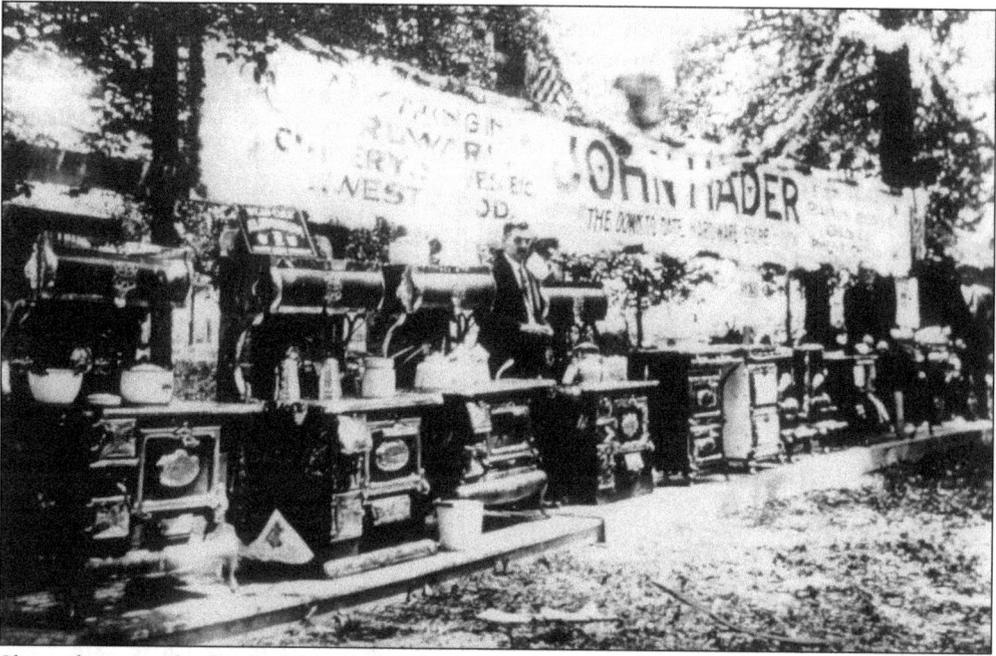

Shown here is a display for John Hader Hardware, "the Down to Date Hardware Store." He sold many items in his store, including hardware, cutlery, stoves, paints, oils, and glass. Note the display is of the latest in modern stoves and cookware.

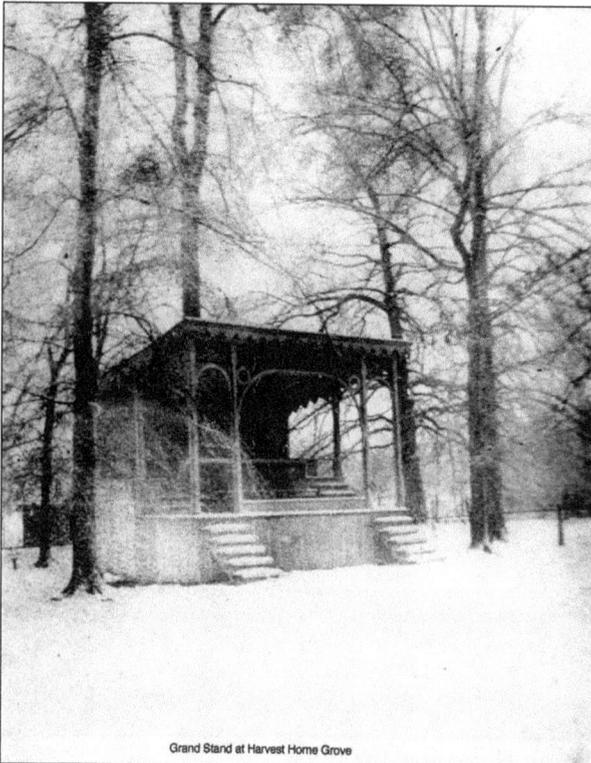

Grand Stand at Harvest Home Grove

This illustration depicts the grandstand at Harvest Home Grove. The year is unknown.

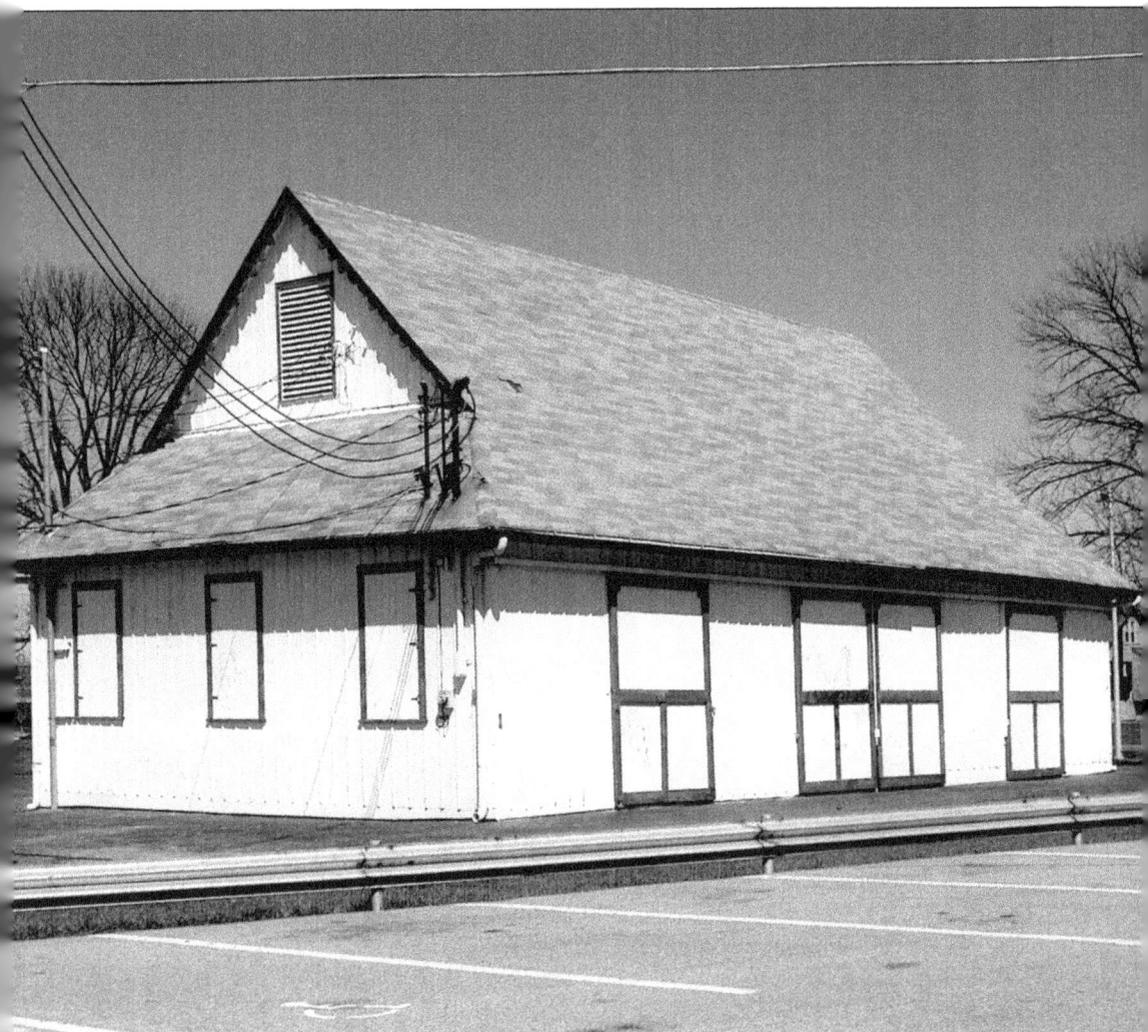

The dance pavilion and barn were renovated in time for the 1990 Harvest Home Fair. The pavilion's old cedar post platform was replaced with a concrete floor. It is now used for the art and flower shows, as well as for city, organizational, and community events. (Courtesy of David Bushle.)

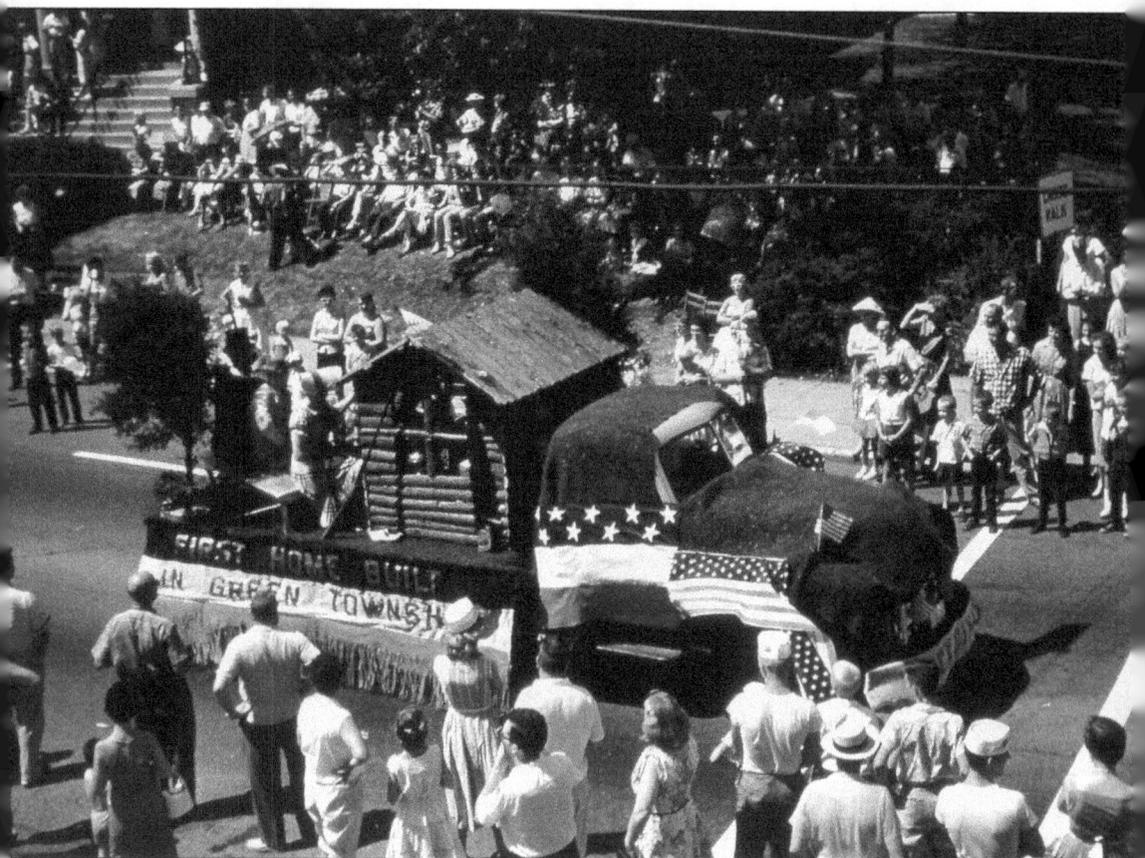

This photograph shows the first home built in Green Township, a log cabin. It was featured in a float for the Green Township Sesquicentennial Parade in 1959, which was actually the first Harvest Home Parade.

Three

ON THE MOVE

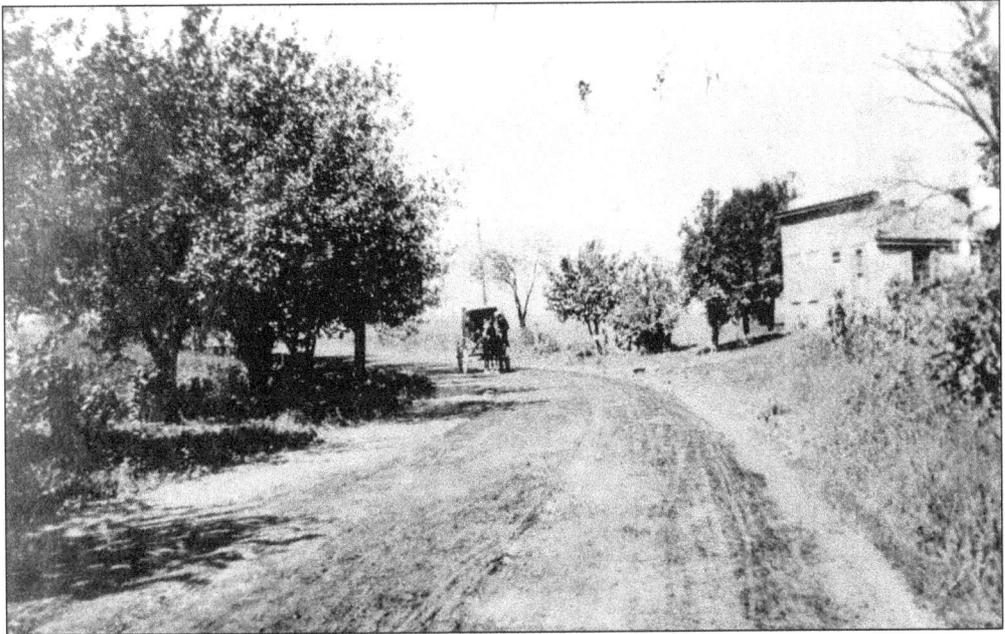

Transportation had a dramatic impact on the development of the hilltop suburbs of Cincinnati. Green Township is a perfect example. In the early years of settlement in the 1800s, the township was isolated from the city. Travel by horse-drawn vehicles, like the one shown here, limited the ability to reach Green Township from the city in a reasonable length of time. Steep hills leading to the city's west side made the situation more difficult. As a result, most Green Township settlers were farmers, along with residents in small "crossroad communities." A trip to Cincinnati by horse could take two to three hours. Horses and mules were the beasts of burden on local farms. This is on Bridgetown Road at the Kramer Farm, looking west. Around the bend would be today's St. Jude Church.

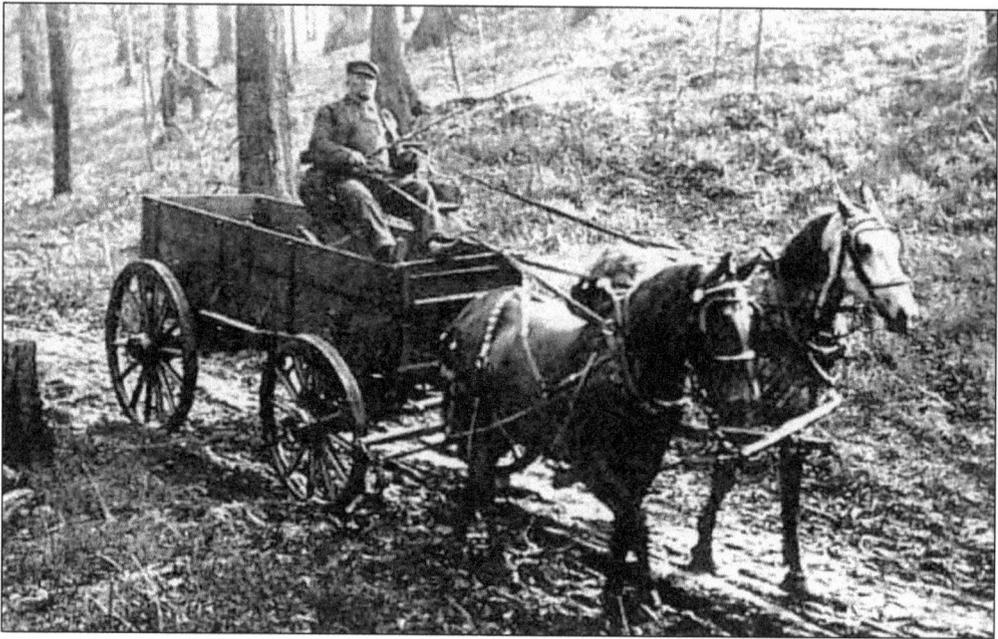

Horse-drawn wagons typically were used by farmers to haul products to market. Early roads usually followed valleys, ridge tops, or old footpaths. Roads were dirt—dusty in dry weather and very muddy when wet. The ride was bumpy, and the riders were often exposed to harsh weather. Travel was slow by today's standards.

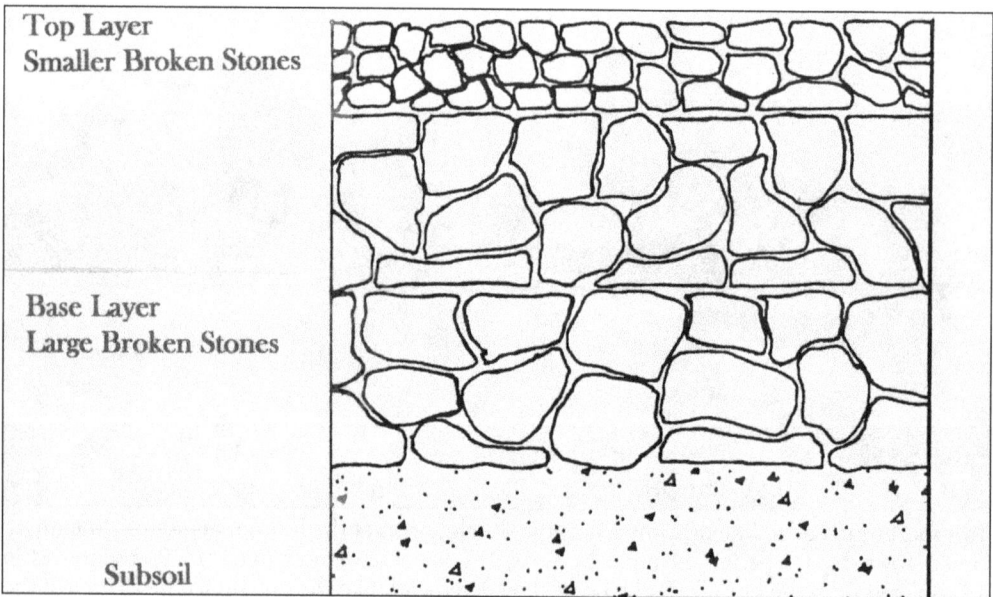

To help make dirt roads more passable, crushed rocks were spread on the dirt, especially in muddy areas, a process known as the macadam system. Piles of stone would be dropped off along the road, and men would sit on the pile, cracking the stones into smaller pieces about the size of a chicken egg. Then it was spread on the muddy roads. In Ohio, every male had to spend a specified number of hours cracking stones—they had to put in their time. The requirement ended many years ago.

THE

STATE OR CLEVES ROAD

TURNPIKE COMPANY

This Certifies, that _Henry Applegate_ is entitled to _Eight 82/44100_ Shares of the Capital Stock of the STATE OR CLEVES ROAD TURNPIKE COMPANY.

Transferable only in accordance with the Rules and By-laws of the Company, and on the Company's Books, by the said _Henry Applegate_ in person or by Attorney upon surrender of this Certificate properly endorsed.

In Witness Whereof, the President, and Secretary have hereunto affixed their Signatures, at Cleves, Ohio, this _31st_ day of _Jany_ 1879.

Geo W May Secretary. _Henry Flinsdorf_ President.

This State or Cleves (now Bridgetown Road) Road Turnpike Company stock certificate is dated from 1879. In the late 1880s, it was a turnpike, partially financed by state funds and partially by this turnpike company's funds. The company operated the roads and collected tolls to raise funds for road repairs. Several township roads were turnpikes with tollgates. Gradually the state, county, cities, and villages purchased these turnpikes and took over ownership and maintenance.

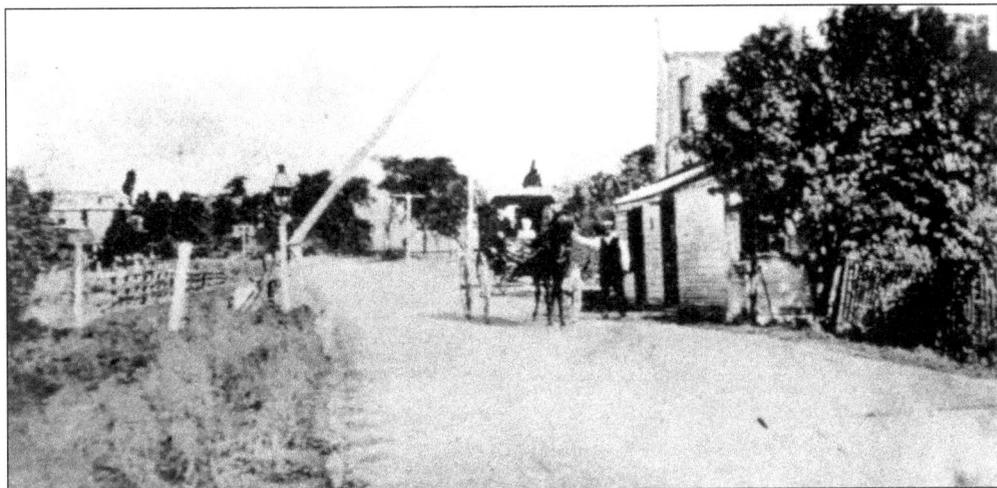

Pictured here is the Dent Tollgate on Harrison Pike in Dent between today's Filview Circle and Westwood Northern Boulevard. The turnpike toll rates were on a carved wooden sign used at the tollgate. Rates were per mile based on the following categories: one-horse buggy; each additional horse; one-horse wagon; two-horse wagon; four-horse road team; led or driven cattle every 20 head; hogs or sheep every 20 head; less number in proportion of cattle, hogs, or sheep; and one horse and rider.

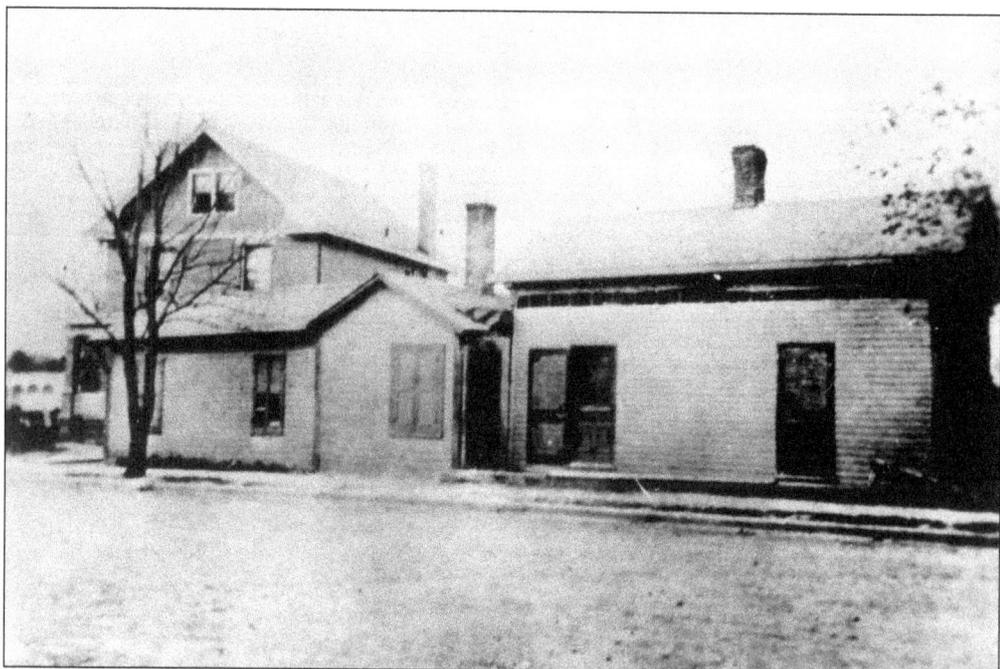

Cheviot Tollgate House is shown in this photograph with a window that opened to traffic where collections were taken. The location is Harrison Avenue west of Glenmore Avenue across from the old cemetery, which is still there.

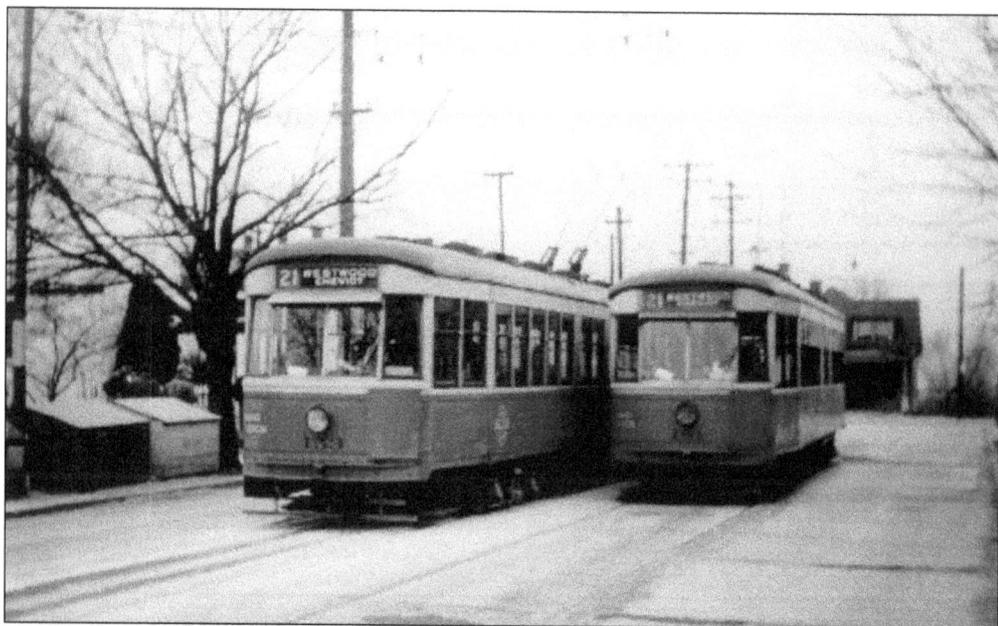

Commuting to a job in the city was not practical for most Green Township residents in the 1800s. The coming of streetcars changed things dramatically. Electric streetcars came to the Westwood and Cheviot area about 1900, helping to spur residential growth. This photograph shows the end-of-the-line layover of the Westwood Cheviot No. 21 streetcar, looking west on Montana Avenue toward Glenmore Avenue. (Courtesy of Phil Lind.)

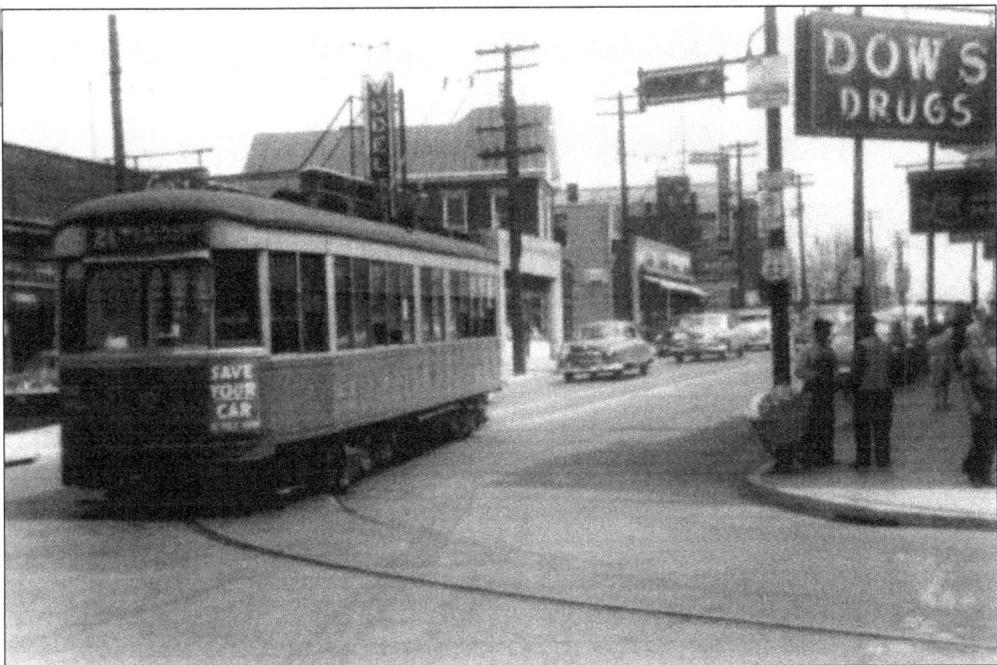

Westwood Cheviot No. 21 streetcar's last day of operation was April 28, 1951. The car is turning left on Glenmore Avenue at Harrison Avenue.

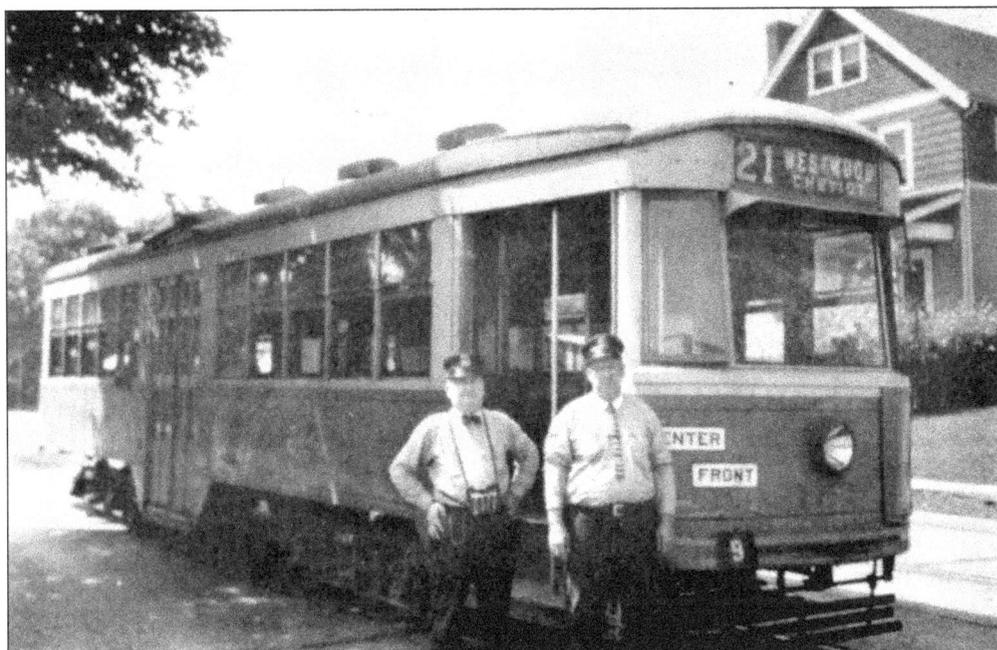

This streetcar is in the loop at the end of Route 21 Westwood-Cheviot, at Glenmore and Montana Avenues. Motorman L. Bennett (left) and conductor George Dietz posed with local streetcar 151 on August 12, 1935. (Courtesy of C. L. Bandy.)

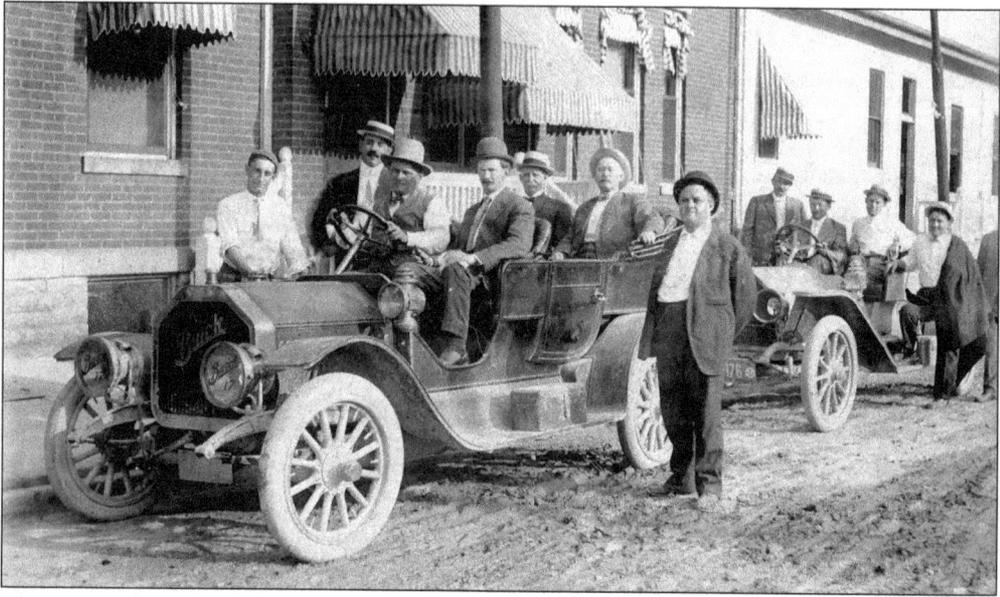

This 1909 photograph shows Nicholas Ruebel posed next to several Cheviot and Hamilton County elected officials in an old touring car beside the now defunct Krollman Beer Gardens on what was then a graveled Glenmore Avenue off Harrison Avenue. Nicholas Ruebel is behind the wheel. Included in the car were Judge Stanley Struble and Frank S. Krug, county engineer from 1891 to 1906. Nicholas Ruebel was the grandfather of current Green Township resident and Green Township Historical Association member Les Brenner.

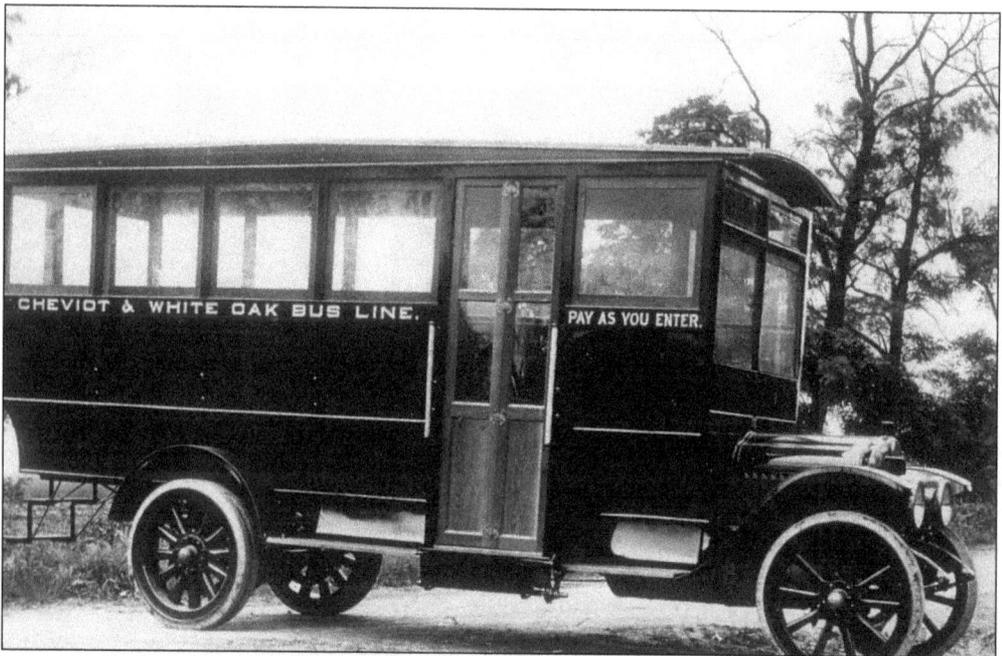

The Cheviot and White Oak Bus Line, operated by George Geiser, ran from White Oak to Cheviot. People could then catch a streetcar in Cheviot to go downtown to work. The bus had solid rubber tires and was originally driven by Geiser himself until 1918. Geiser was a White Oak resident.

William Gutzwiller's Auto Bus Line ran from Miami (Miamitown), Taylor Creek, and Dent to Cheviot. A 1921 bus schedule is pictured here.

AUTO BUS LINE
BETWEEN
Cheviot, Dent, Taylors Creek, Miami
In Effect from May 1st, 1921 to December 1st, 1921

Leave Miami Daily Except Sunday
7:00 A. M. 9:30 A. M. 1:00 P. M. 5.30 P. M.

Leave Cheviot Daily Except Sunday
8:00 A. M. 10:30 A. M. 2:00 P. M. 6:30 P. M.

Leave Miami Extra Saturday Leave Cheviot
3:00 P. M. 7:30 P. M. 4:00 P. M. 9:00 P. M.

Leave Extra Sundays and Holidays
Miami A. M. Cheviot A. M.
5:30 7:15 8:30 10:15 6:30 8:00 9:30 11:00

Miami P. M. - Leave - Cheviot P. M.
1:00 3:00 5:30 7:30 2:00 4:00 6:30 8:30

TOURING CARS FOR HIRE AT ALL HOURS

FOR RATES AND INFORMATION CALL

WM. GUTZWILLER, Proprietor
BELL PHONES
Cleves 86-R3 Warsaw 1108
BEVIS HOTEL MIAMI, OHIO

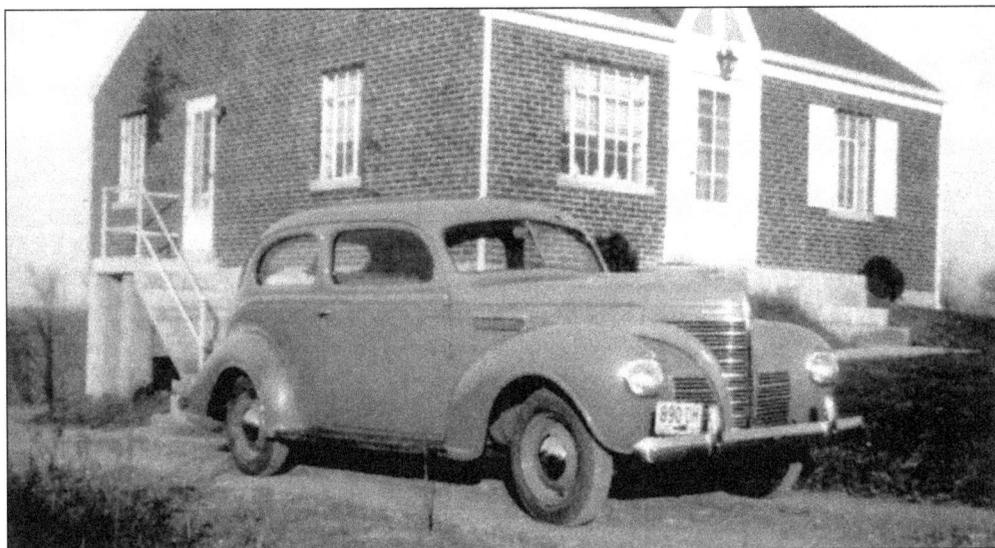

The coming of the affordable automobile for the average person in the 1920s through the 1950s was a catalyst for explosive growth in Green Township's population. Farms were sold as land became more valuable as residential developments. In 2006, very few family farms remain in Green Township and there are few large tracts of land that have not seen some development. Pictured here is a 1939 Plymouth parked at a newly built brick home on Benken Lane in Mack in the early 1940s.

OPA FORM R-534 STUB	BUDGET BUREAU NO. 08-R084 APPROVAL EXPIRES MAY 31, 1945	This STUB, when approved by a War Price and Rationing Board, becomes a record of the mileage rations issued.
UNITED STATES OF AMERICA—OFFICE OF PRICE ADMINISTRATION		IT MUST BE PRESENTED TO THE BOARD WITH EACH APPLICATION FOR A GASOLINE RATION.

MILEAGE RATIONING RECORD

DESCRIPTION OF VEHICLE — DO NOT WRITE IN SPACE WITHIN HEAVY LINES

VEHICLE LICENSE NO. 708 A D YEAR MODEL 1937

SERIAL NO. OF RATION ISSUED 0514097 DATE OF ISSUE 9-18-44

STATE OF REGISTRATION Ohio MAKE Plymouth Sedan.

BOARD NO. 34-31-13 COUNTY AND STATE Hamilton, Ohio

SIGNATURE OF ISSUING OFFICER M. C. Spiess

ADDRESS TO WHICH RATION IS TO BE MAILED:
(Print or type.)

NAME Elmer C. Motsch

STREET AND NUMBER Box 335A-RR13- Werk Rd.

CITY, POSTAL ZONE NO. AND STATE Cincinnati 33 Ohio.

Endorse ALL your coupons as soon as you get them.

HELP KILL THE BLACK MARKET!

Gas for automobiles, among other things, was rationed during World War II. Here is a mileage rationing record of the author's grandfather, Elmer C. Motsch, dated September 18, 1944. He and his family lived on Werk Road in Mack.

DO NOT WRITE ON THIS SIDE

RECORD OF MILEAGE RATIONS ISSUED

DATE OF ISSUE	TYPE AND QUANTITY OF EVIDENCES	GALLONAGE AND PURPOSE FOR WHICH ISSUED (IF SPECIAL RATION)	NUMBER AND ADDRESS OF ISSUING BOARD
1/13/44	3/C		34-31-15 - 6583 Rives Rd
3/14/45	3/e		" " " " " "
7/24/45	26/B		" " "

☆ U. S. GOVERNMENT PRINTING OFFICE : 1944 16—89981-1

This is the back side of the mileage rationing record that belonged to the author's grandfather, Elmer C. Motsch.

This is a World War II war ration book from the U.S. Office of Price Administration. Note that it has Motsch's name and his signature. The author's mother, Adele M. Motsch (now Lueders), also had war ration books. Sugar and liquor were also rationed during World War II.

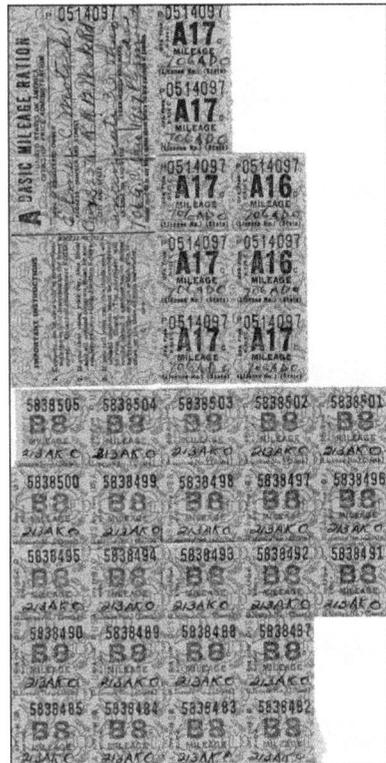

These are original World War II gas-rationing coupons from 1944, issued to Elmer C. Motsch. He was a veteran of World War I.

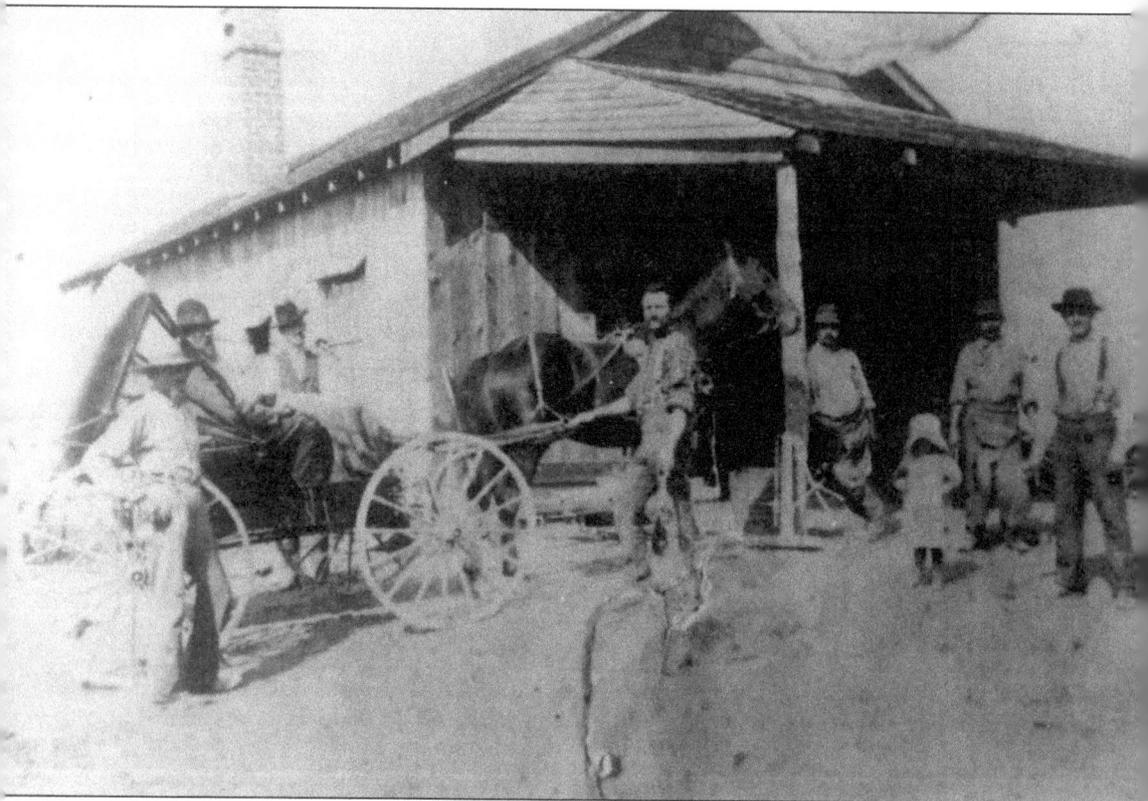

Blacksmith shops were the "service stations" of the era of transportation by horses. Each community had at least one blacksmith shop. The blacksmith was sometimes a wagon maker too. In many cases, the blacksmith shop was a place for local farmers to meet and discuss the latest news. In the photograph here is George Scheidt's Blacksmith Shop at the Five Points intersection in Mack (Bridgetown Road, Ebenezer Road, and Taylor Road). Today a bank is on this site.

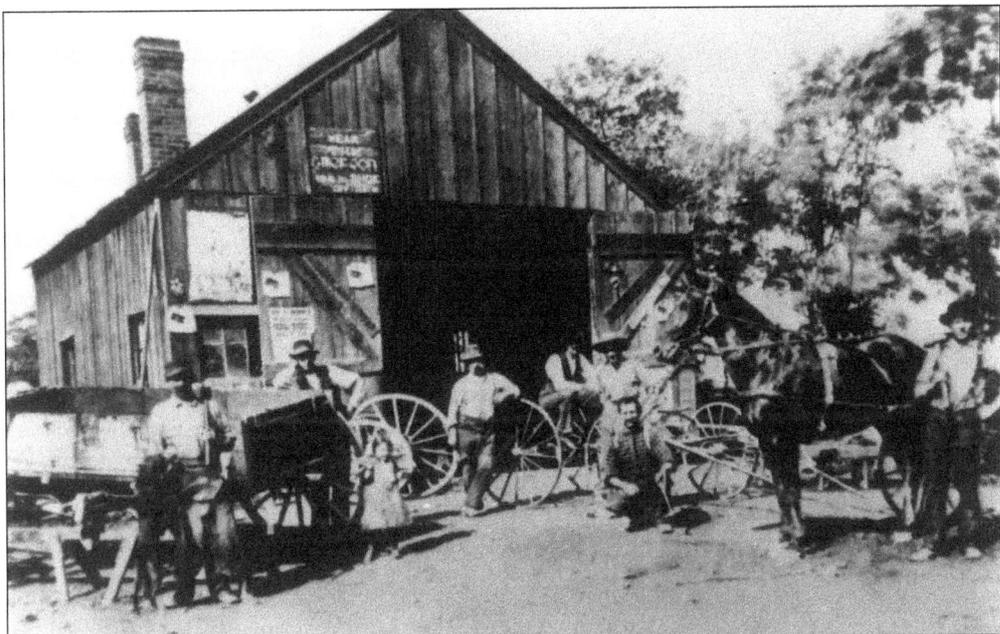

George Neiert's Blacksmith Shop was also at the Five Points intersection. This photograph is from 1897.

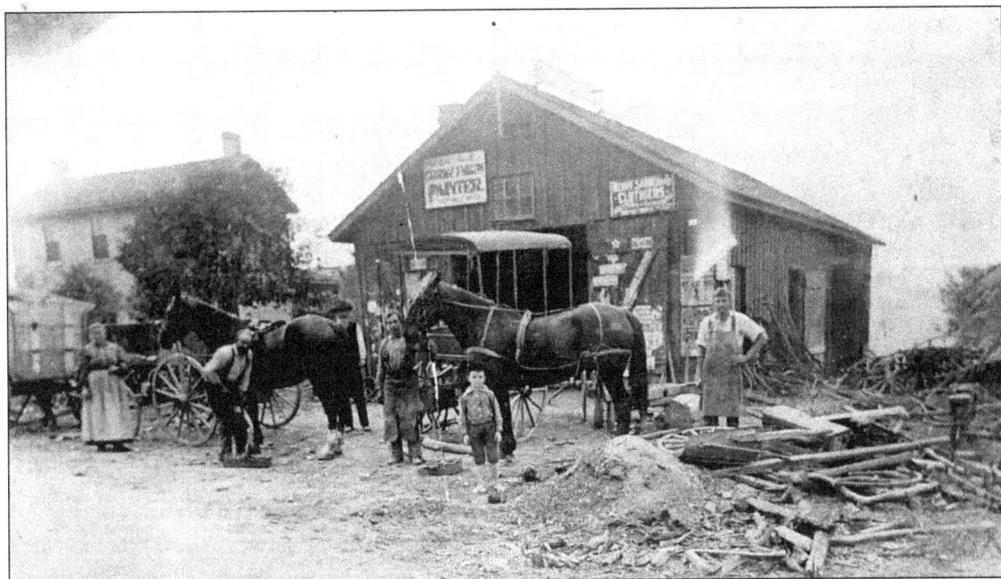

Schaffer's Blacksmith Shop was at the southwest corner of West Fork Road and North Bend Road in Monfort Heights.

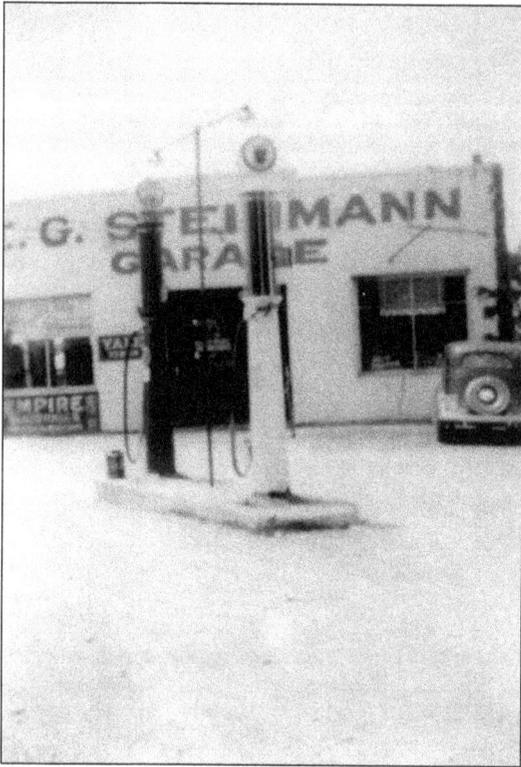

E. G. Steinmann's Garage was an early service station for automobiles, operating at the Five Points intersection in Mack.

PHONES { RESIDENCE, DELHI 10-L
GARAGE, WARSAW 794-R

M Geo Focke

Mack, Ohio, Sept 2 192 4

STEINMANN GARAGE

NASH SALES AND SERVICE
AUTOMOTIVE EQUIPMENT
EVERYTHING FOR AUTOMOBILE AND MOTOR TRUCK

WELDING { AUTOMOBILE PARTS
FARM MACHINERY

MACK, OHIO

TIRES - OILS - LUBRICANTS

April 5	1	Front spring			2 50	
		Labor.			1 00	
					$3 50	

Here is a bill from the Steinmann Garage from April 5, 1924. George Focke had a front spring installed. Parts were $2.50 while labor was $1. The garage telephone number was WARSAW 794-R.

46

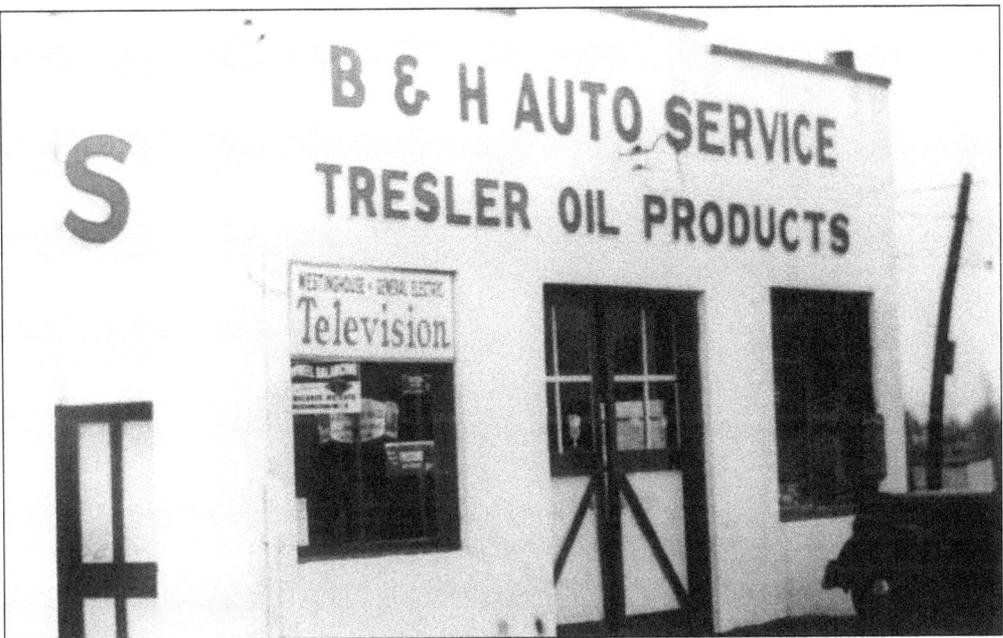

B&H Auto Service was a Tresler Oil Service Station at the Five Points intersection.

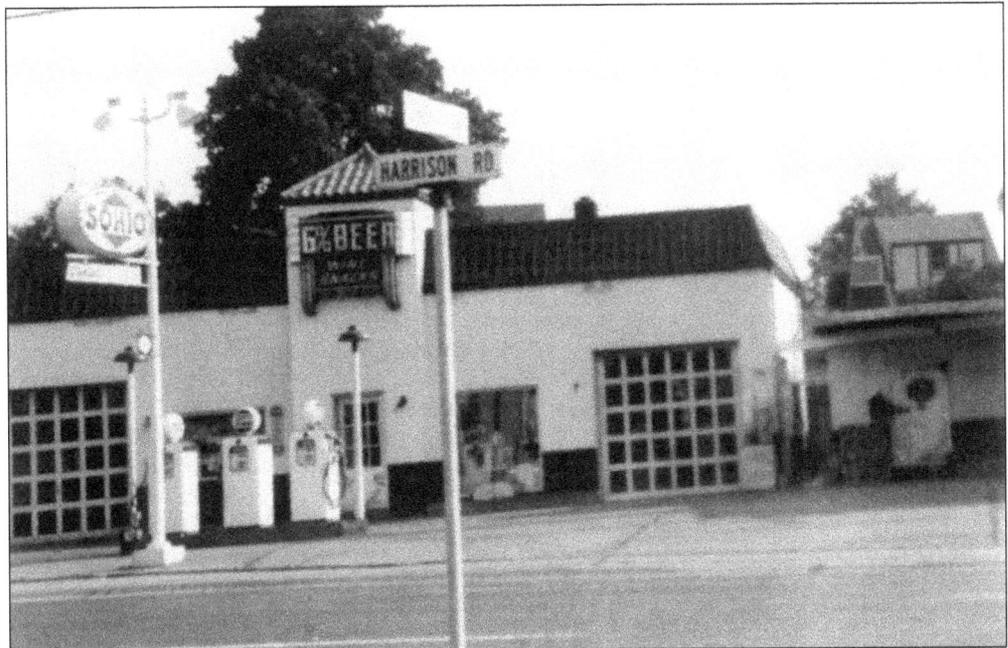

Schaffer's Service Station at the corner of Harrison and Grace Avenues in Bridgetown used to sell Sohio Gasoline. Harrison Avenue at this time was still Route 52. Now a convenience store, it has been at this location since the 1930s and 1940s. It is no longer operated by the Schaffer family.

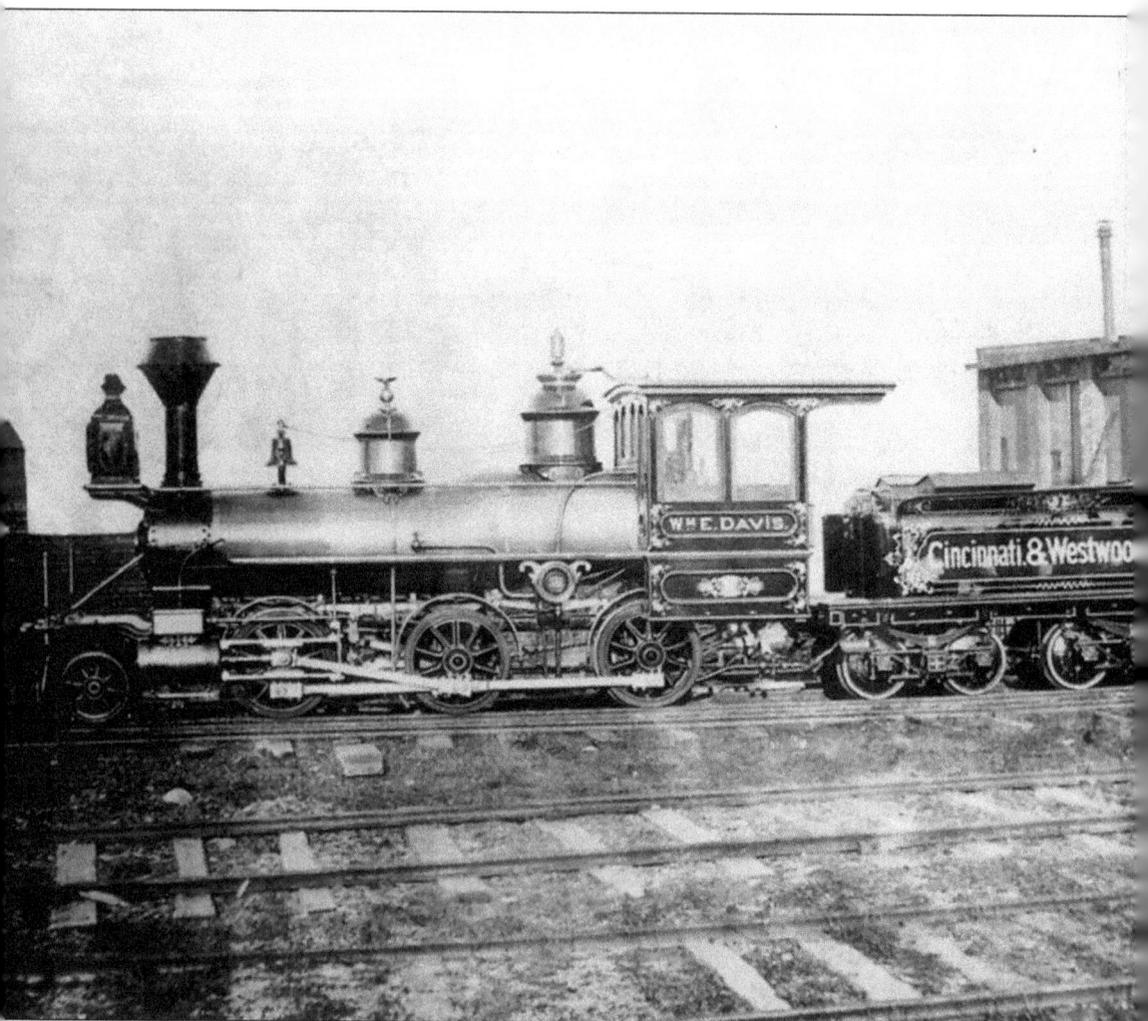

In his book *On the Right Track*, John H. White Jr. wrote that the Cincinnati and Westwood Railroad provided faster and more dependable transit transportation for passengers from Western Hills to the Mill Creek Valley from 1876 until 1896. Freight service was provided after passenger service was suspended in 1896, a victim of new electric streetcars. The Cincinnati and Westwood Railroad, a steam train, was chartered by people like James N. Gamble (of Procter and Gamble fame), Michael Werk, James Robb, and F. W. Schwartz. Money problems plagued the railroad throughout its lifetime, but service began in 1876 and continued until 1924. The line ran from the west end of the Western Hills Viaduct to the Robb Farm near today's Robb and Applegate Avenues. At its peak, six passenger trains ran each day, from 5:38 a.m. to 5:53 p.m. (Courtesy of the Cincinnati Historical Society.)

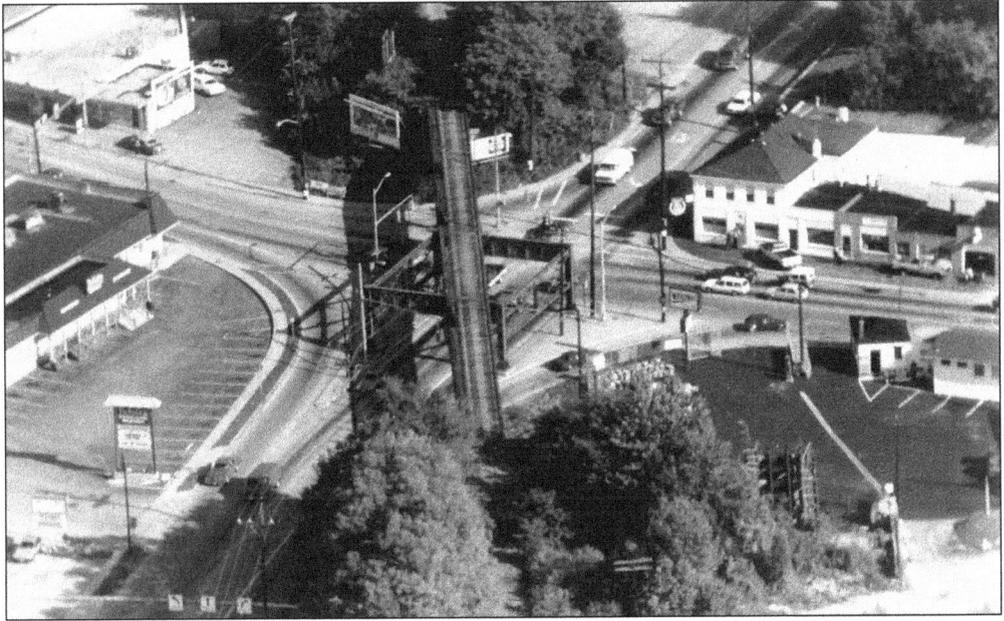

This is an aerial view of the Chesapeake and Ohio (C&O) Railroad trestle at the intersection of Bridgetown Road, Race Road, and Glenway Avenue. Bridgetown runs east (right) to west (left). Glenway Avenue runs south (to bottom). Race Road runs north (to top). The Wagon Wheel Café is the white building in the upper right at Bridgetown and Race Roads. The C&O Railroad cuts diagonally across the intersection. The trestle became a landmark in Bridgetown.

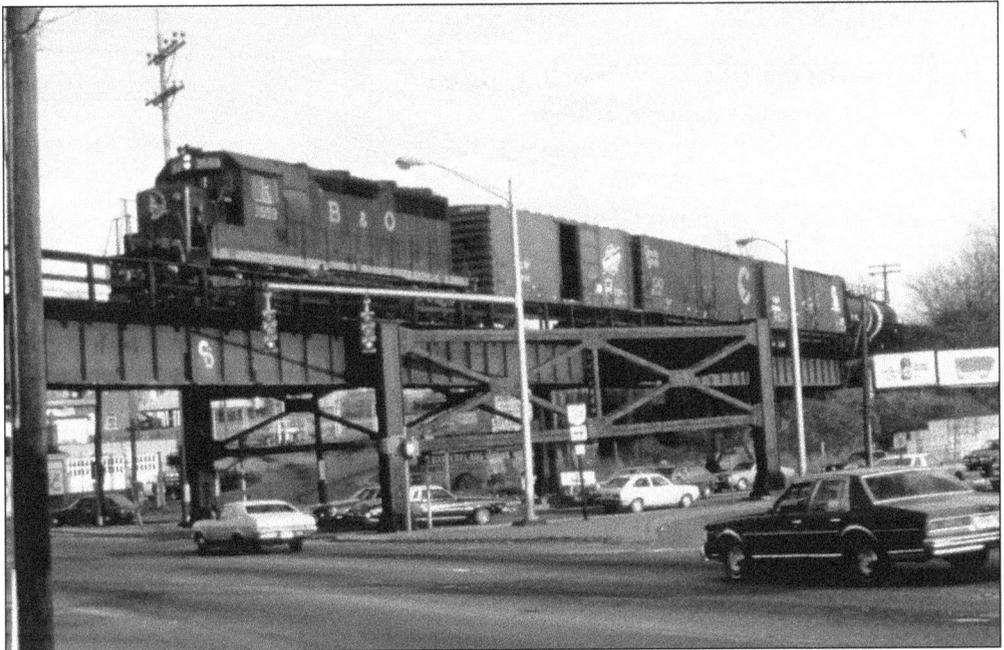

This Baltimore and Ohio (B&O) revenue freight train was the last one to run on the C&O line. The date is March 24, 1981. C&O bought the B&O Railroad in 1963. This bridge crossed the intersection at Bridgetown Road and Glenway Avenue/Race Road. (Courtesy of Todd Bakemeier, collection of Mike Brestel.)

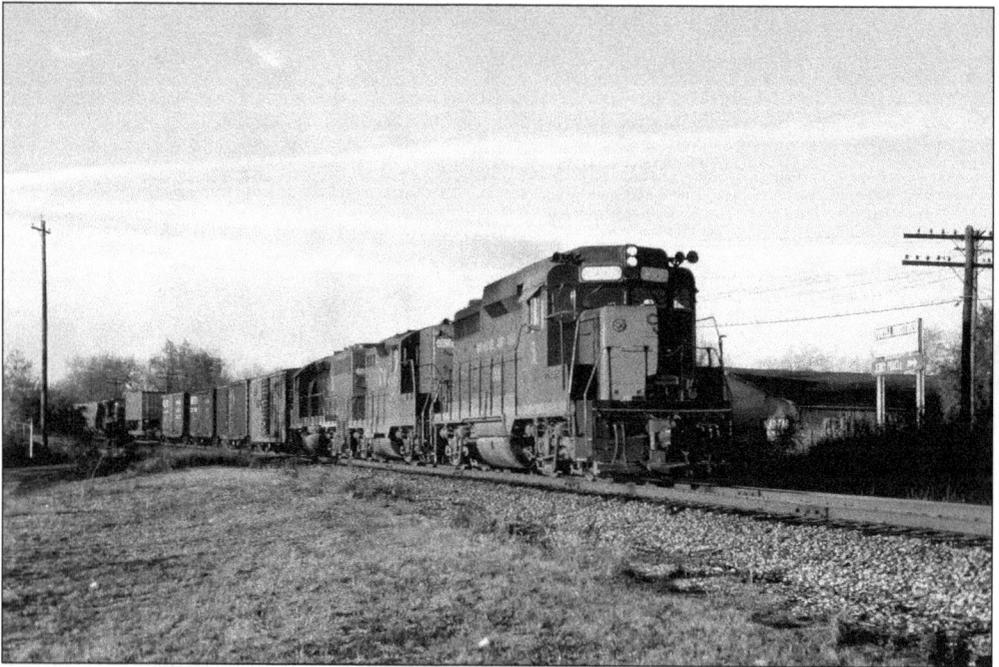

This photograph shows an eastbound C&O freight train passing Marfab Lumber Company along the north side of Glenway Avenue in Green Township. The train's destination was Newport News, Virginia. (Courtesy of Mike Brestel.)

THE CINCINNATI UNION TERMINAL COMPANY

ARRIVAL AND DEPARTURE OF TRAINS

18

EFFECTIVE SUNDAY, JANUARY 20, 1935
Eastern Standard Time

18

CHESAPEAKE & OHIO RAILWAY (Chicago Division)

Train
No.

Depart

17—Richmond, Marion, Hammond, daily_____ 8 40 AM

Train
No.

Arrive

18—Hammond, Marion, Richmond, daily_____ 5 40 PM

Here is an excerpt from a 1935 Cincinnati Union Terminal Schedule. It shows the C&O Railroad, Chicago Division train No. 17 departing at 8:40 a.m. daily for Richmond, Marion, and Hammond, Indiana. Train No. 18 arrives at 5:40 p.m. daily from Hammond, Marion, and Richmond, Indiana. These trains traveled along the C&O line through Green Township.

This view shows the C&O trestle on Bridgetown Road looking west to the Bridgetown, Glenway, and Race Roads intersection.

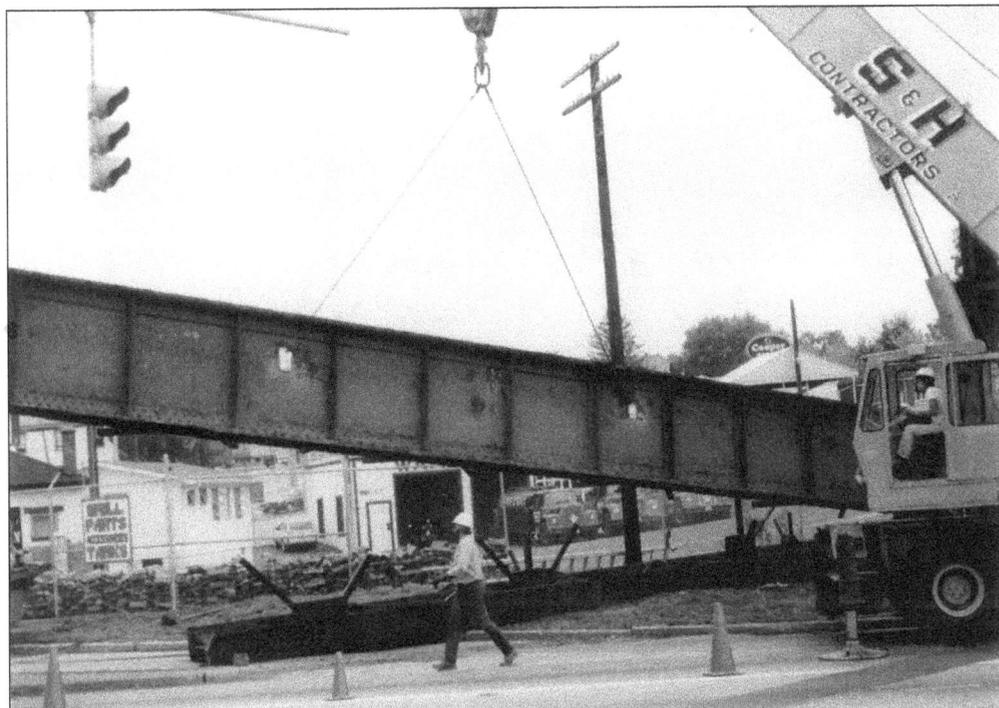

This photograph shows the dismantling of the C&O trestle in 1984.

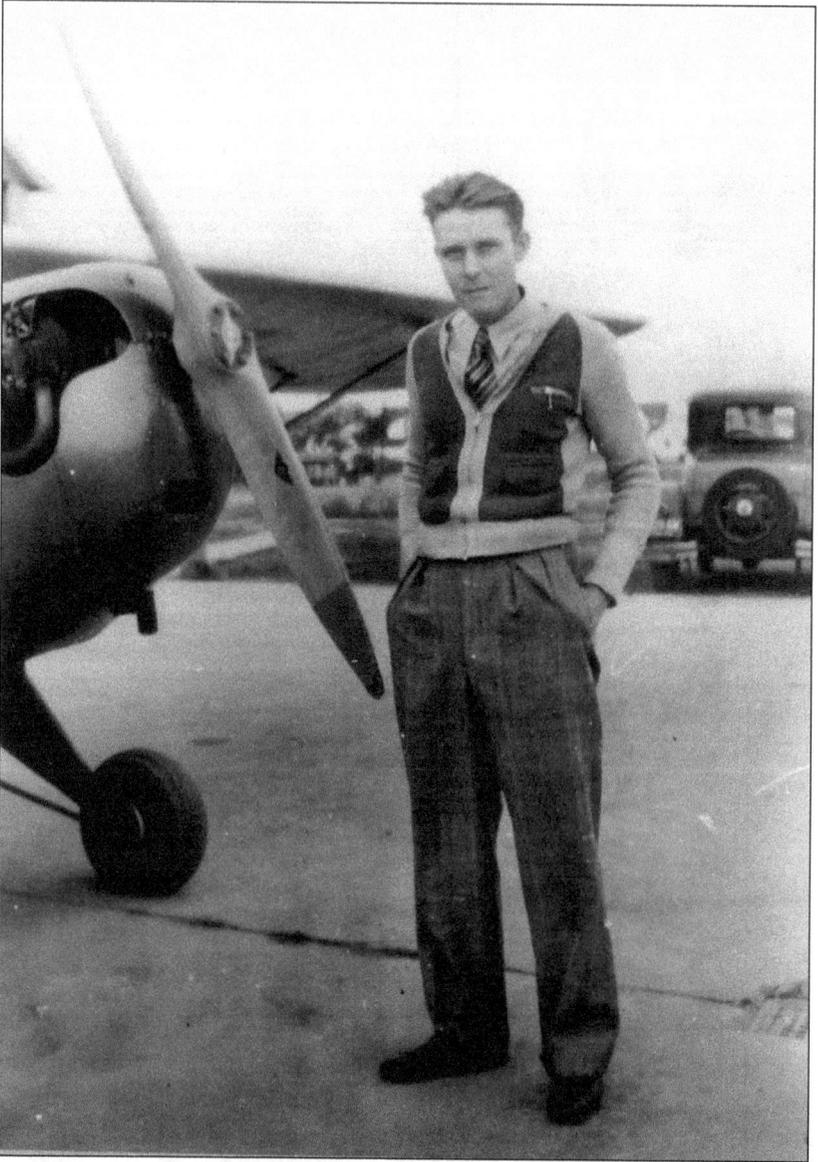

Howard Geiger managed the Western Hills Airport in the 1930s and early 1940s. The airport's dedication was on August 10, 1929. It was known as the Frank Airport originally, named after Harry Frank who built it. The airport was slightly south of Bridgetown Road and was located on 50 acres in Mack, east of Ebenezer Road. The hangar and grass runways, one north-south and one east-west, were near today's Eyrich, Coral Cables, and North Glen Roads. Barnstorming and parachuting were popular weekend activities at the airport. Ownership changed hands, and the name was changed to the Western Hills Airport in the 1930s. The airport was never a commercial success. At the onset of World War II, nearly all the aviators in the area left to serve in the military. The greatest moment for the airport was in 1937 when the record-setting flood of the Ohio River devastated the Ohio Valley. Airplanes from the airport were used to transport people, especially to and from Indiana because so many roads in low-lying areas along local rivers were also blocked by floodwaters. In 1945, the Western Hills Airport reopened as the Cheviot Airport for just a short time, closing for good in 1946.

This photograph shows an aerial view of Western Hills Airport in Green Township looking northwest. The photograph was taken about 1940. The street at the right center by the houses is Coral Cables. The street ended where the road narrowed and led to the hangar on the right. The rest of the dirt road led to a club farther out in the field. The large road in the upper right is Cincinnati-Louisville Pike, now known as Bridgetown Road.

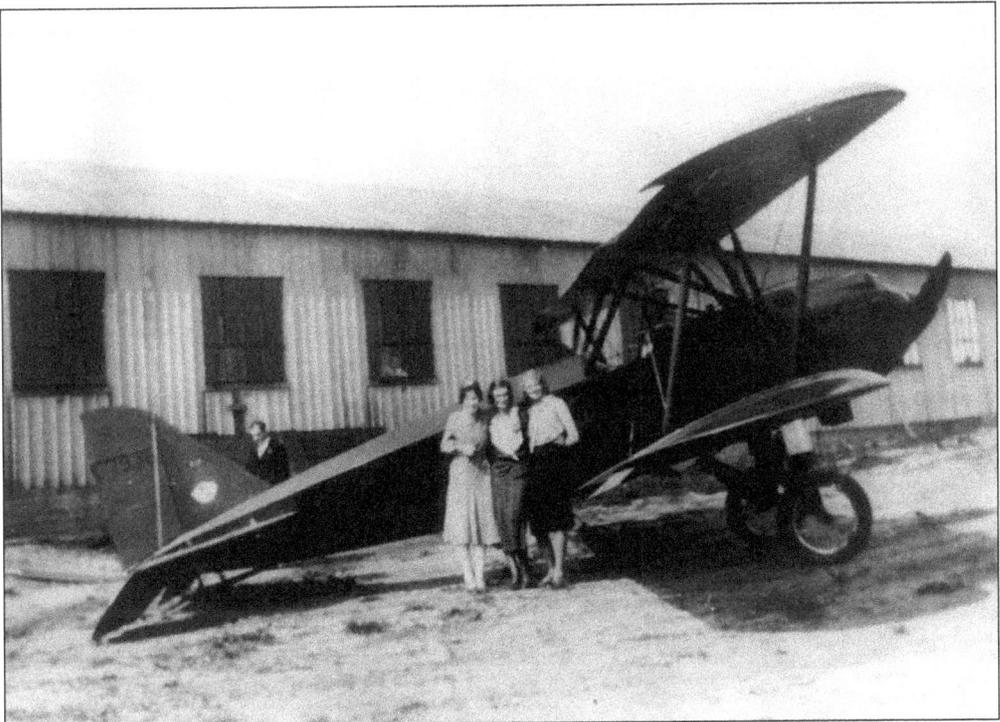

Three young women pose in front of an airplane and the hangar at Western Hills Airport.

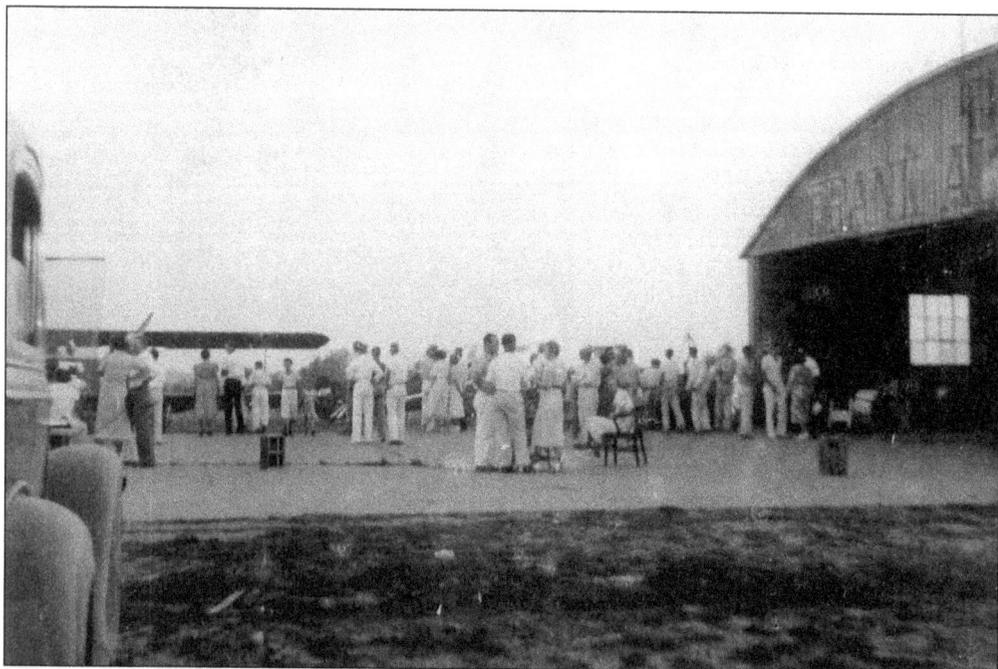

The photograph here shows a gathering at Frank Airport (later Western Hills Airport), possibly its dedication ceremony on August 10, 1929.

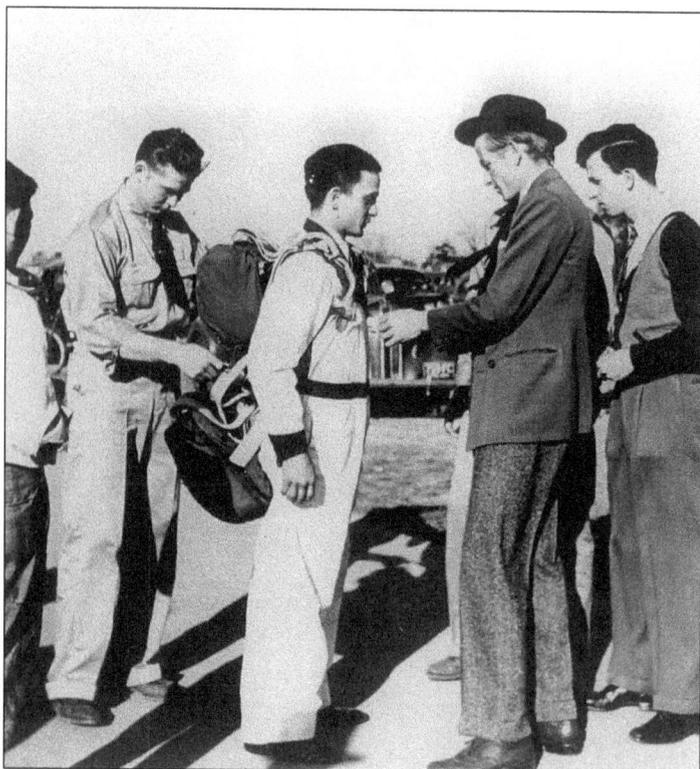

Members of the Triangle Parachute Club at Western Hills Airport get ready for a Sunday afternoon jump.

Four

INNS AND TAVERNS

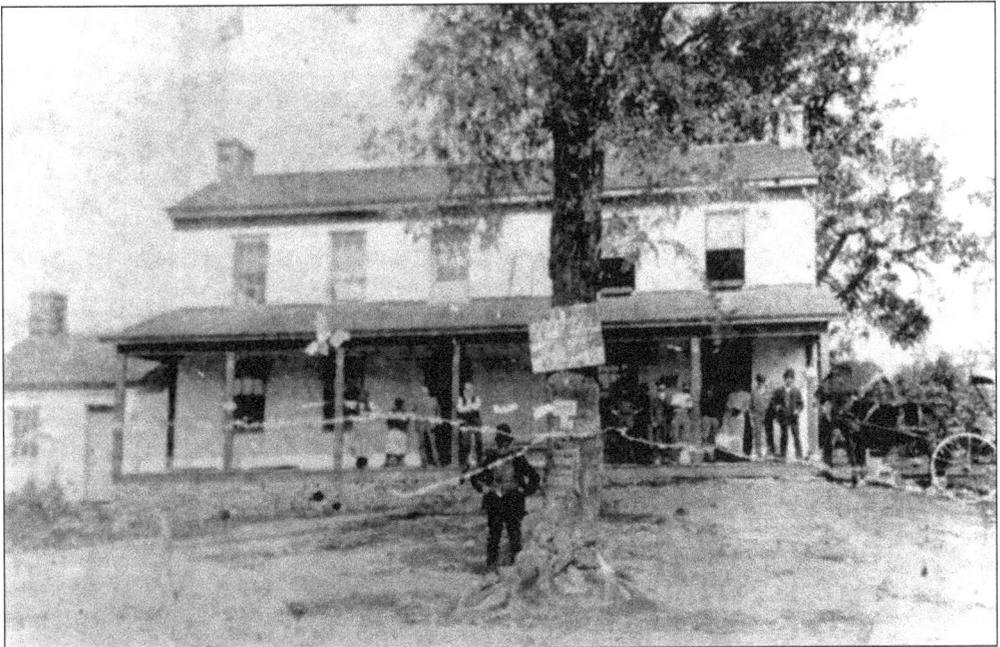

When Green Township was a farming community, dining establishments and hotels were much different from today's chain and fast-food restaurants and modern hotels. Early inns and taverns were usually locally owned and family operated. They often accommodated farmers driving livestock to and from Cincinnati stockyards or travelers on their way to the city or returning home. Green Township was still a few hours by horse from the city, more if one was driving livestock to market. Seven Mile House was built by Roswell Fenton at the "old forks" where Bridgetown Road meets Harrison Avenue. Throughout the 1800s, it passed through various owners. For a brief time, it was known as "the Dixie." In 1926, Cheviot School was built on the site.

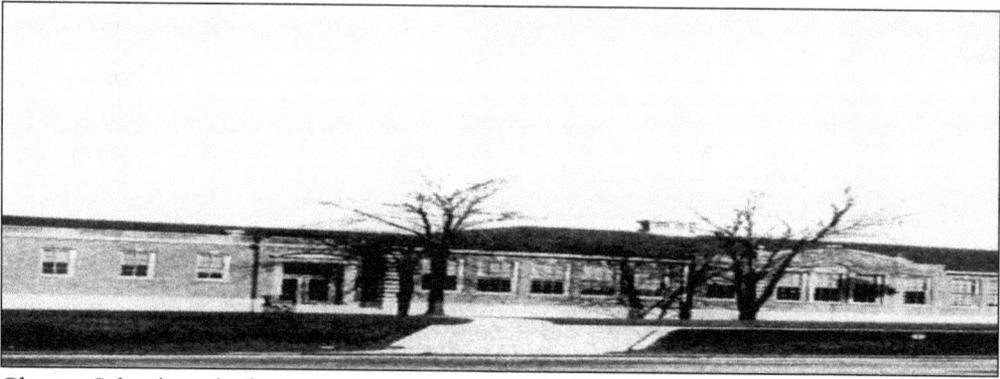

Cheviot School was built on the site of Seven Mile House in 1926.

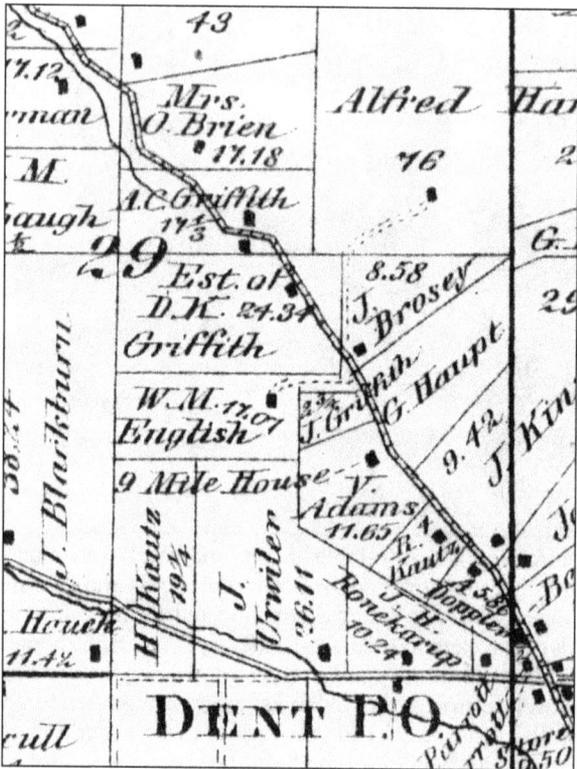

The 1869 map shows the spot in Dent on which Nine Mile House was built along Harrison Avenue.

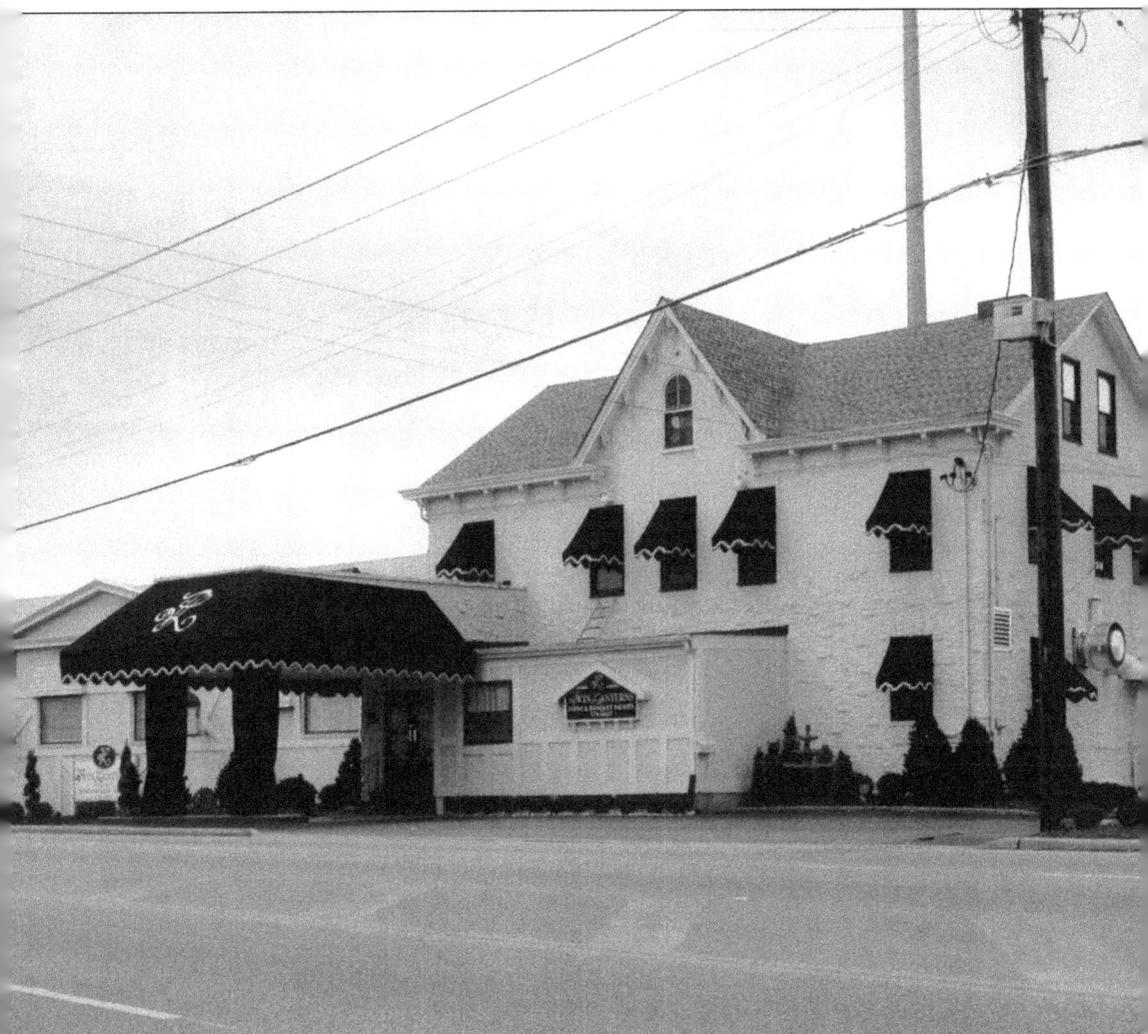

Nine Mile House was along Harrison Avenue in Dent, and portions of it today are part of Twin Lanterns. John Patton built the first Nine Mile House in 1812, and it prospered in the days of farmers driving hogs to market. They would water their stock from the well, corral the hogs in adjoining fields, then eat and socialize at the inn before bedding down for the night. It changed ownership many times over the years. The present building is the third on the site, and parts are over 100 years old. During Prohibition in the Roaring Twenties, it was visited often by liquor agents, and the sheriff was on the lookout for gambling into the 1930s and 1940s. Big band music was still featured at Twin Lanterns into the 1950s and 1960s. Some musicians who played there called it "the Little Beverly Hills." It must have been quite the place. The date of the name change from Nine Mile House to Twin Lanterns is unknown. (Courtesy of David Bushle.)

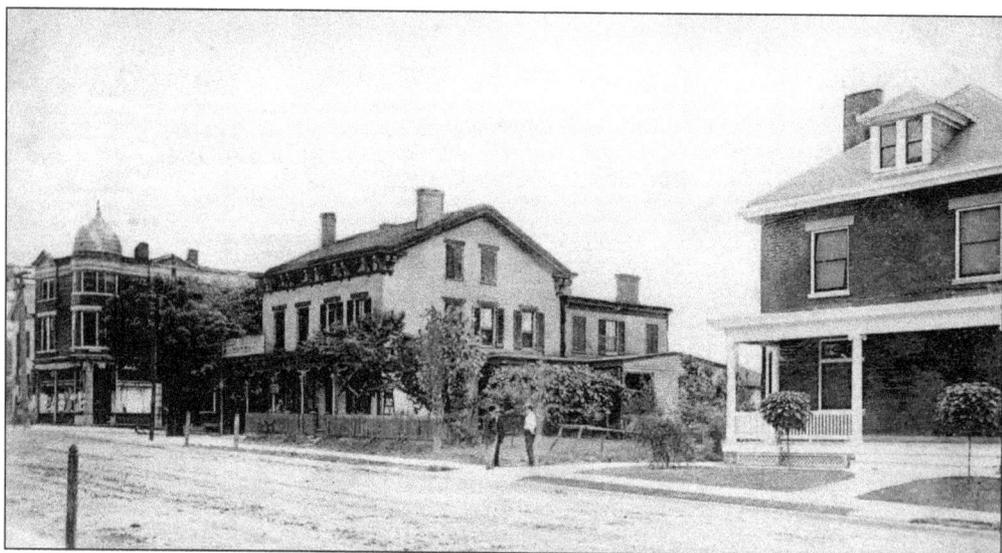

The Green Township Hotel was at the corner of Harrison Avenue and North Bend Road. This is a 1¢ postcard showing the hotel. The building on the far left still stands at Harrison Avenue and North Bend Road. It was the first telephone exchange building for Cheviot.

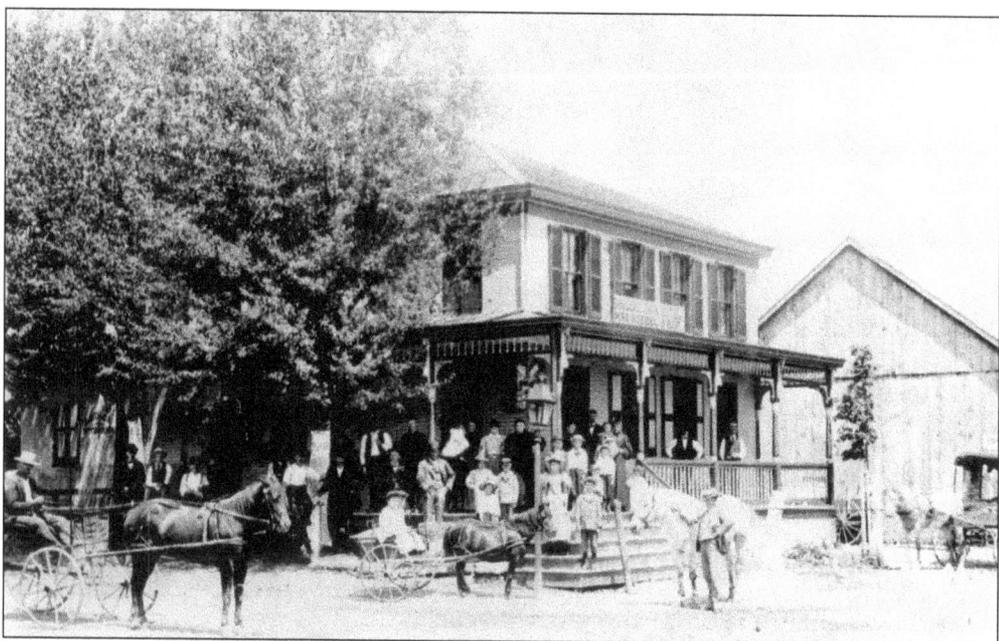

Christian and Mary Ruebel bought 46 acres of land at Race and Reemelin Roads with a log cabin that was 20 feet by 20 feet. Christian enlarged the log cabin, and he and Mary had 10 children. Two died in infancy. Later he sold the homestead to his oldest son, Nicholas, and bought acreage at the corner of Race Road and Cleves Pike where he operated the Bridgetown Hotel and Saloon. After Christian's death, his wife, Mary, and son George ran the hotel. It is said that Mary could pick up a half-barrel of beer and put it on the bar to tap. Part of the building is still used as a tavern today, the Wagon Wheel Café.

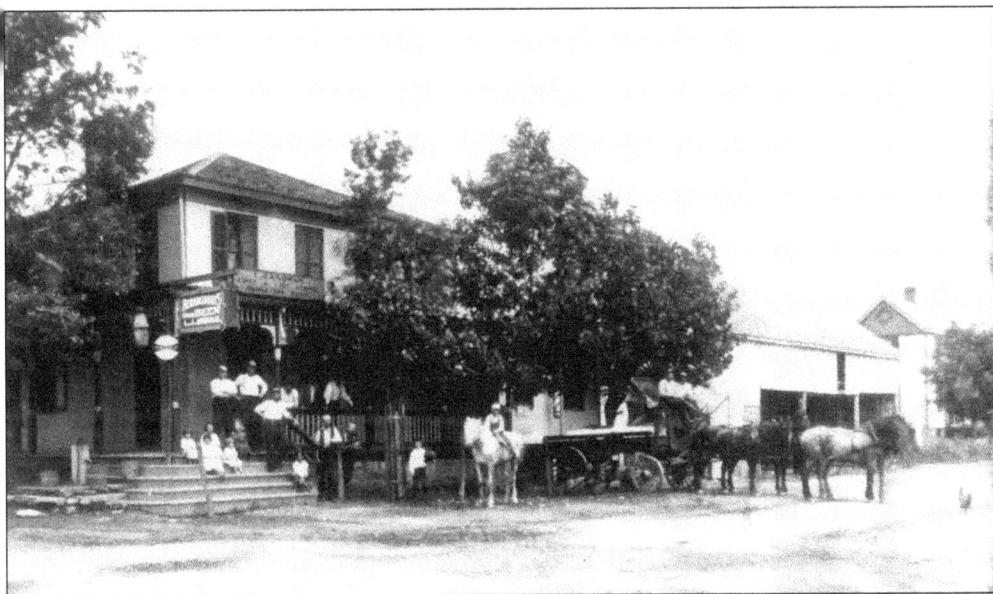

In the early 1900s, the Bridgetown Hotel and Saloon was taken over by L. J. Andwan and dubbed the "first and last chance" saloon, probably referring to farmers driving livestock to and from the Cincinnati stockyards. Note in this photograph the barns to the right, which could have been used to pen animals on their way to the stockyards. Also note the chicken at the far right—standing in the middle of today's busy Bridgetown Road.

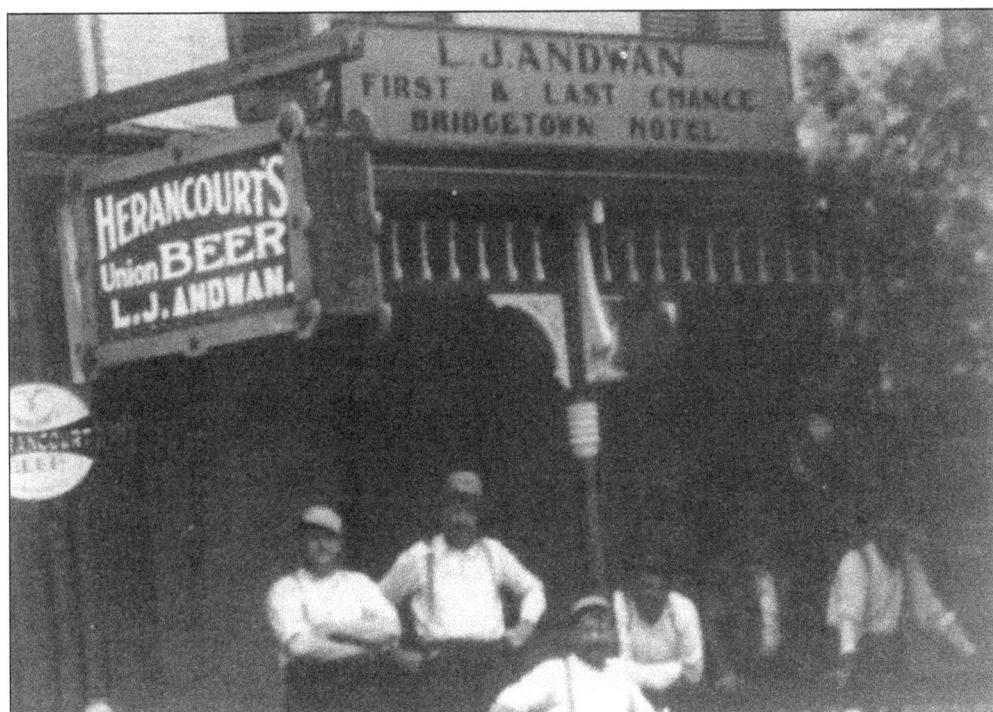

This photograph features L. J. Andwan's Bridgetown Hotel and Saloon showing Herancourt's Union Beer, one of many beers that were locally brewed in Cincinnati.

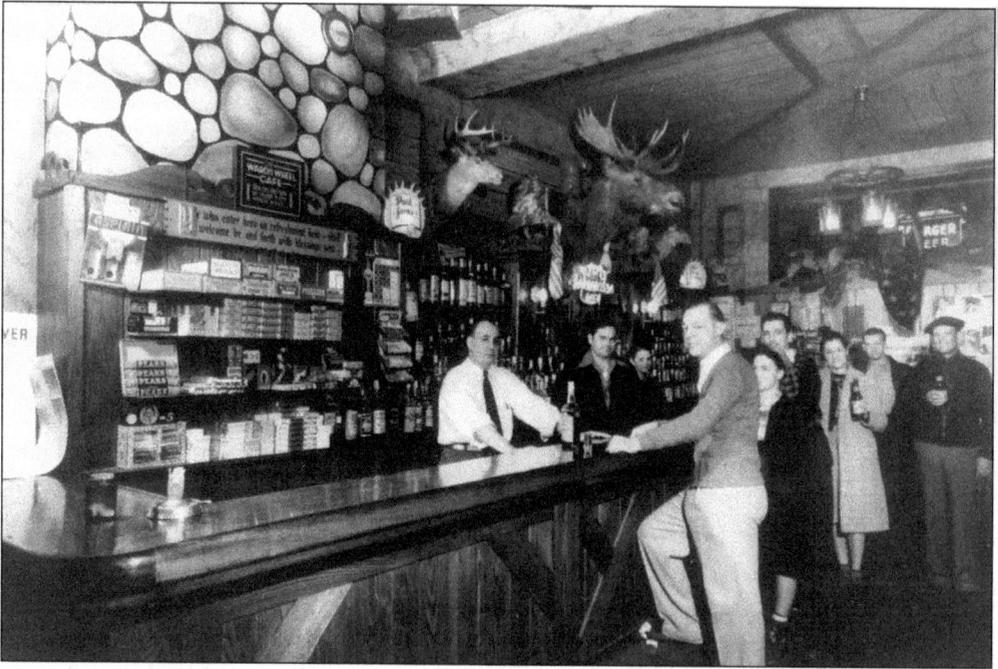

This is an interior shot of the Wagon Wheel Café in 1939 or 1940, named by owner Frank Fehr. The bartender in the shot is Frank Fehr Sr. In the back of the bar are Frank Fehr Jr. and Agnes.

In the early 1900s, Cheviot was still part of Green Township, and Krollmann's Garden at Harrison and Glenmore Avenues was a popular dining establishment. The Krollmann family opened it in 1898. Krollmann's was open year round, but it became well known for its meals served outdoors. Many patrons would spend a Sunday afternoon taking an electric streetcar or buggy ride to Krollmann's. Orchestra-type music often entertained diners. The restaurant was open for 29 years. In 1929, it was demolished and replaced by the Glenmore Building, still on the site today.

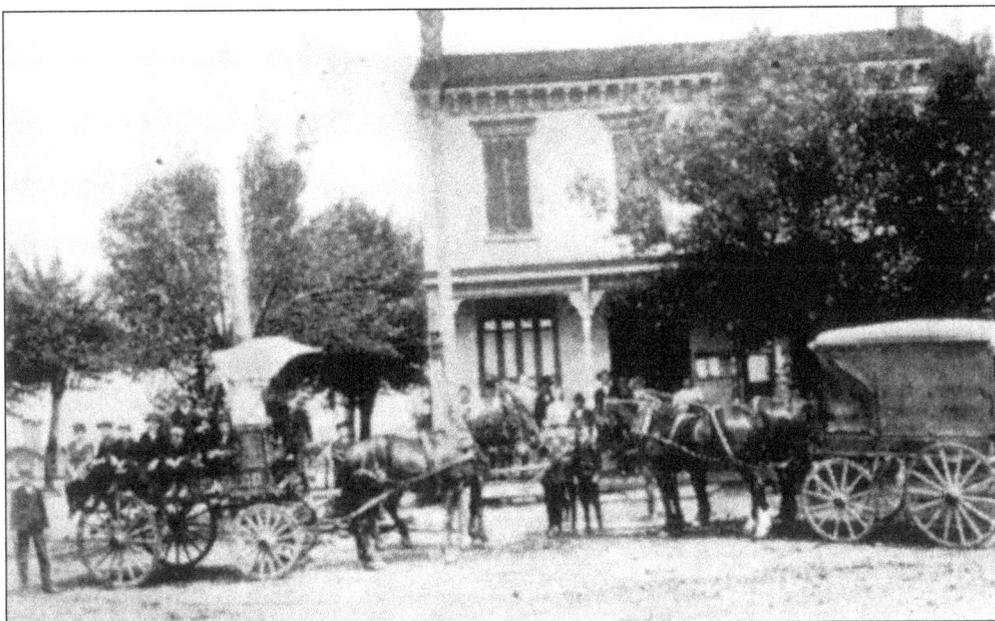

Focke's Tavern was a popular spot in Bridgetown, located at the corner of Bridgetown Road and Church Lane (northeast corner) across from St. Aloysius Church. Over the years it had several names including Focke's, Rack's Hall, and Bridgetown Tavern. The Green Township Anti-Thieving Protective Association held its first organized meeting here in 1885. The Green Township trustees occasionally met here as well. The building was razed in the mid-1950s.

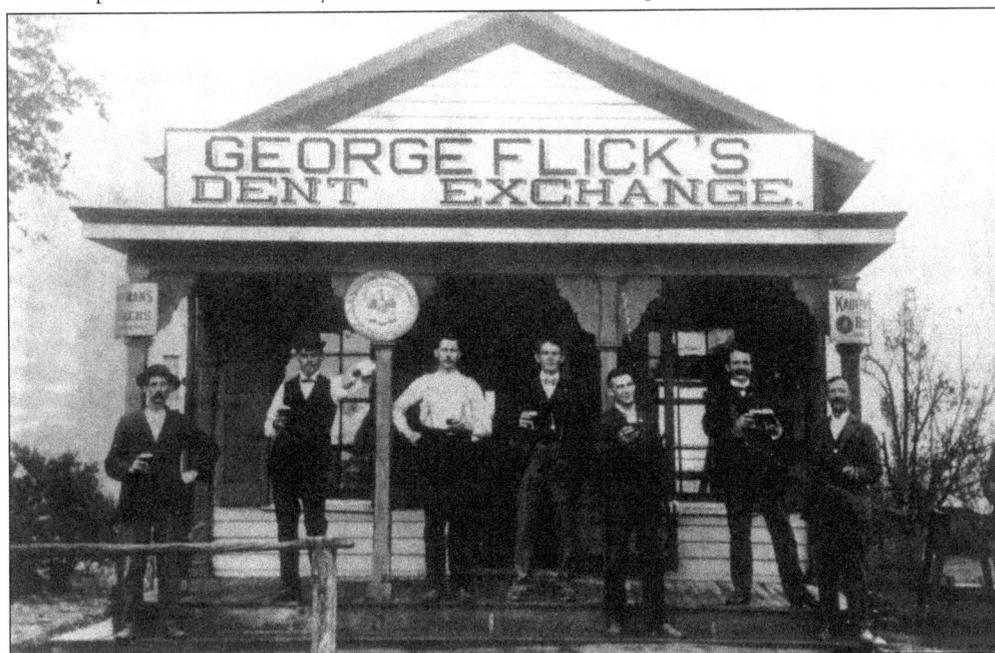

George Flick's Dent Exchange was on Harrison Avenue in Dent, somewhat south and east of the intersection with Johnson Road. Note that the gentleman patrons are all ready to quench their thirst, perhaps with the Cincinnati-produced Kauffman's Beer advertised on the signs at both sides of the porch.

These are the Green Gables tourist cabins in about 1926. School Section Road can be seen in the background.

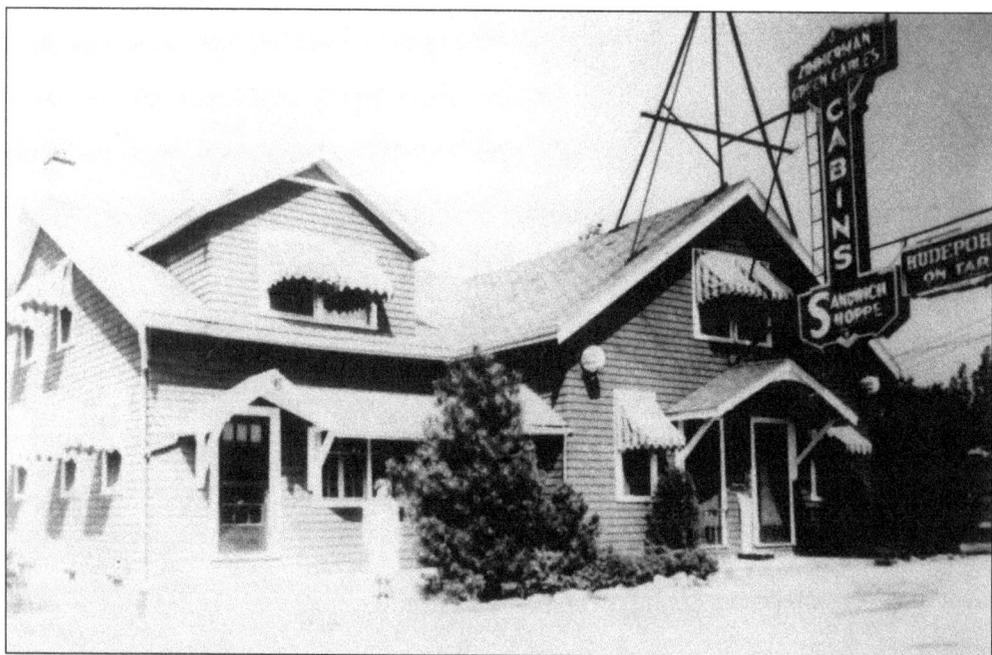

Green Gables Tavern and Motel was at the corner of Harrison Avenue and School Section Road. Throughout the country in the 1920s and 1930s, automobile ownership grew. Small independently owned motels popped up along main routes to serve those new to automobile travel. Green Gables, owned by the Zimmerman family, was one of these.

Here are the Green Gables tourist cabins in about 1939. Houses in the background are on Grace Avenue. The bridge crosses an open creek that started in Cheviot, crossed under Harrison Avenue in front of the Green Gables Motel, and wound its way through Bridgetown and along Westbourne Drive as a branch of the Muddy Creek.

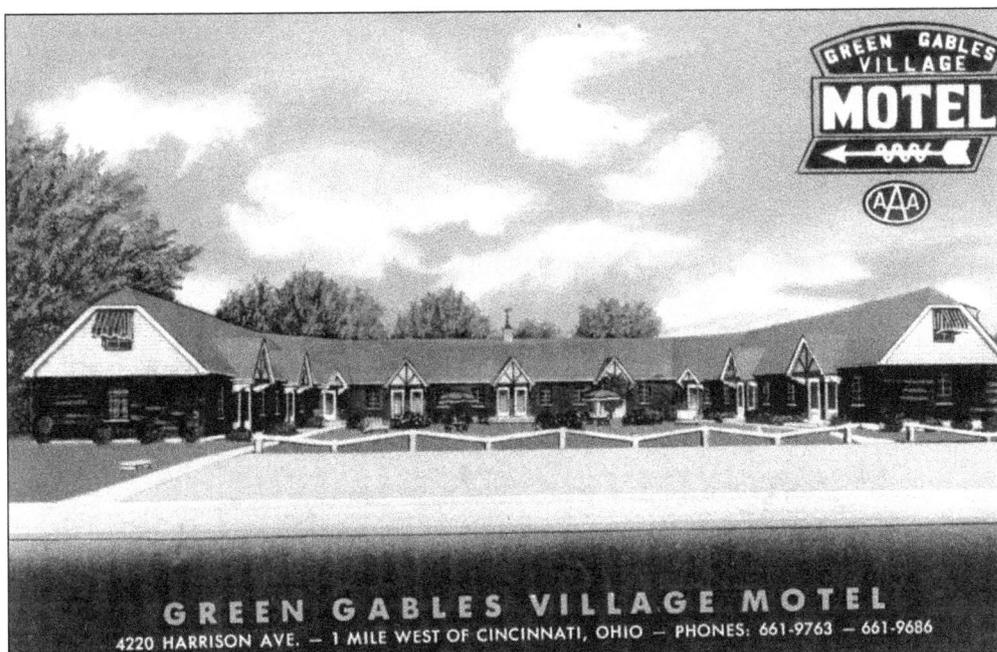

GREEN GABLES VILLAGE MOTEL
4220 HARRISON AVE. — 1 MILE WEST OF CINCINNATI, OHIO — PHONES: 661-9763 — 661-9686

Around 1947, a modern motel was built on the site. By the 1980s, I-74 changed automobile traffic patterns and Harrison Avenue was no longer the main route west. Green Gables business felt the pinch, and the end came about 2000.

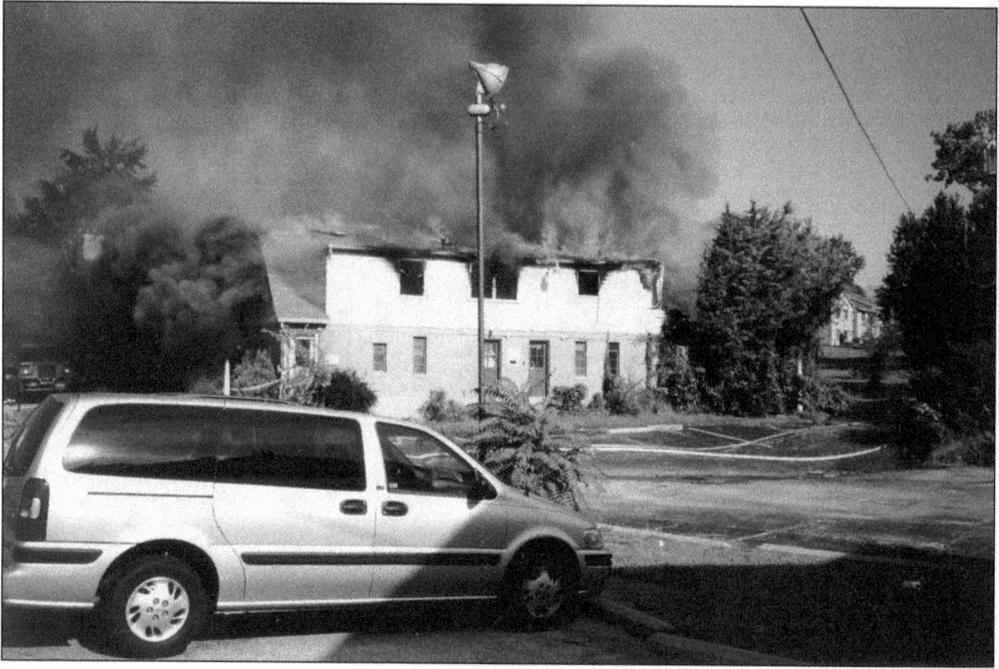

In 2003, the motel was burned by the Green Township Fire Department as a training exercise. The Green Gables name is gone from the neighboring tavern as well.

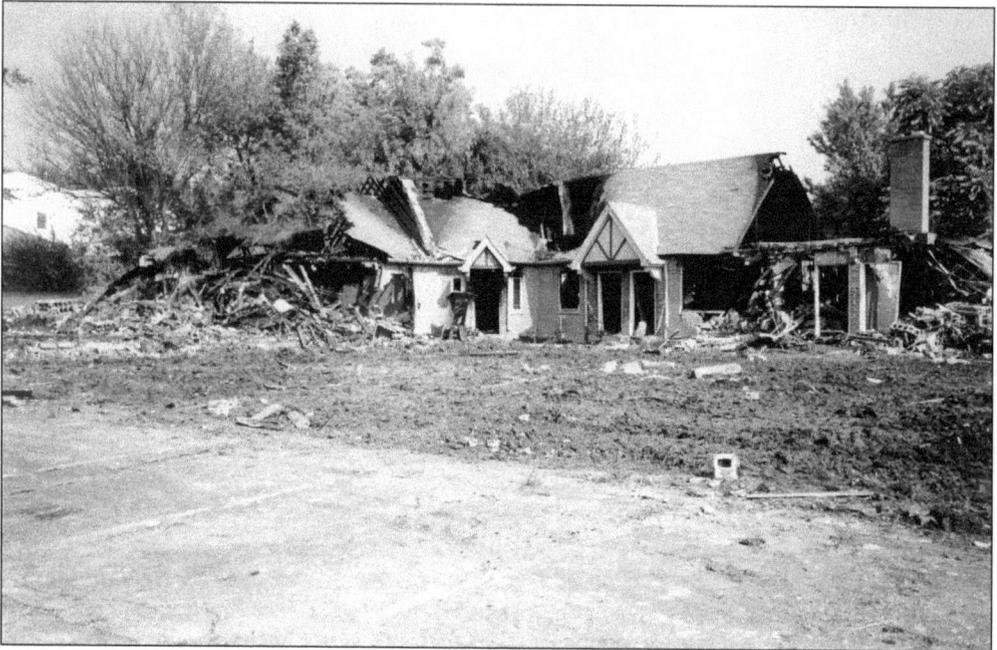

Green Gables was demolished and excavated for future development.

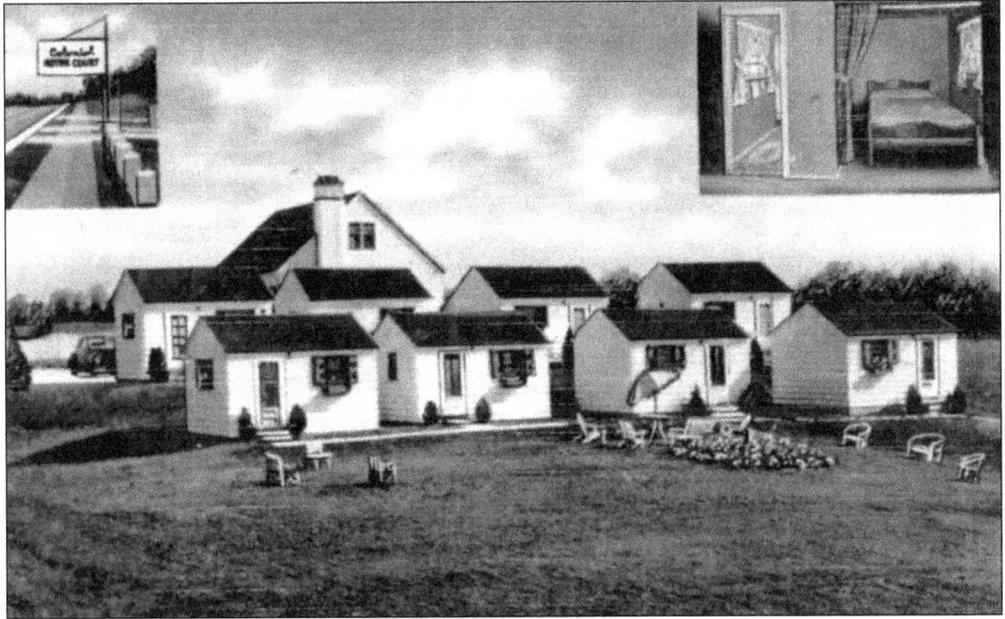

The Colonial Motor Court was another motel along Harrison Avenue, U.S. Route 52 in Dent. Located between the two intersections of Filview Circle with Harrison Avenue, it featured small tourist cabins. After closing sometime in the late 1960s or early 1970s, the cabins were moved.

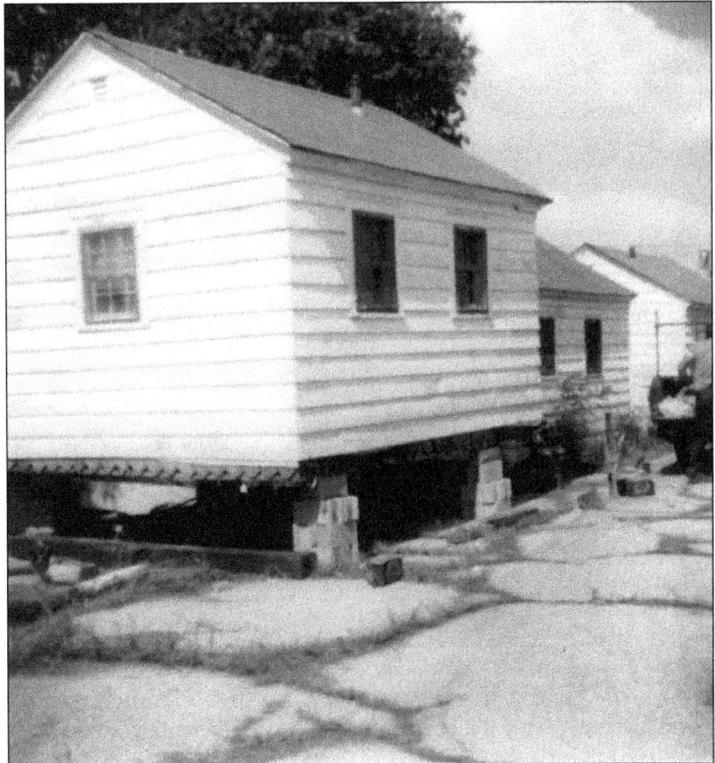

The cabins of the Colonial Motor Court were raised on blocks and were prepared to be moved.

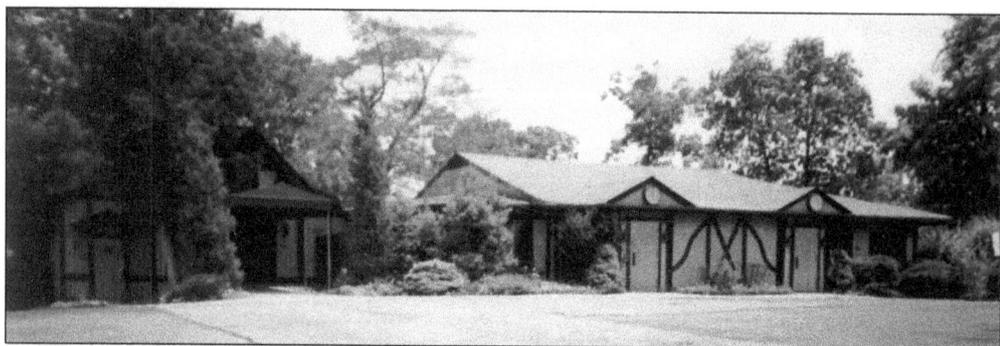

Forest View Gardens on North Bend Road in Monfort Heights was a popular dining establishment in Green Township. Tourist buses were a common sight at the restaurant, and the food and ambiance were distinctly German. The main attraction was the entertainment provided by the waiters and waitresses who were also College Conservatory of Music (CCM) students at the University of Cincinnati. The Christmas programs proved especially popular.

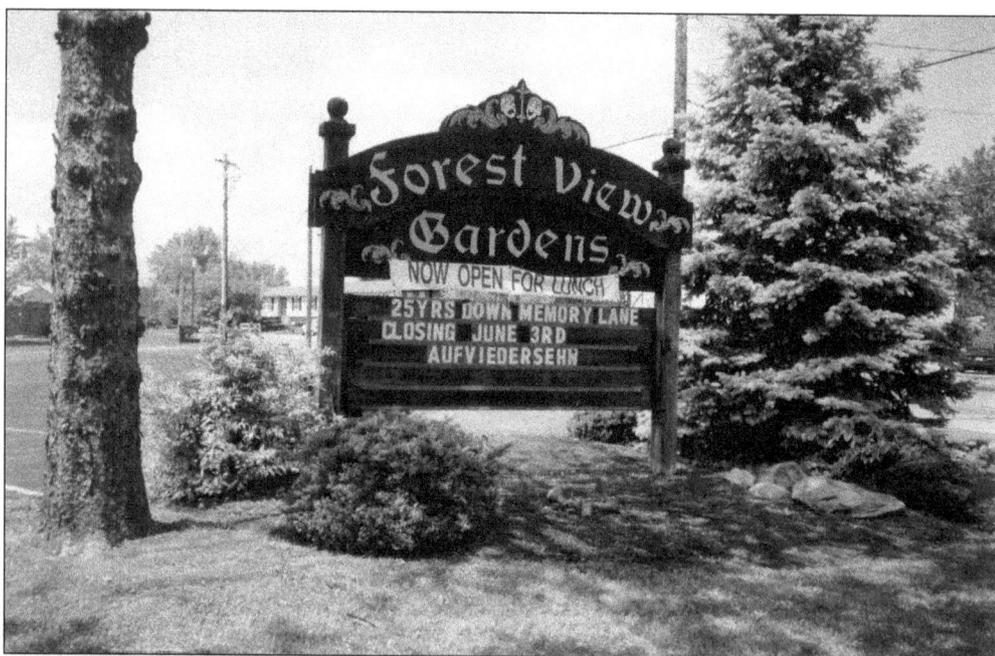

Forest View Gardens was opened in 1940 by Jennie and Karl Klose. In 1976, their daughter, Trudie, started the tradition of CCM students entertaining. In 1983, Trudie married Kurt Seybold, and they carried on the Forest View Gardens popular tradition until its closing on June 3, 2001.

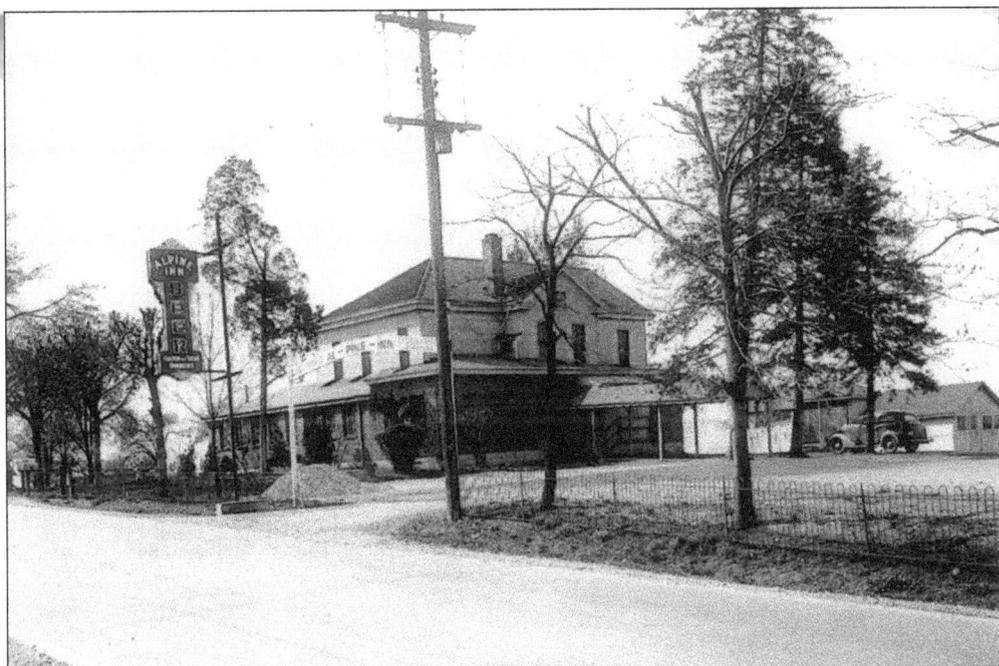

The 100-year-old Alpine Inn had pink and green neon lights that framed the building in the 1940s. Much of the styling of the restaurant on Bridgetown Road remains from the 1940s.

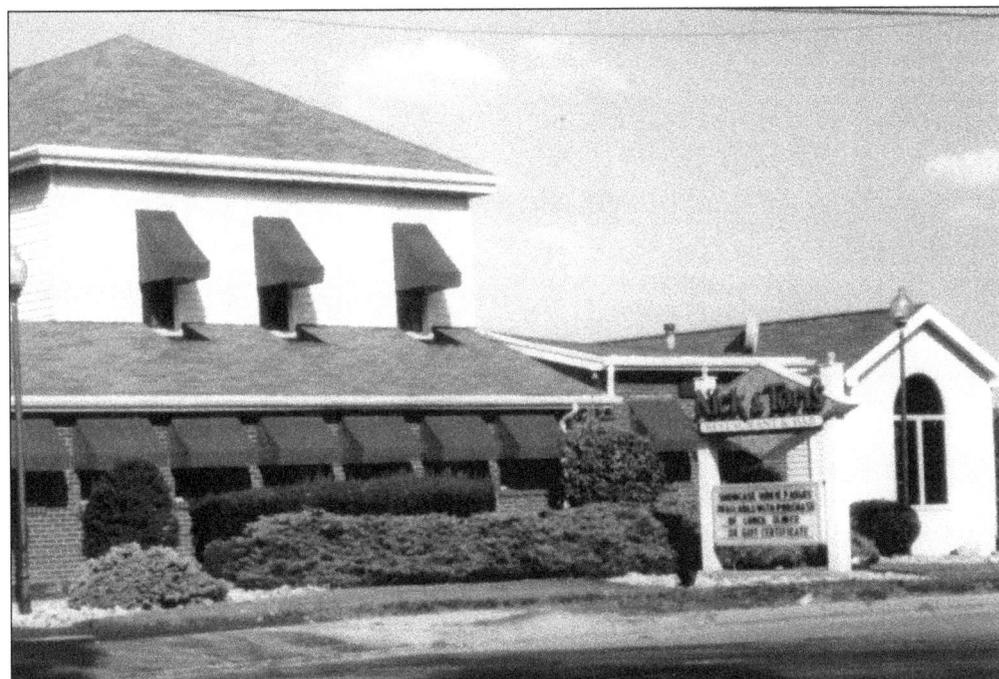

In 1988, brothers Nick and Tom Lambrinides purchased the Alpine Inn and are keeping the restaurant's history in front of their patrons. Nick and Tom's has original photographs and old menus decorating the walls of the lobby of this family-oriented restaurant.

Electrical Workers' Picnic

LOCAL No. 212

Saturday, August 12, 1939

SCHAIBLE'S GROVE

Werk Road Westwood

Opening of Grounds, 11 A. M.

EVENTS:

1:30 P. M.—BALL GAME

3:00 to 5:00 P. M.—
 Men's Race, 100 Yard dash.
 Ladies' Race, 50 yard dash.
 Ladies' Rolling Pin Contest.
 Men's Beer Drinking Contest.
 Men's Three-Legged Race.
 Men's Blindfolded Wheelbarrow Race.
 Men's and Women's Egg Throwing Contest.
 Ladies' Pie Pan Contest.
 Ladies' Wheelbarrow Race.
 Fat Ladies' Race, 50 yard dash.
 Boys, 10 to 13 years, 50 yard dash.
 Boys, 14 to 18 years, 100 yard dash.
 Girls, 10 to 13 years, 50 yard dash.
 Girls, 14 to 18 years, 100 yard dash.
 Boys under 10 years, Shoe Race.
 Girls under 10 years, Shoe Race.

Valuable Prizes Awarded for All Contests. Gate Prizes as Announced
5 P. M.—INTERMISSION

DANCING

6 P. M. Till? 9 P. M. Prize Waltz
9:30 P. M. Jitterbug Contest

Alms Prtg. Co. ◀▶ 15 E. Court, Cin.

Several Green Township picnic groves hosted family picnics and reunions, church outings, sporting events, and other community gatherings. Schaible's Grove was one of these. Located on Werk Road about one-half mile west of Glenway Avenue (there is a small shopping center and industrial plant near the site today), the announcement shown here was for an electrical workers' picnic in August 1939 at Schaible's Grove. Other picnic groves in Green Township included Lahmann's Grove in Dent and Gutzwiller's Grove on Blue Rock Road in White Oak. All three are now gone.

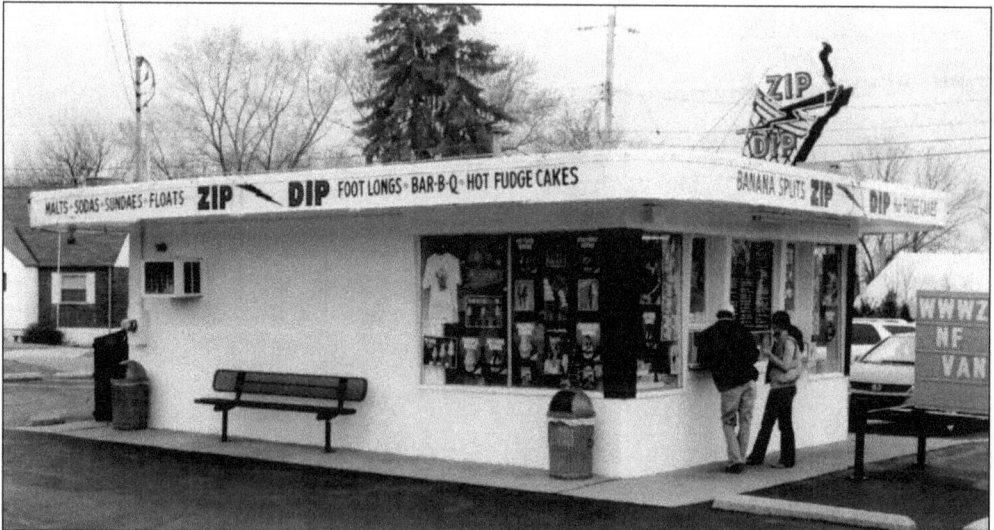

Zip Dip on Harrison Avenue remains one of the last few soft-serve ice-cream shops. It opened in 1950. Chris and Sue Torbeck are the fourth owners. When serving Little Leaguers after a game (win or lose), its tradition of cleanliness, friendly service, and fresh products has made it one of the top five creamy whips in Cincinnati. The original 1950s look with its neon sign as a lighting bolt across an ice-cream cone still perches proudly on the roof today. (Courtesy of David Bushle.)

Five

YESTERDAY'S SCHOOLS

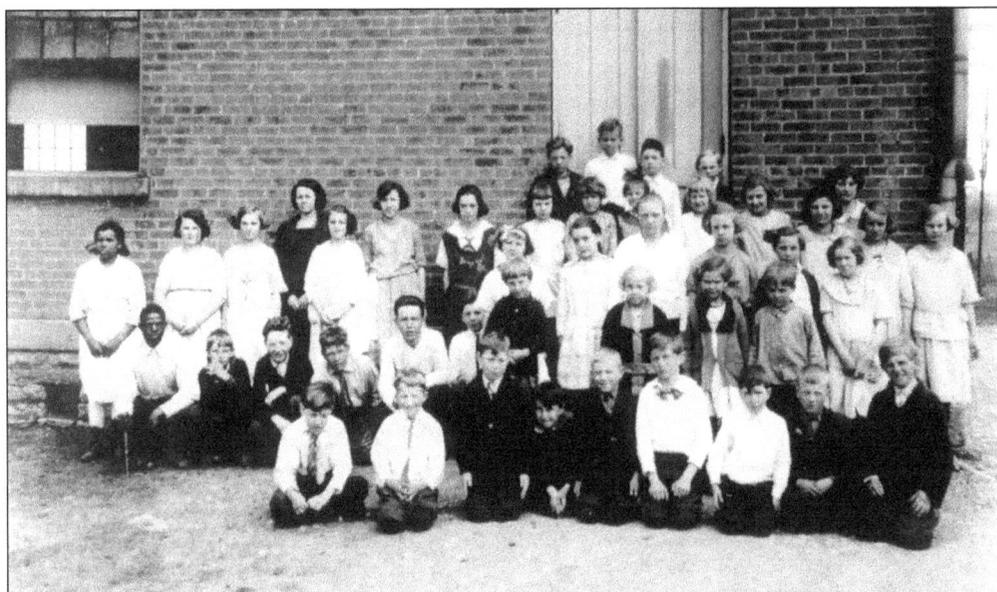

The earliest township schools were small, private subscription schools. Later in the 1800s, Green Township children attended a number of public township district schools. There were at least 12 districts, including District No. 1 in Westwood and District No. 5 in Cheviot. Both are no longer a part of Green Township. In the early 1900s, these school districts were gradually consolidated into larger districts. By the middle of the 20th century, the old district schools were gone, replaced by today's school districts: Oak Hills, Northwest, Cincinnati, and Diamond Oaks Career Center. South Avenue School District No. 2, was at the west side of South Road at the end of Werk Road. In the early years, it was also called Rofelty's School because an 1869 map shows a D. W. Rofelty as the owner of 11 acres across South Road from the school. The photograph here is of South Avenue students District No. 2 in 1924. Later South Avenue was merged with Dent School (District No. 12) about 1950 into Springmeyer School. A house built with some brick and foundation stone from the old South Avenue School is on the South Avenue School site today.

This report card from South Avenue School is dated May 18, 1933.

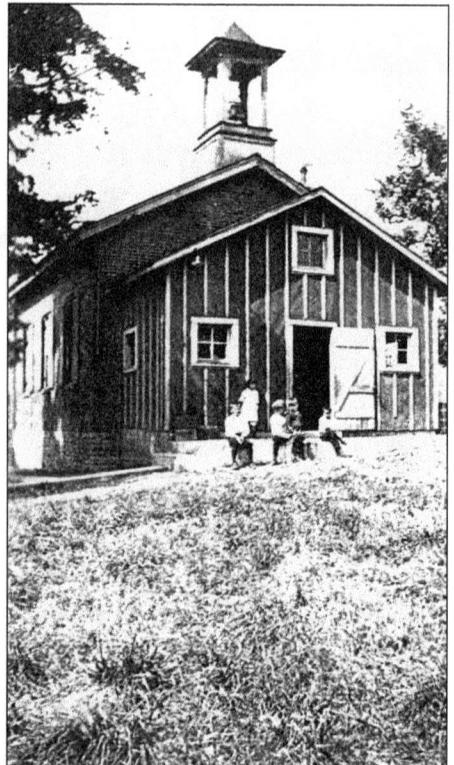

HAMILTON COUNTY
PUBLIC SCHOOLS

SCHOOL

South Avenue.

NAME OF PUPIL

Rae Hollinger

GRADE *Seventh.*

O. H. BENNETT, COUNTY SUPT.

ASSISTANT SUPERINTENDENTS:
A. L. WILSON
W. F. SIZELOVE
MARY R. CROWLEY

The Pounsford Stationery Company, Cincinnati, Ohio

South Taylor Creek School was District No. 3 on Taylor Road between Rybolt Road and Powner Road. The land for the school, pictured here in 1928, was purchased by Green Township for $5 in 1827. The school operated until about 1940 and has been used as a private home since then.

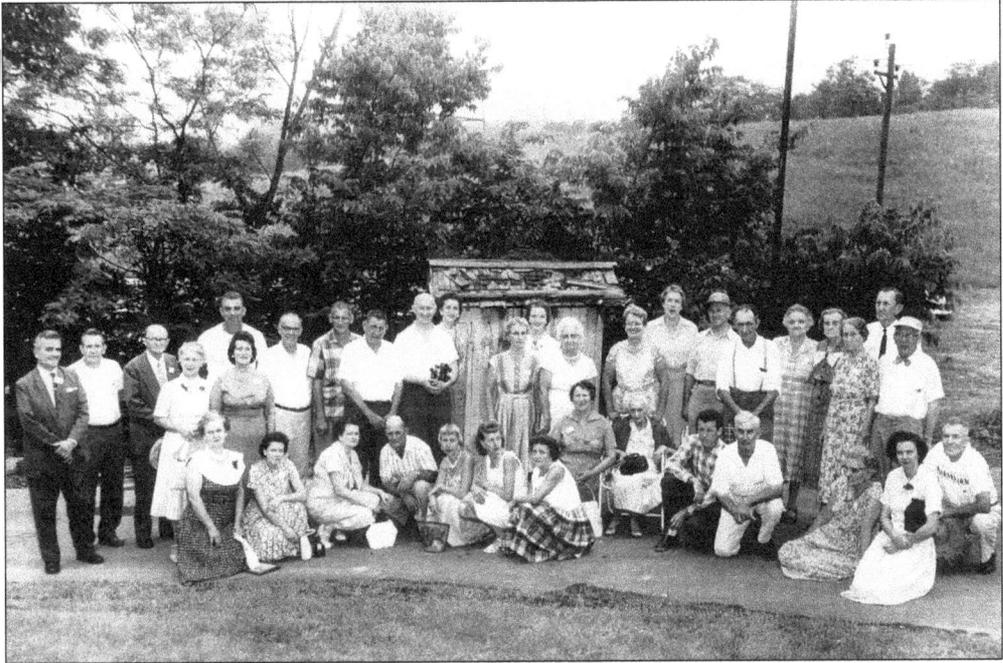

This photograph shows a reunion of South Taylor Creek School former students in 1960. Notice they are posed by an old school outhouse.

This District No. 3 South Taylor Creek School report of teacher Alexander Long was for the quarter ending July 28, 1848.

District #3 South Taylor Creek School
Report of Alexander Long, Teacher
For Quarter Ending July 27, 1848

Number of Students	49
Males	23
Females	26
Average Daily Attendance	23

Subjects taught: Spelling, reading, writing, arithmetic, geography, English, grammar, algebra, natural philosophy, general history.

Wages paid to teacher for quarter	$75.00
Paid from school fund	51.59
Collected from parents of scholars	23.41

No district tax was levied for the year 1848 and no repairs made to schoolhouse.

July 27, 1848 Alexander Long, Teacher

**Note: Alexander Long was a teacher in Green Township in the 1840s. He taught at District #2 (South Avenue) School, but spent more time at District #3 (South Taylor Creek) School on Taylor Road. About 1850 he left teaching to enter the practice of the law and politics. He was elected to the U.S. House of Representatives in 1862.

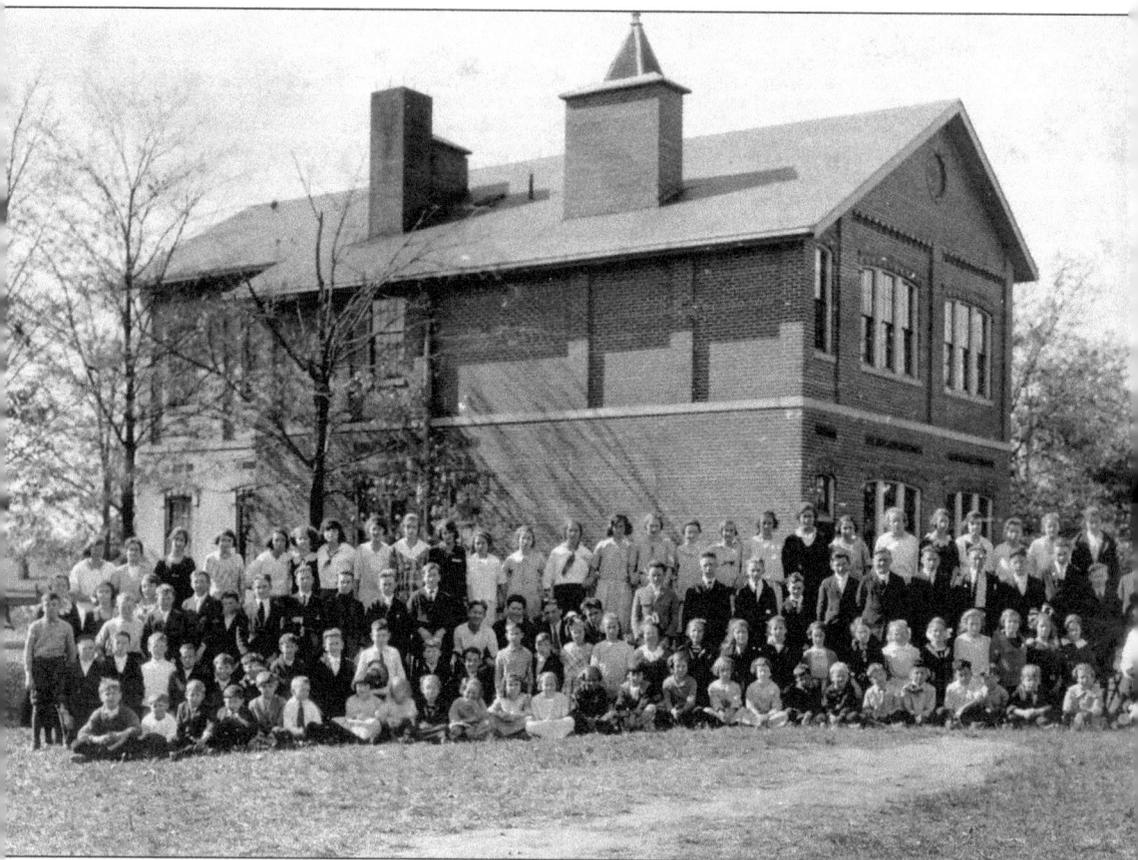

Bridgetown School began as a one-room school in 1864 on Bridgetown Road at Marie Avenue. In 1876, it had two rooms and was on the site of today's Bridgetown Church of Christ. Bridgetown Special School District was organized in 1889, making it independent of the township system. By 1917, a two-room addition was constructed. There were 94 students. This photograph of Bridgetown School was taken in 1929 or 1930. In 1940, a new Bridgetown School was built on the present site, a little north of the old school site. It had eight rooms and a kindergarten with a new wing added in 1948. In 1954, 12 new rooms, a kindergarten suite, and a cafeteria were added. Another addition was completed in recent years. Today Bridgetown is a middle school in the Oak Hills School District.

BOARD OF EDUCATION

Martin Zimmerman, President
Arthur Pfaff, Vice-President
Edwin Greiser
Charles Schinkal
John Brockhoff
Mrs. Harry Scheidt, Clerk

O. H. BENNETT, County Superintendent
W. F. SIZELOVE, Asst. Superintendent

TEACHERS

Rachel Metzger
Alicia Heid
Gertrude Underwood
Agnes Saffer, Music
Joseph M. Hawk, Principal

Programme

OF THE

Eighth Grade Commencement

AT THE

First Evangelical Church

Bridgetown, Ohio

Thursday, June 16, 1932

8:00 P. M.

This is the eighth-grade commencement program for Bridgetown School at the First Evangelical Congregational Church in Bridgetown on June 16, 1932.

CLASS ROLL

Harry J. Lindle
Helen F. Haft
Lester O. Kolbinsky
Dorothy H. Hahn
Clifford H. Kunkel
Dorothy A. J. Ernst
George E. Grimmeisen
Dorothy Anders
Irma V. Grimmeisen
Bernard A. Vollmer
Ruth M. Marx
John Jung
Amy R. Miller
Elizabeth E. Neuforth
Helen Zaeske
Myrtle L. Vollmer
Allene Warner
Jeanette L. West

CLASS COLORS—Blue and Gold.
CLASS MOTTO—Perfection.

PROGRAMME

March ... Mrs. Saffer
Invocation Rev. Paul Schmidt

GEORGE WASHINGTON CANTATA

I. George Washington Chorus
II. His Childhood—Dorothy Ernst, Elizabeth Neuforth, Allene Warner, Myrtle Vollmer, Irma Grimmeisen
III. His Education Seventh Grade Girls
IV. Youth Clifford Kunkel, Harry Lindle
V. Manhood Chorus
VI. Ferment—Dorothy Hahn, Helen Haft, Dorothy Ernst, Amy Miller.
VII. Revolution Chorus
VIII. French Help Helen Haft, Dorothy Hahn, Amy Miller
IX. The Constitution Eighth Grade Girls
X. Presidency Chorus

Class Address Hon. Judge Wm. H. Lueders
Presentation of Diplomas Supt. O. H. Bennett
Class Song Graduates
Presentation of Awards Joseph M. Hawk
Benediction Rev. Paul Schmidt

The inside of the eighth-grade commencement program is shown here. The class address was given by the Honorable Judge William H. Lueders (1867–1936). Judge Lueders was a brother to the author's great grandfather, Frederick Robert Lueders.

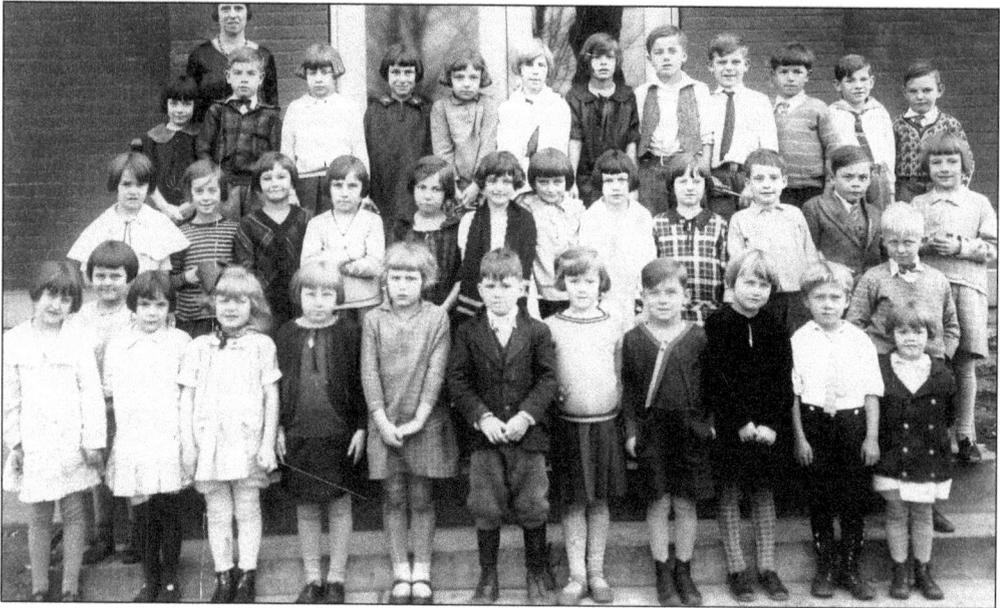

First- and second-grade classes pose at Bridgetown School in 1930. At the top of the photograph is teacher Rachel Metzger.

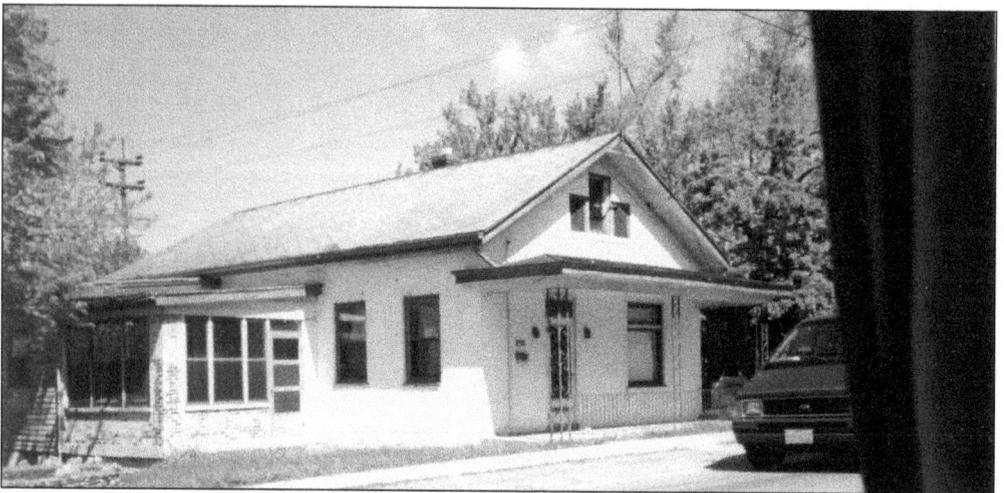

Early Bridgetown School District No. 4 is seen here on Race Road and Marie Avenue.

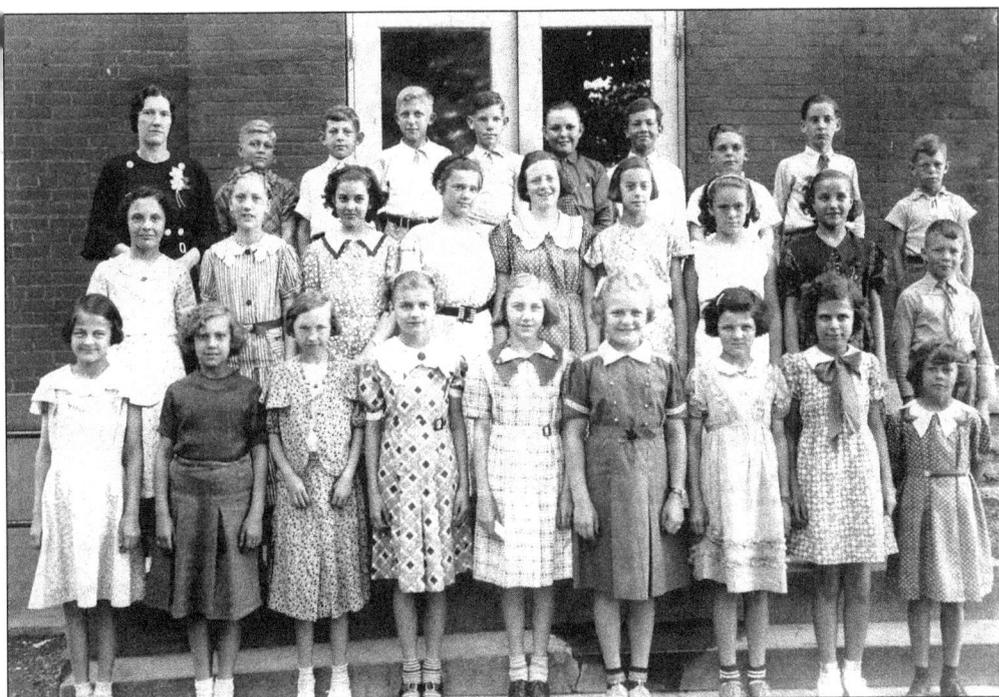

The fifth- and sixth-grade classes at Bridgetown School have their photograph taken in 1935. Gertie Underwood, pictured at the top of the photograph, was the teacher.

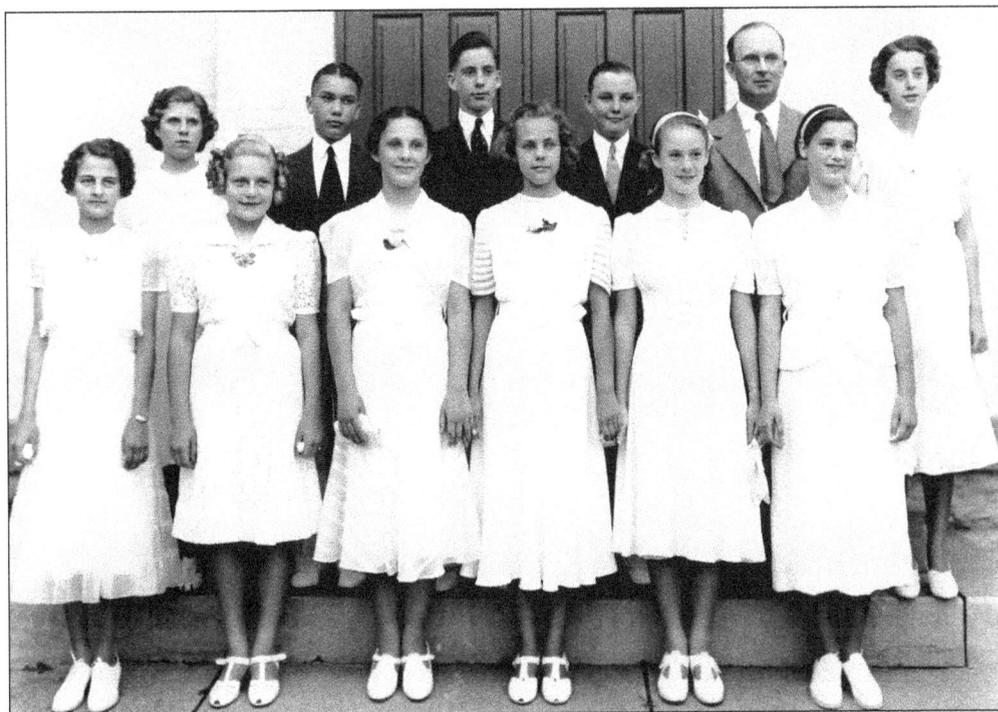

The 1938 Bridgetown School commencement was held again at the First Evangelical Congregational Church in Bridgetown. The date was June 16, 1938.

CLASS ROLL

Betty Jane Curd

Jack Roll

Georgia Ellen Green

Harriet L. Meyers

Mary Lou Birdzell

Clara L. Spreen

Orlestus R. Brenner

Edwin Hildebrand

Audrey J. Applegate

Betty Jane Bertram

Eugene Hines

Helen Jean Schaumloeffel

PROGRAM

MARCH	Miss Matilda Hornberger
INVOCATION	Rev. Paul Schmidt
PRAISE YE THE LORD	Seventh and Eighth Grades
HAD YOUTH BEEN WILLING TO LISTEN	Clara L. Spreen
DUET—*Age and Youth*	Eugene Hines, Orlestus Brenner
YOUTH AND THE WORLD	Eugene Hines
LIFT THY HEAD	Chorus
CLASS ADDRESS—*"Our Adolescents"*	Rev. H. N. Geistweit
FAREWELL TO GRADUATES	Seventh Grade
PRESENTATION OF DIPLOMAS	Supt. O. H. Bennett
CLASS SONG	Eighth Grade
PRESENTATION OF AWARDS	W. F. Sizelove, Jos. M. Hawk
FRIENDS	Chorus
BENEDICTION	Rev. Paul Schmidt

Students who graduated were Betty Jane Curd, Jack Roll, Georgia Ellen Green, Harriet L. Meyers, Mary Lou Birdzell, Clara L. Spreen, Orlestus R. Brenner, Edwin Hildebrand, Audrey J. Applegate, Betty Jane Bertram, Eugene Hines, and Helen Jean Schaumloeffel.

BOARD OF EDUCATION

Mr. Martin W. Zimmerman, *President*

Mr. Arthur Pfaff, *Vice-President*

Mr. John Brockhoff, *Clerk*

Mr. Earl West

Mr. Elmer Schubert

TEACHERS

Mr. Joseph M. Hawk, *Principal*

Miss Gertrude Underwood

Miss Alice Hoock

Miss Lillian Radcliffe

Miss Matilda Hornberger, *Music*

Miss Jane Shick, *Art*

PROGRAM

OF

Eighth Grade Commencement

Bridgetown Public School

AT

Evangelical Protestant Church

THURSDAY, JUNE 16, 1938

Eight P. M.

The program lists the board of education members as Martin W. Zimmerman, president; Arthur Pfaff, vice president; John Brockhoff, clerk; Earl West, member; and Elmer Schubert, member. The principal was Joseph M. Hawk. Teachers included Gertrude Underwood, Alice Hoock, Lillian Radcliffe, Matilda Hornberger, and Jane Shick.

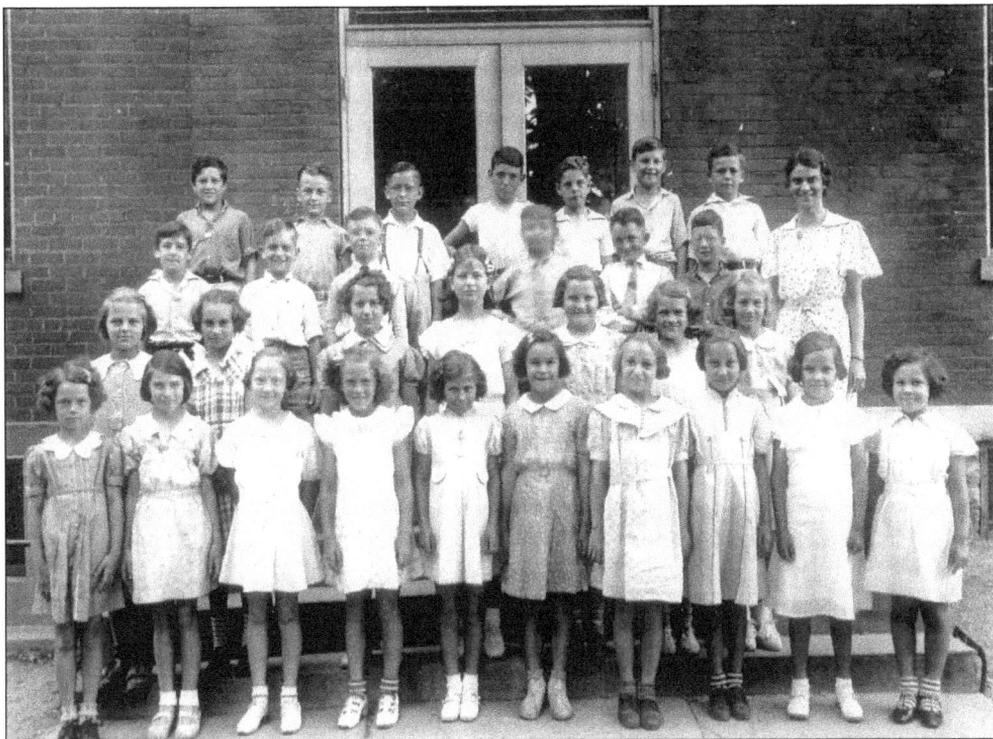

Here are the third- and fourth-grade students at Bridgetown School in 1935.

Jessup Road School District No. 6 was located on the north side of Jessup Road near today's Seiler Drive.

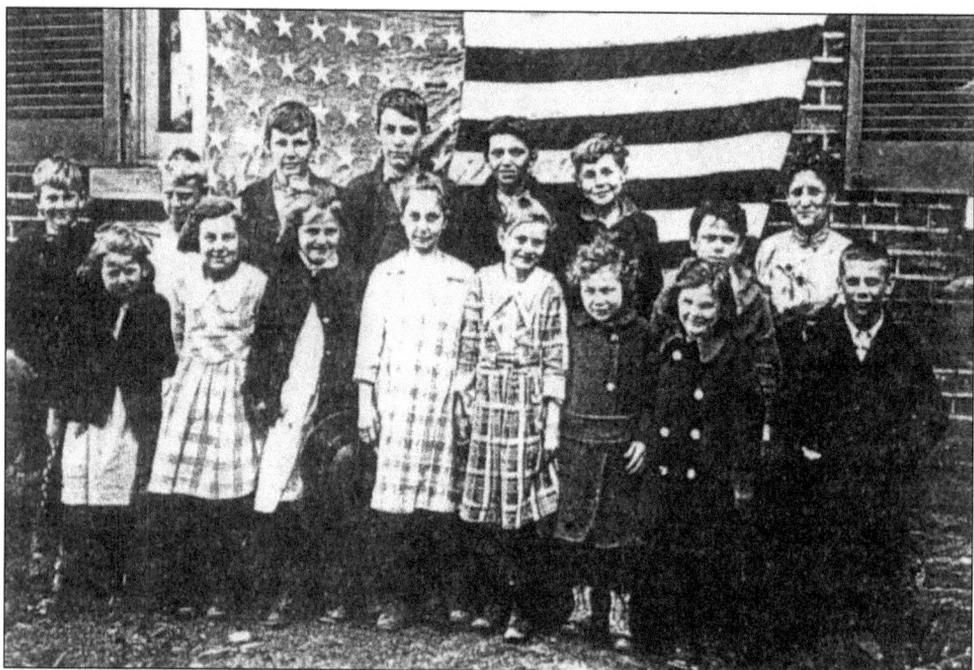

Students pose for a picture at Jessup Road School. Their teacher was Hattie Eversall. District No. 6 consolidated with District No. 8 and District No. 11 to form Monfort Heights Elementary School in 1930. The building is no longer standing.

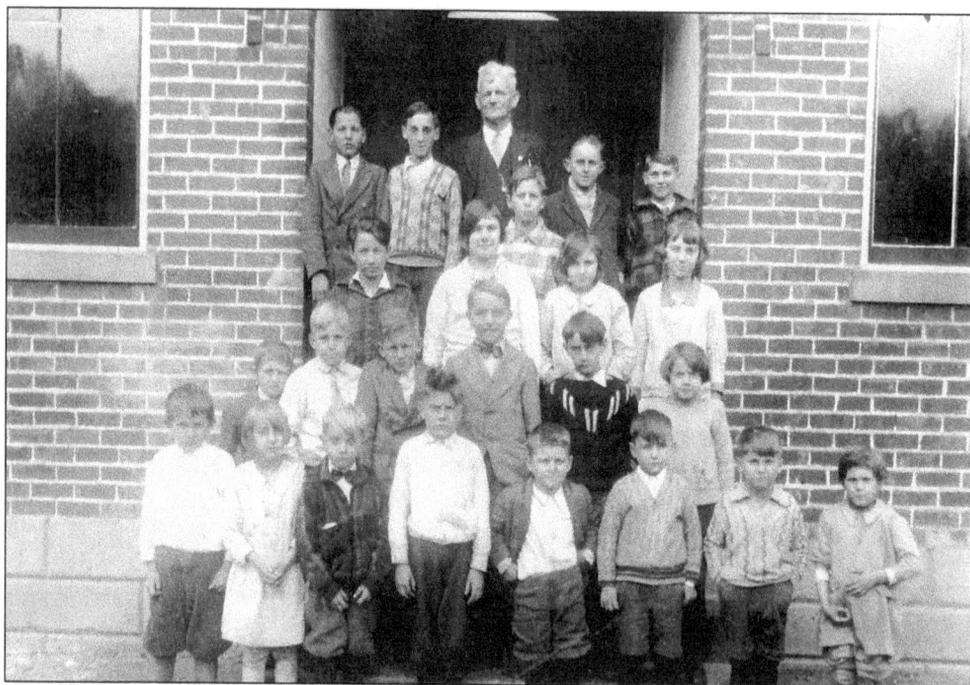

District No. 7 was the Green Township School located at Harrison Pike and Sheed Road. Students pose here with their teacher, M. E. Wheatley. The school closed about 1930 with students going to Dent School District No. 12.

The old District No. 7 Green Township
School building was recently torn down.

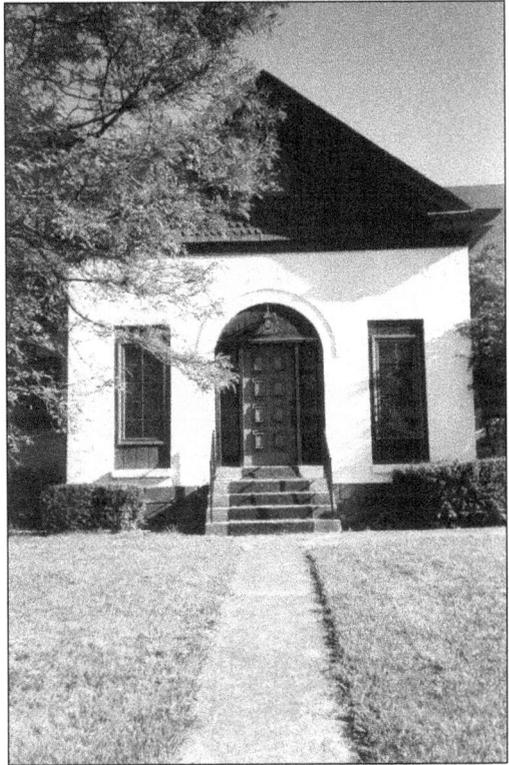

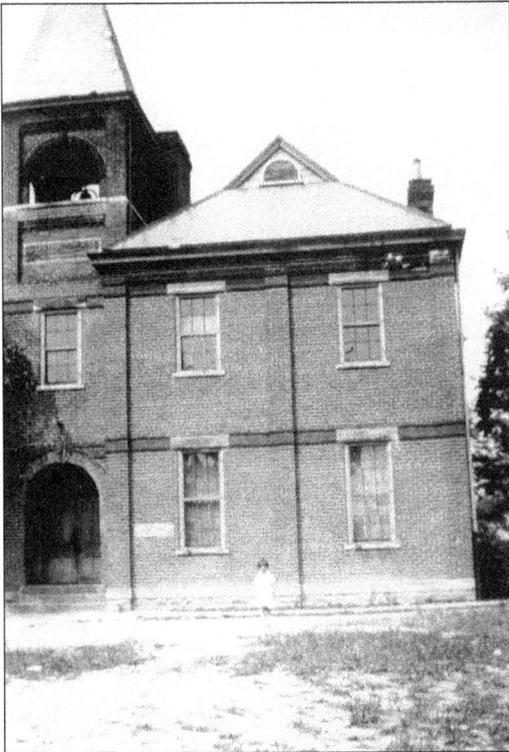

District No. 8 was the North Bend Road
School in Monfort Heights. The school
was located on the west side of North
Bend Road, just north of today's I-74. The
final school building had two rooms on
two floors. This photograph of the school
building was taken in 1928. The little
girl standing in front of the school is Sis
Berberich, secretary and treasurer of the
Green Township Historical Association.
The old building was used as apartments.

79

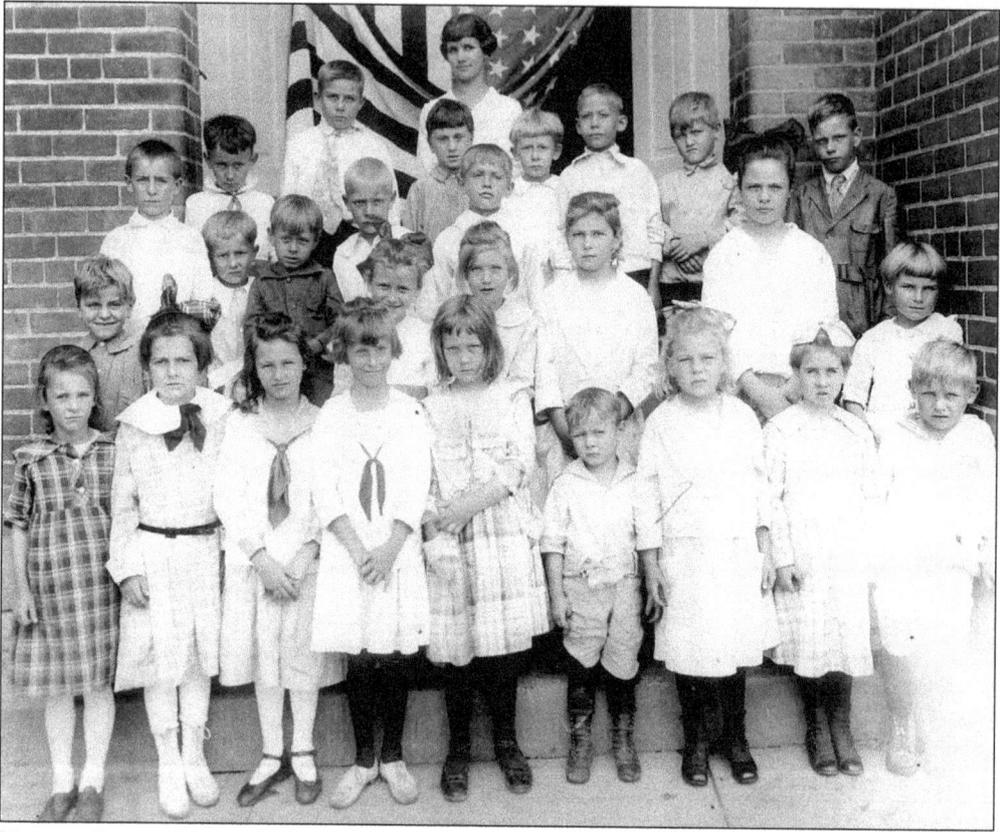

Here are District No. 8 North Bend Road School students in 1920.

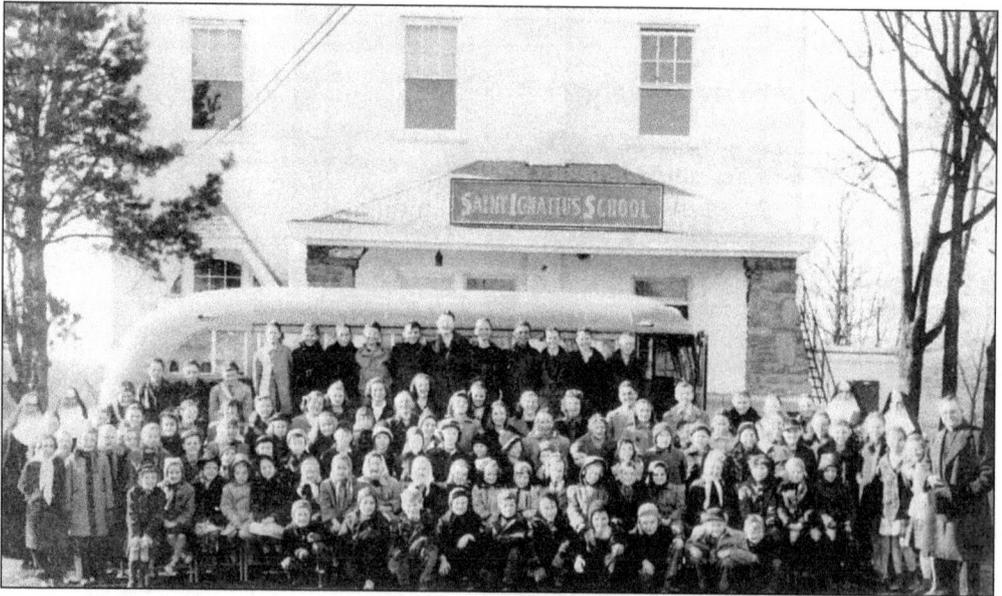

In 1947, the District No. 8 building, after being converted to apartments, was sold to St. Ignatius Loyola for its first school building from around 1947 to 1950.

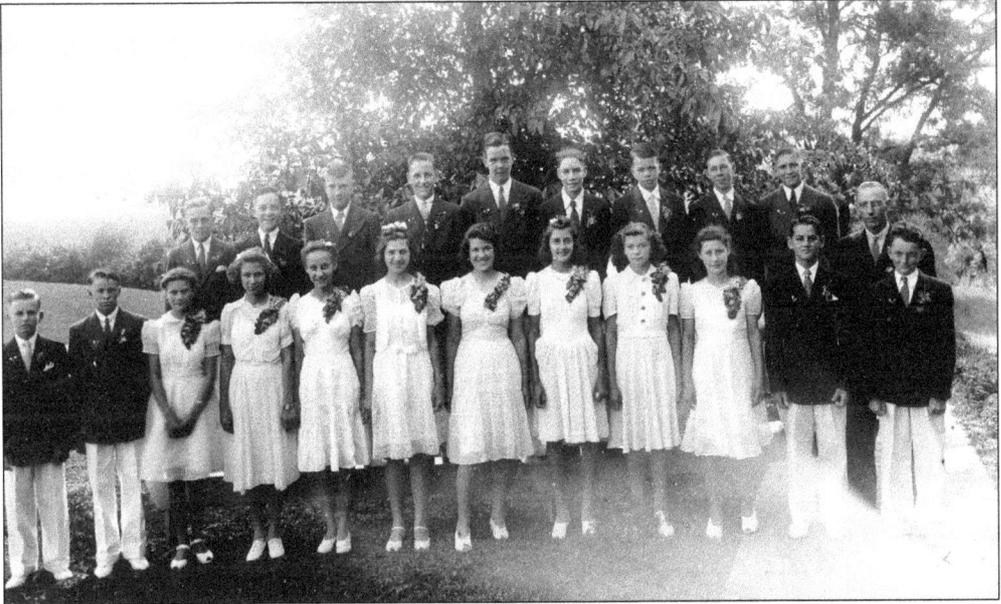

Mack resident Ken Scheidt's eighth-grade graduation class at Monfort Heights School is pictured here in 1941. Scheidt is pictured by the "X."

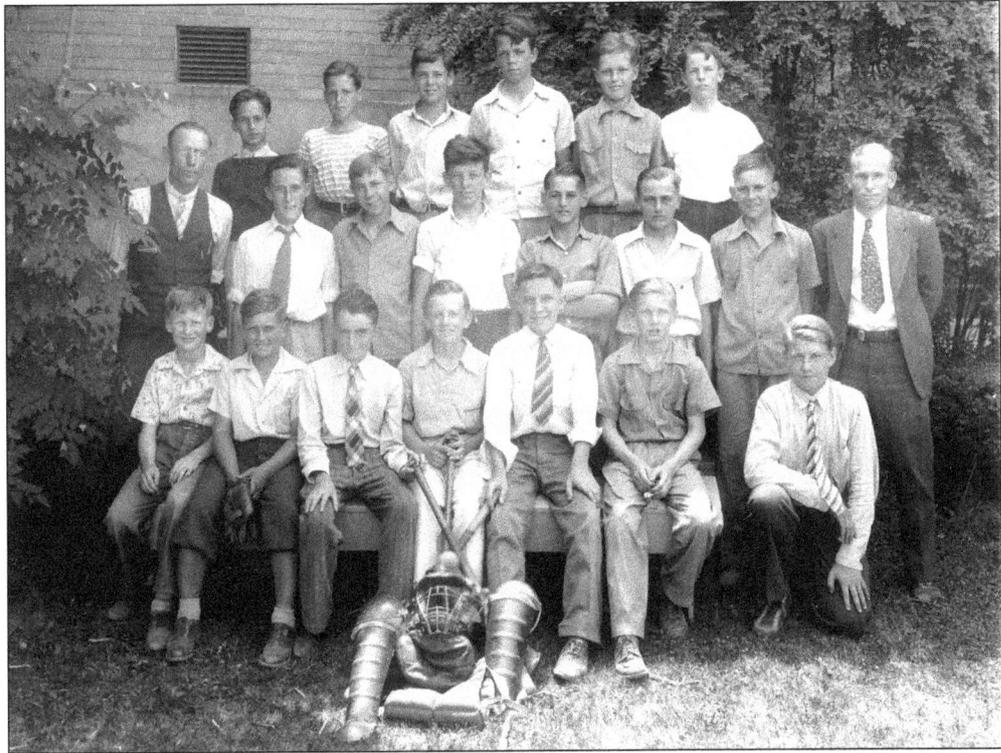

Monfort Heights School fielded several eighth-grade sports teams that Ken Scheidt was a member of, including baseball, shown here, and basketball.

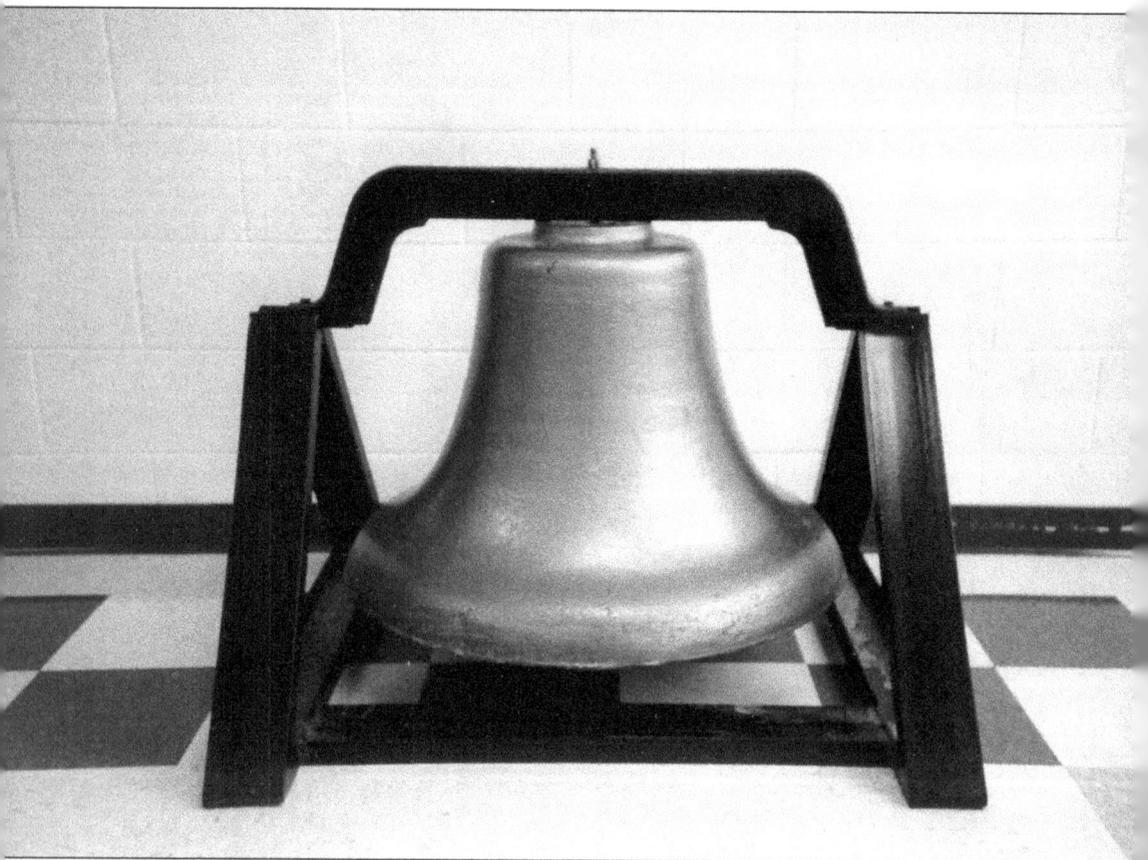

Here is the bell from the old District No. 8 North Bend Road School. The old bell is now in the new Monfort Heights Elementary School on West Fork Road. The first school was demolished in 2000, and the new Monfort Heights School was built next to the old one on West Fork Road.

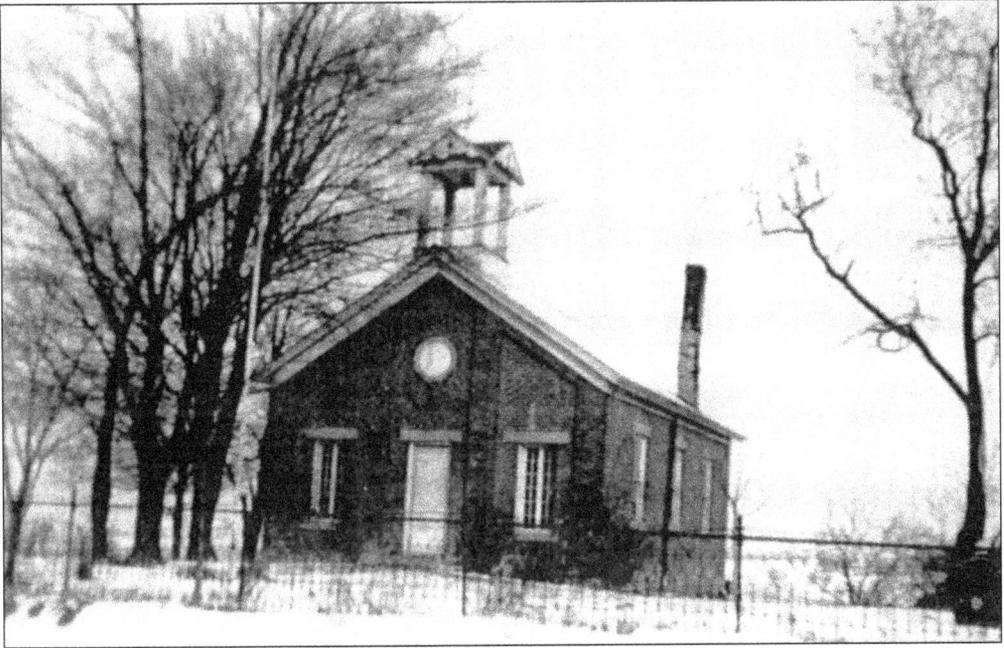

This photograph shows the old District No. 11 West Fork School on the north side of West Fork Road, east of Gaines Road. It was a one-room school. Around 1920, there were 26 students attending.

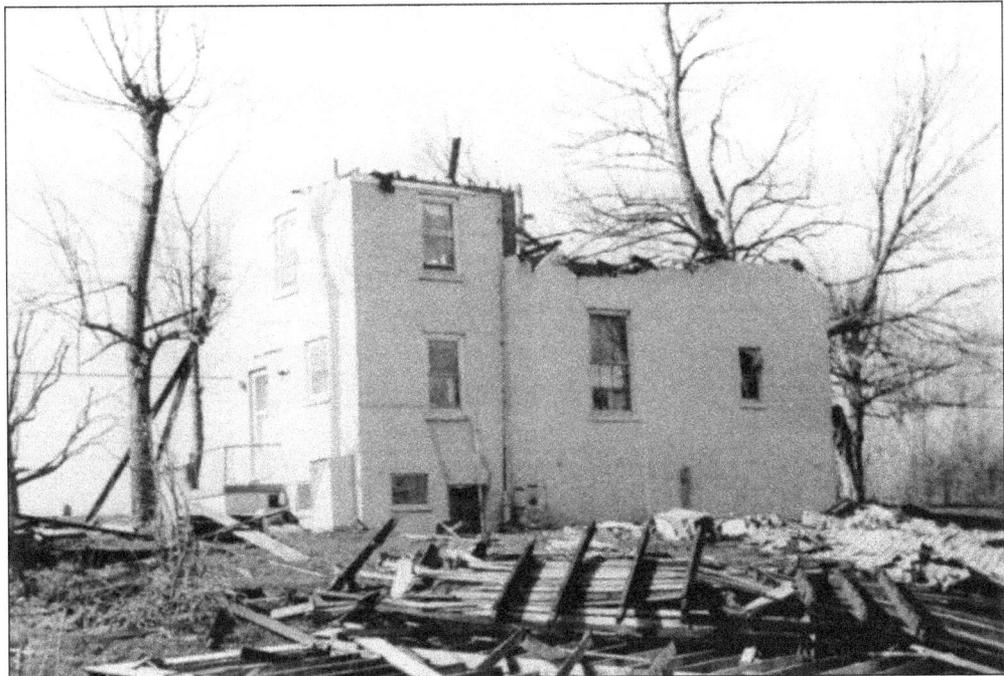

The building was converted to a private residence in 1930 after the district school was consolidated into Monfort Heights Elementary. During the April 3, 1974, tornado the building unfortunately was destroyed.

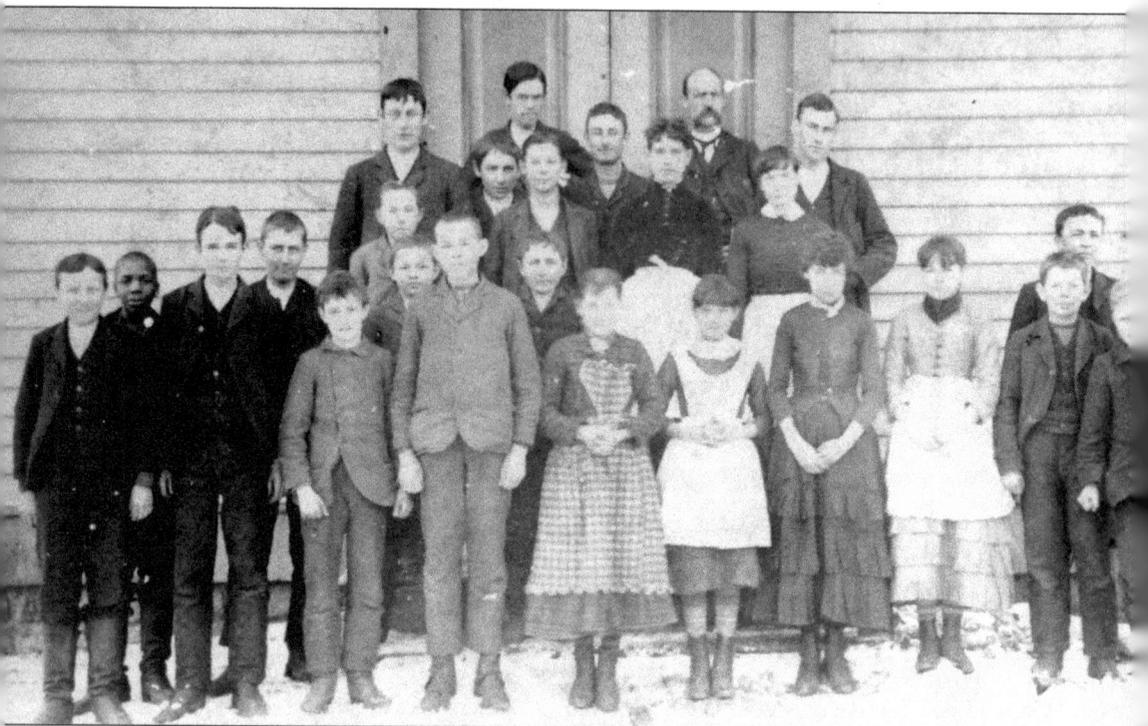

District No. 12 was the old Dent School on Harrison Pike, near Wesselman Road. The school was on the 1869 Green Township map. A frame school, as seen in this photograph, was built on the site before the current red brick building, which was built in 1894 and still stands on the site. The red brick school building had two rooms on the first floor and two on the second floor. For a number of years, the school included two years of high school classes.

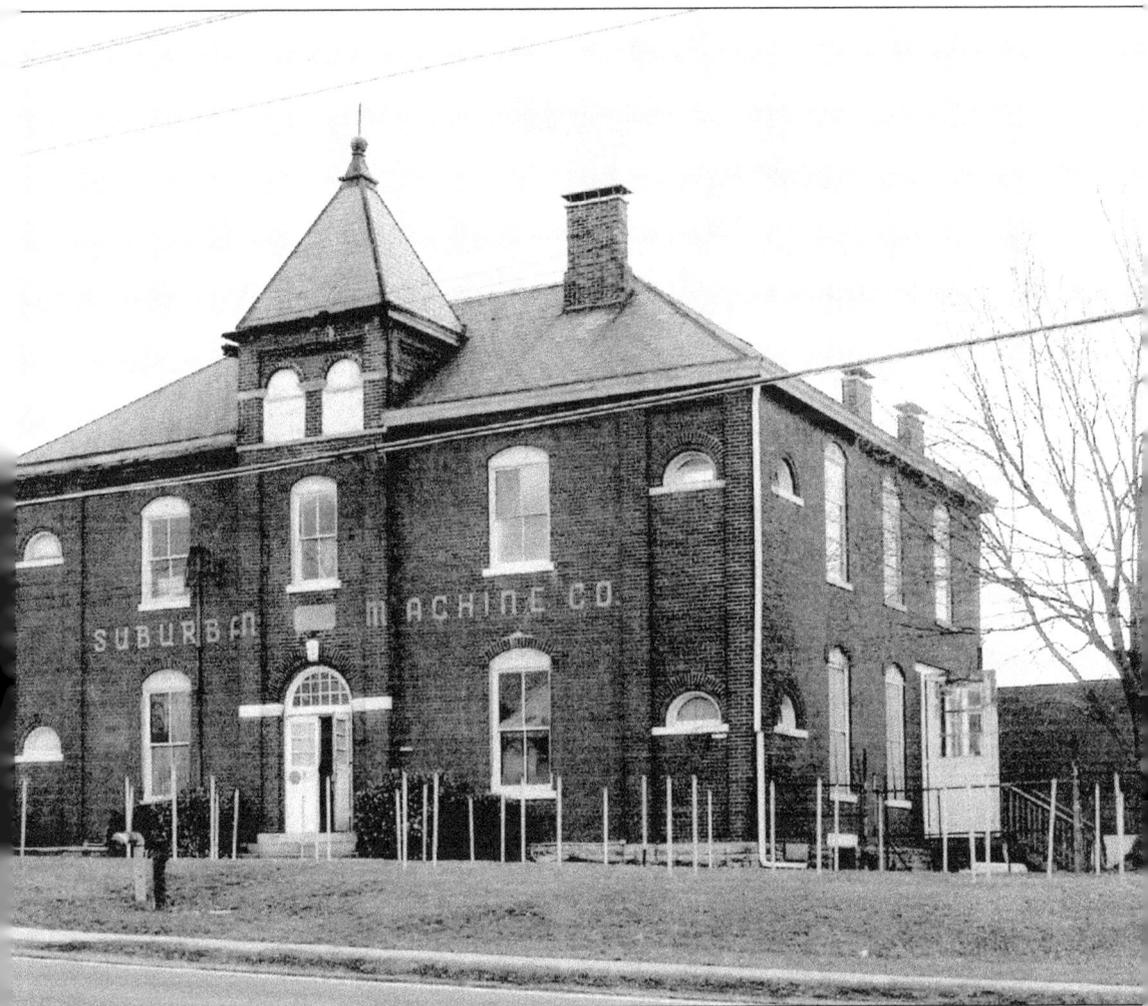

The Dent School was located on Harrison Avenue in Dent. The red brick building is still standing. In past years it has been a machine tool shop, and now each year it is used as a haunted house for Halloween. (Courtesy of David Bushle.)

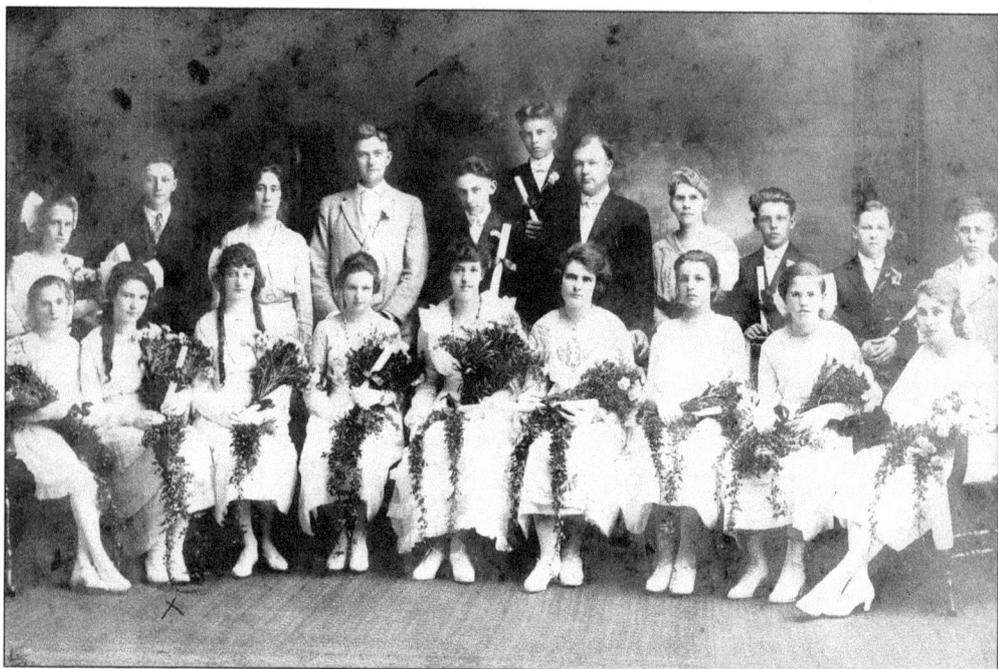

The Dent School graduation class of 1917 includes Mack resident Ken Scheidt's mother, Lulu Sammons, pictured here second from left in the front row. Lulu Sammons is now deceased, but she was a longtime Mack resident in Green Township, as are Ken Scheidt and his family.

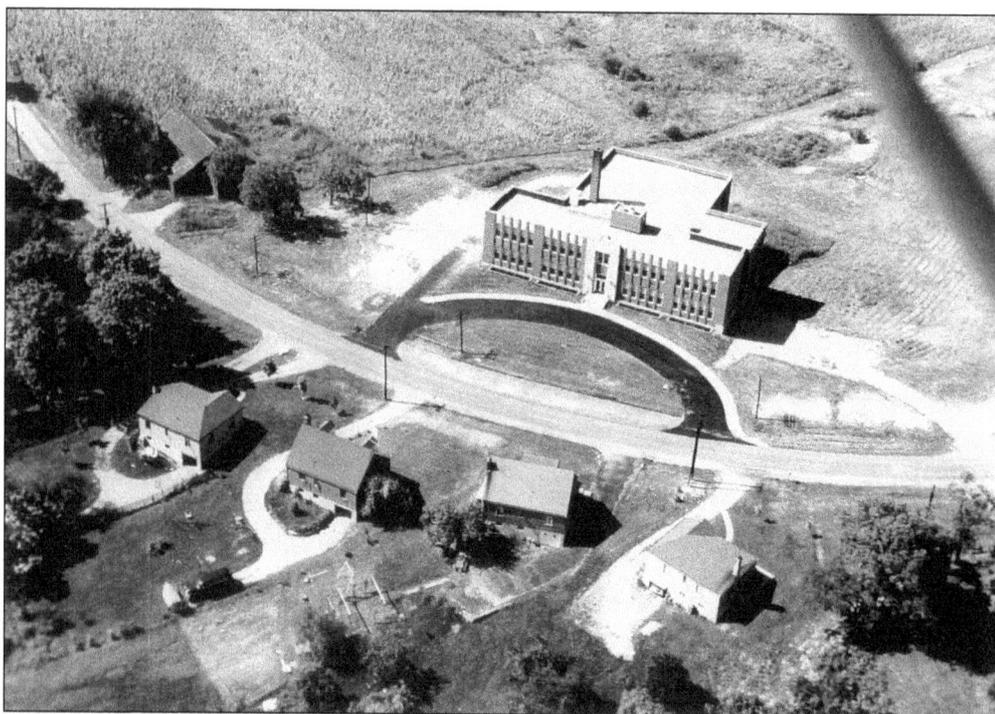

Dent School was combined with South Avenue District No. 2 School into Springmeyer School around 1950. The aerial photograph shows Springmeyer School about 1950.

School Board.

WILLIAM J. CLAYTON, President.

CHARLES SIEFERT, JOSHUA P. TAYLOR,
THOMAS J. BRADFORD, GOTTLIEB KOENIG,
FRANK LUMLER, WILLIAM KRAMER,

ROBERT CONGER, Clerk.

Graduating Class.

HARRY W. SCHEIDT, EDWARD TAYLOR,
ANNA M. RODLER, MARTHA C. LUMLER,
OMER H. BENNETT, HENRY A. SCHEIDT,
JOHN M. SEVESTER, WILLIAM G. NEIERT,
ETHEL F. BACON, EDWARD F. MYERS,

WILLIAM W. MARKLAND.

Fourteenth Annual Commencement

—OF THE—

Green Township Graded Schools,

—AT THE—

WESTWOOD TOWN HALL,

—ON—

FRIDAY EVENING, JUNE 17TH, 1898.

EXERCISES TO BEGIN AT 7.30.

U. D. CLEPHANE, SUPERINTENDENT.

PRINCIPALS.

U. D. Clephane. Horace Hearne.
No. 2. No. 8.

A. C. Flinchpaugh.
No. 12.

NO FLOWERS.

This is part of the program from a Green Township Graded Schools commencement from June 17, 1898.

The Class of '98

desires your presence at the

Graduation Exercises

of the

Green Township Graded Schools,

Westwood Town Hall,

Friday, June 17th, 1898,

at 7.30 P. M.

Seen here is an invitation to the Green Township Graded Schools commencement from June 17, 1898.

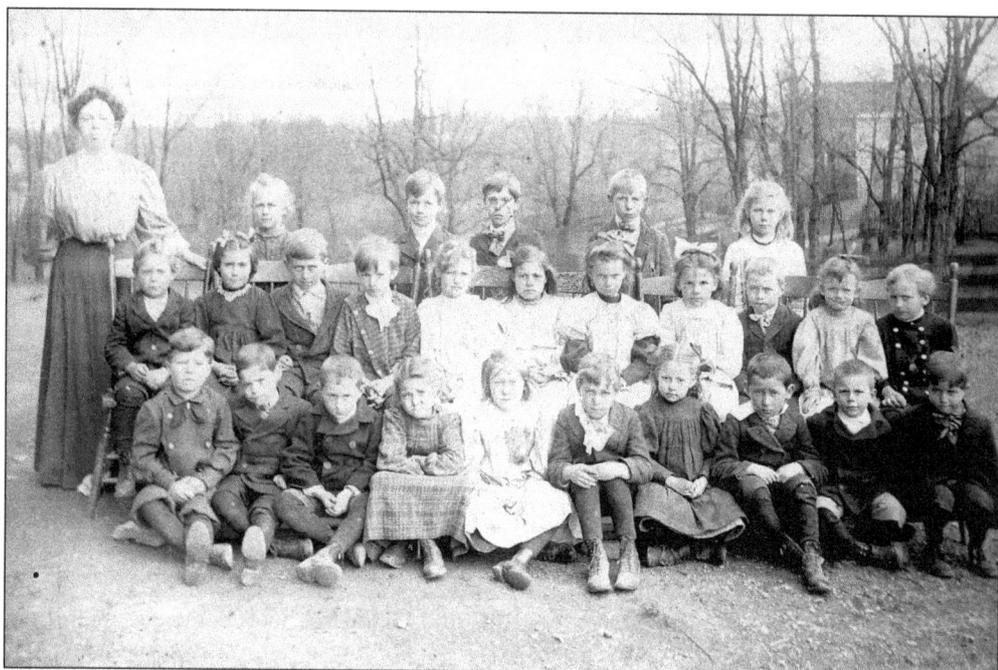

Students at Covedale No. 10 Elementary School gather outside for a photograph around 1910.

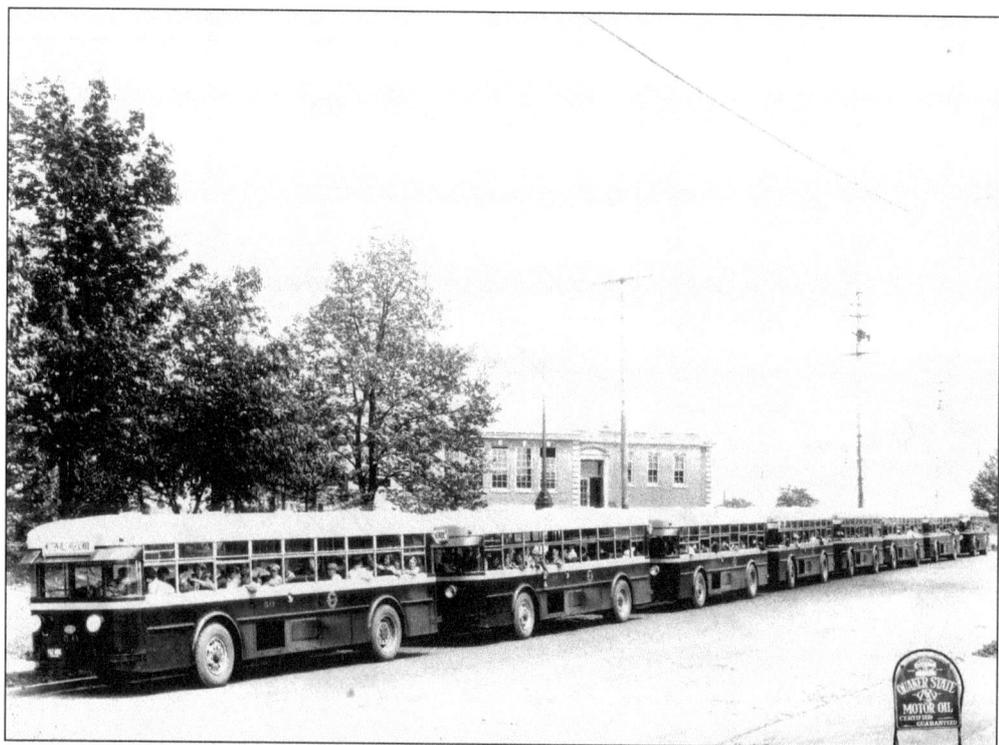

Eight school buses filled with students are parked in front of Cheviot School around 1930. (Courtesy of Phil Lind.)

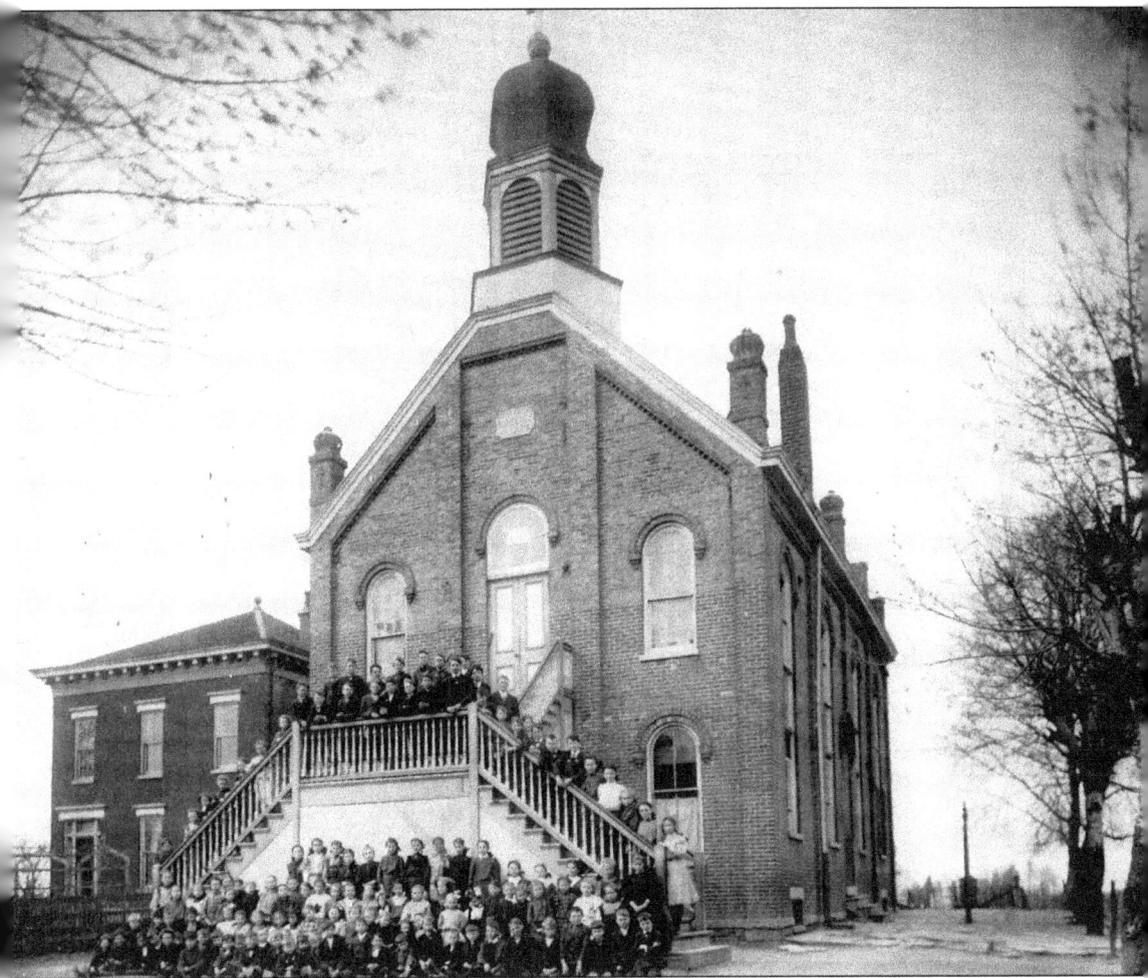

Over the years a number of parochial schools also educated many Green Township children. Two located in Green Township date back to the 1800s—St. Aloysius in Bridgetown in 1866 and St. James in 1843 in White Oak. With the 1900s population growth in the township, several more parishes and schools began in Green Township. In this photograph is the old St. Aloysius Church with schoolchildren posing for the camera. The church was built in 1867 and razed in 1955. The school was on the first floor and the church was on the second floor for many years.

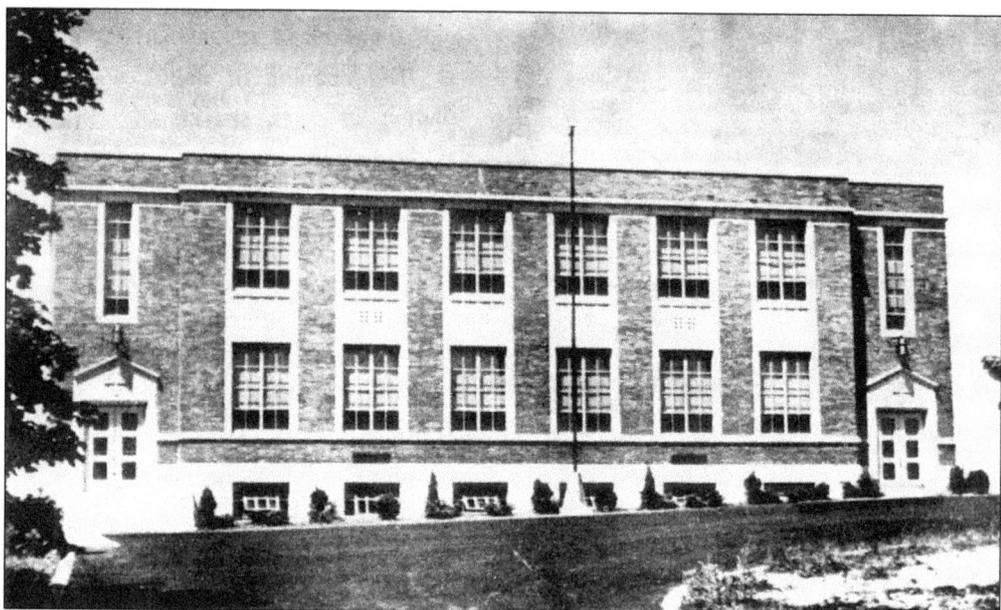

In 1937, St. Aloysius built a new school for students from the first to eighth grades. A few additions to the school have been built over the years.

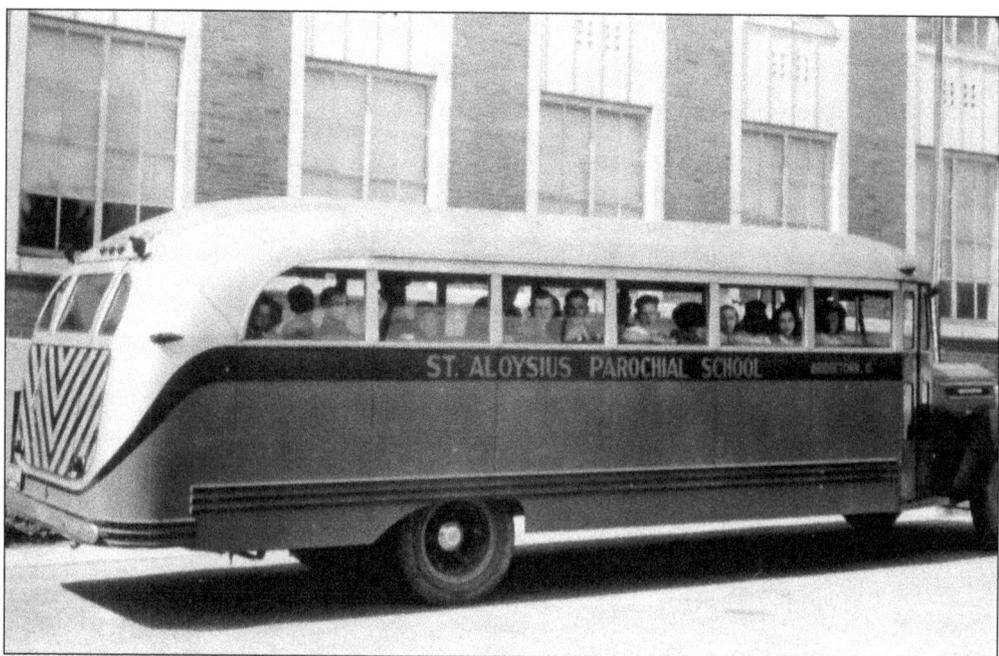

This old St. Aloysius school bus is filled with students anxious to get home.

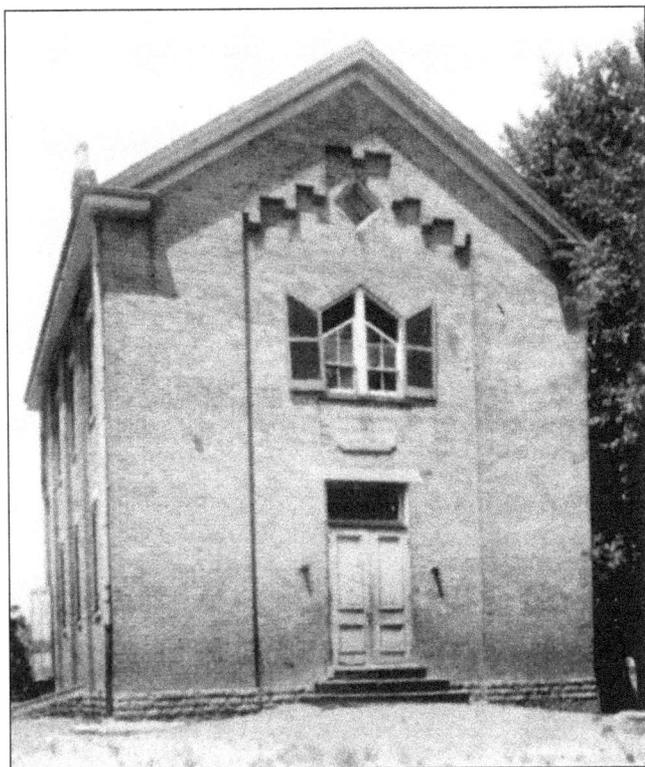

This photograph shows the first brick school built at St. James in White Oak in 1874 by Rev. J. C. Kraemer.

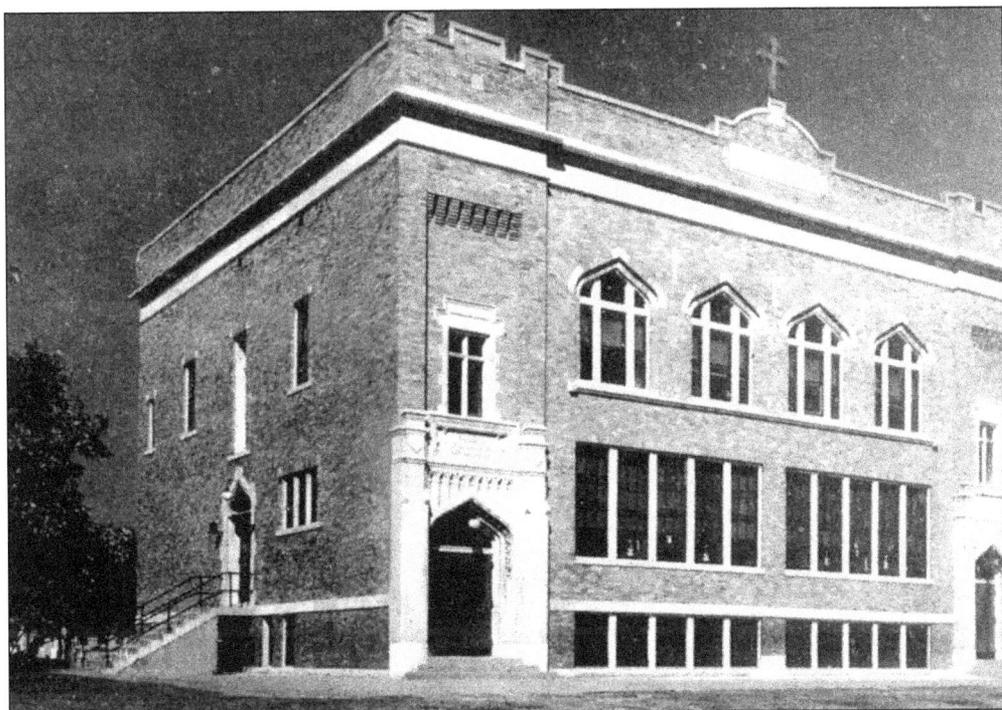

A new school at St. James was erected in 1912 by Rev. Joseph Duerstock with additions built over the years.

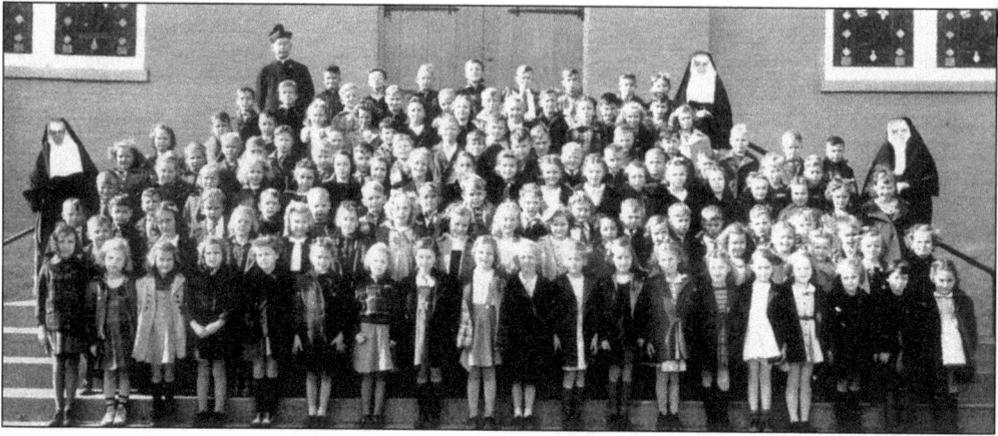

This is the 1942–1943 class of first-, second-, third-, and fourth-grade students at St. James School.

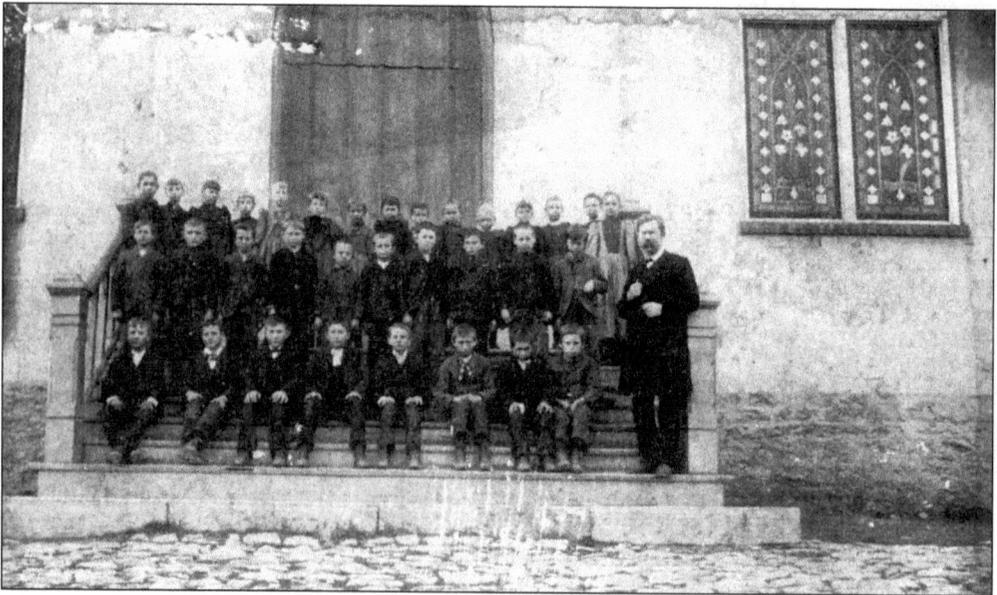

An early class of students at St. James School in White Oak is shown here around 1882.

Six

EARLY CHURCHES

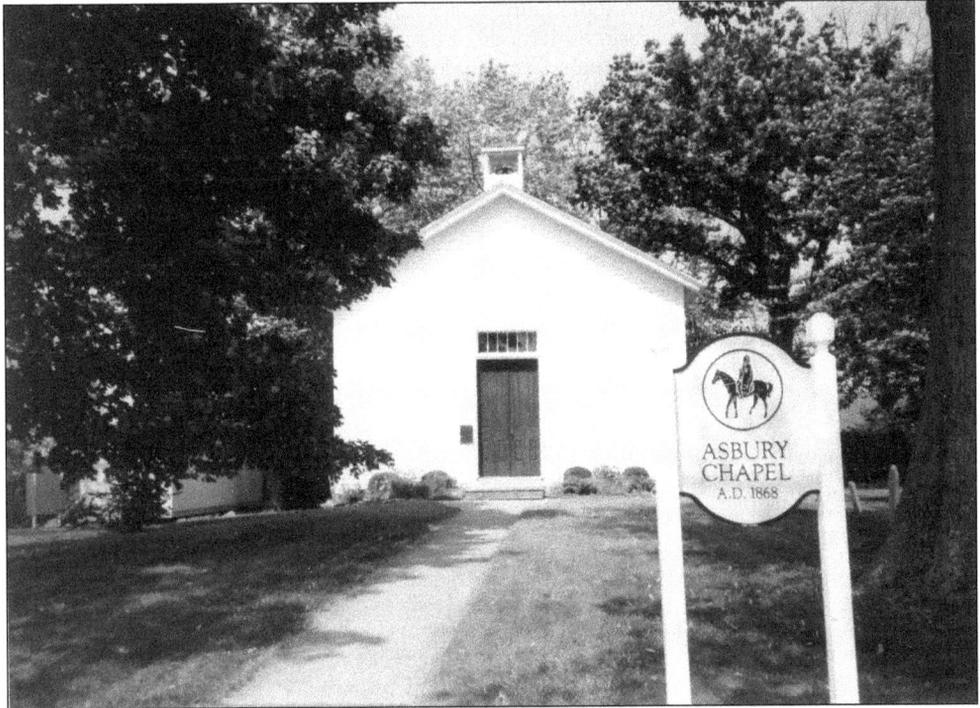

Green Township is served by many places of worship today. In the 1800s, churches were few in number. Among the earliest were ones in Westwood and Cheviot, both communities then in Green Township. One was Baptist and the other Presbyterian. Both Asbury Methodist (1836) in Monfort Heights, shown in the photograph, and Ebenezer Methodist Episcopal Church (1839) in Mack were early Green Township congregations. Today these are Monfort Heights United Methodist and Oak Hills United Methodist Churches. St. James in White Oak (1843) was complemented by St. Aloysius (1866) in Bridgetown and Pilgrim United Church of Christ (1870), also in Bridgetown. Pilgrim began as the First German Evangelical Congregational Church. In the 20th century, many new churches began as the population grew.

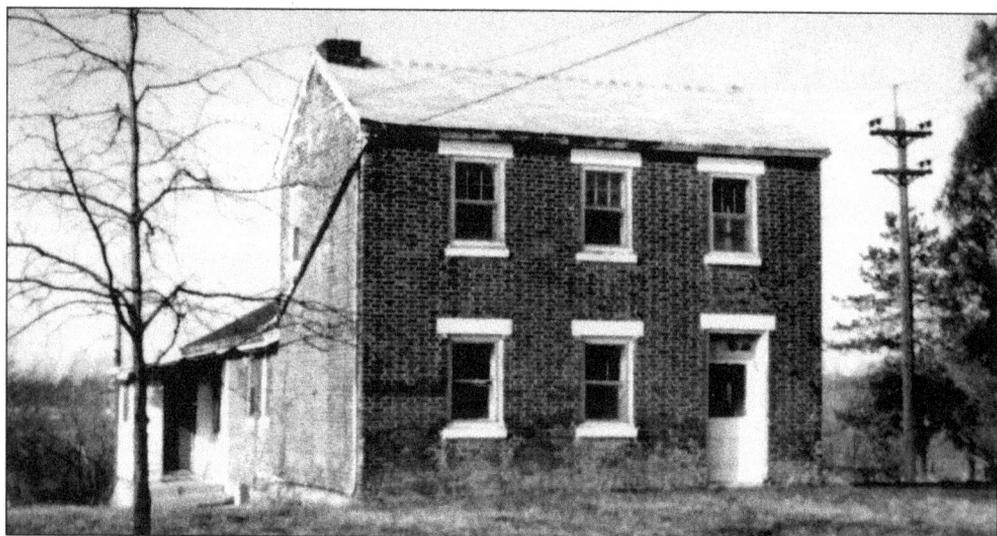

The present wooden-frame Asbury Chapel was built in 1868. The McKnight house, shown in the photograph, was owned by John and Francis McKnight. They offered a half acre of ground for erecting a house of worship for the Methodist Episcopal Church. A brick church was built using bricks from a kiln on the McKnight farm on Pleasant Ridge Road, today's West Fork Road. A tornado in 1868 destroyed the brick Asbury Church, but a new wooden-frame chapel costing $2,000 was dedicated on November 1, 1868. A new Monfort Heights Methodist Church opened in 1952, and the Old Asbury Memorial Chapel was rededicated on June 3, 1984.

REDEDICATION
of
Asbury Memorial Chapel

of the
Monfort Heights United Methodist Church

PARTICIPANTS:

BISHOP DWIGHT E. LODER
Resident Bishop of Ohio West Area

THE REV. R. ROBERT KIMES
District Superintendent

THE REV. DONALD A. BIBLE
Pastor

MR. LAWRENCE COOK
Chapel Chairman

Here is a program cover from the rededication of Asbury Memorial Chapel in 1984.

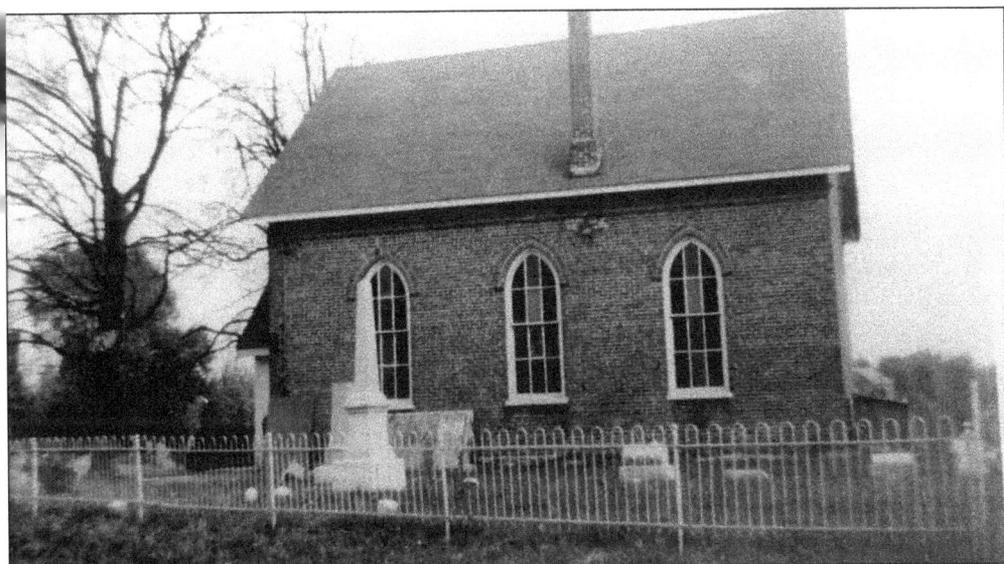

Ebenezer Methodist Episcopal Church was organized in 1839. It was a log church. Rev. James L. Reiley was the first minister from 1839 to 1844. In 1849, the first brick church was built. It was destroyed by a tornado in 1866 and rebuilt with the same bricks. Amelia Wilkie made a generous donation for the land, building, and furnishings of the new Wilkie Memorial Community Church, done as a memorial to her late husband, August "Doc" Wilkie in 1940. In 1971, the present sanctuary and fellowship hall were built. The cornerstone of the 1849 Ebenezer Church was incorporated into the Narthex wall of the new sanctuary. In 1967, the name was changed to Oak Hills Methodist Church and a year later to Oak Hills United Methodist Church.

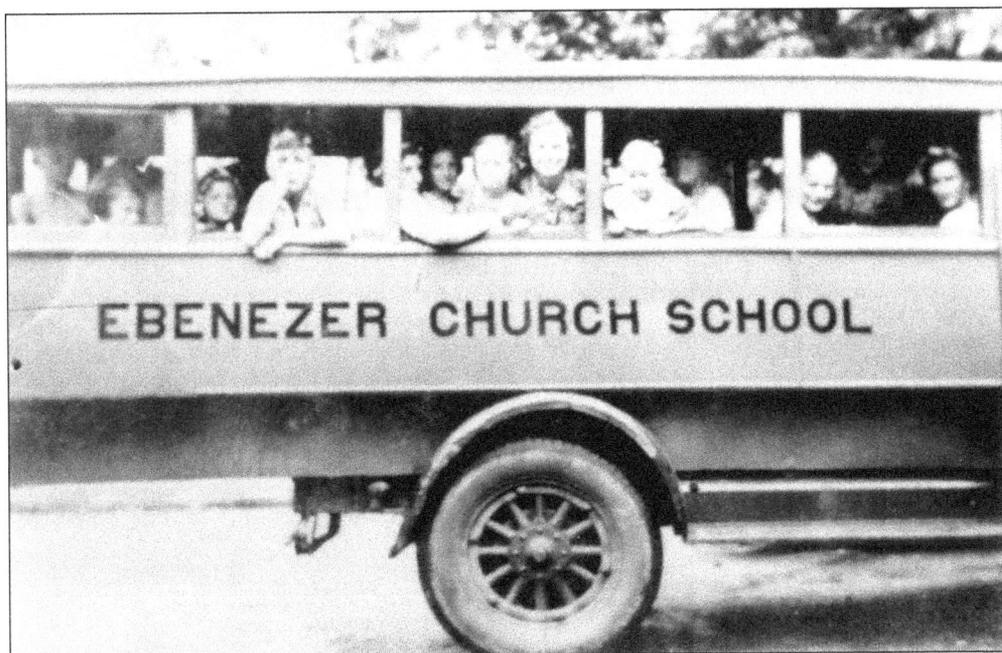

This is an Ebenezer Methodist Episcopal Church school bus, year unknown.

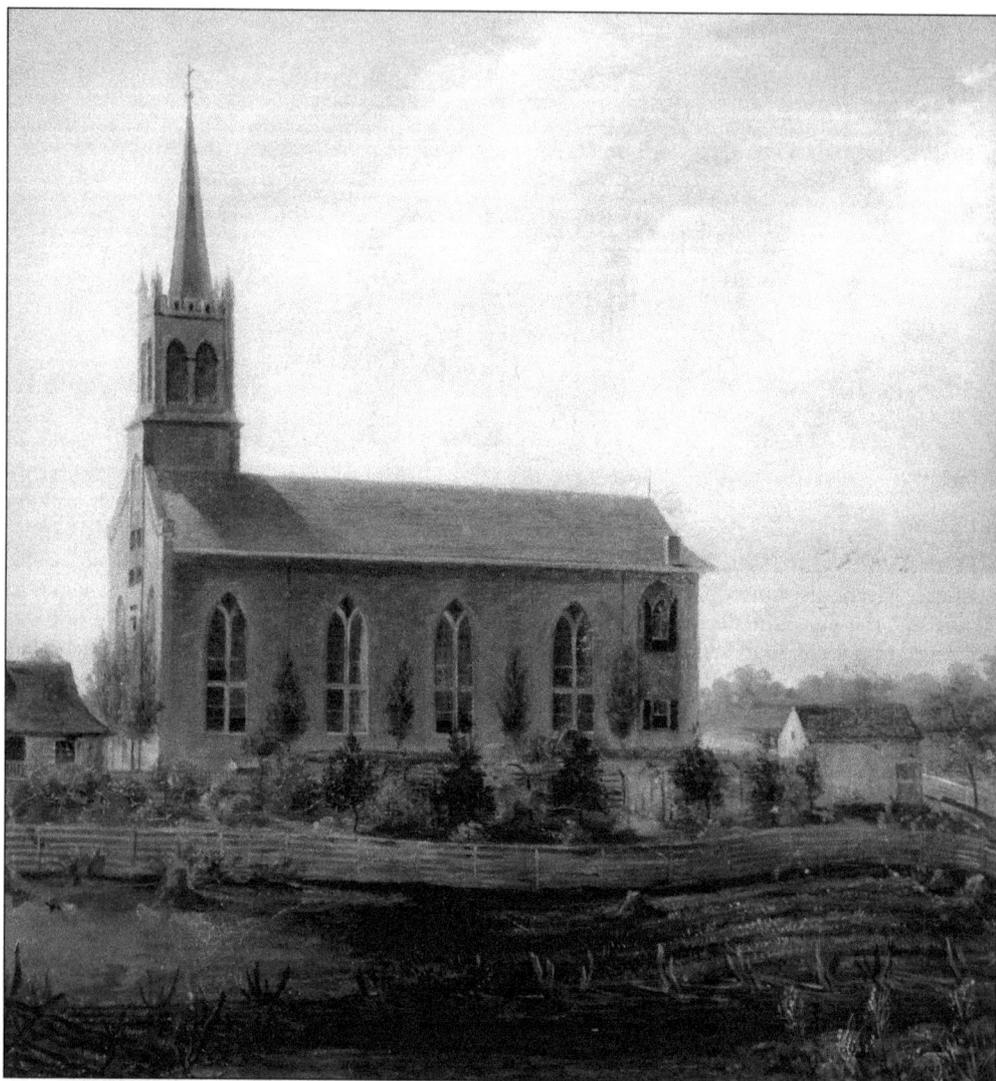

St. James the Greater Church in White Oak, the first Catholic church in Green Township, dates back to 1840 when Rev. John M. Henni S.J., a missionary and pastor of Holy Trinity Church in Cincinnati, said the first mass on August 15, 1840, in a barn owned by Sylvester Oehler. Under the direction of Fr. Joseph Ferneding, the first church, a log building, was erected in 1841–1842. The money needed was $126.62 for building materials, labor, and surveying. A total of $66.62 was collected, with $100 having to be borrowed. Officially 1843 was the parish's formal organization. The brick church shown here is from a commemorative print taken from a painting by the Reverend Francis J. Pabisch, who served St. James from 1851 to 1856. Today St. James the Greater Church has grown from that log cabin church for a handful of faithful parishioners to a suburban parish of almost 3,000 families.

St. James erected a new church building in 1849 with the assistance of Rev. Joseph Weber. This church served the needs of the congregation until 1962 when a new basement church building was begun. The 1849 church was demolished.

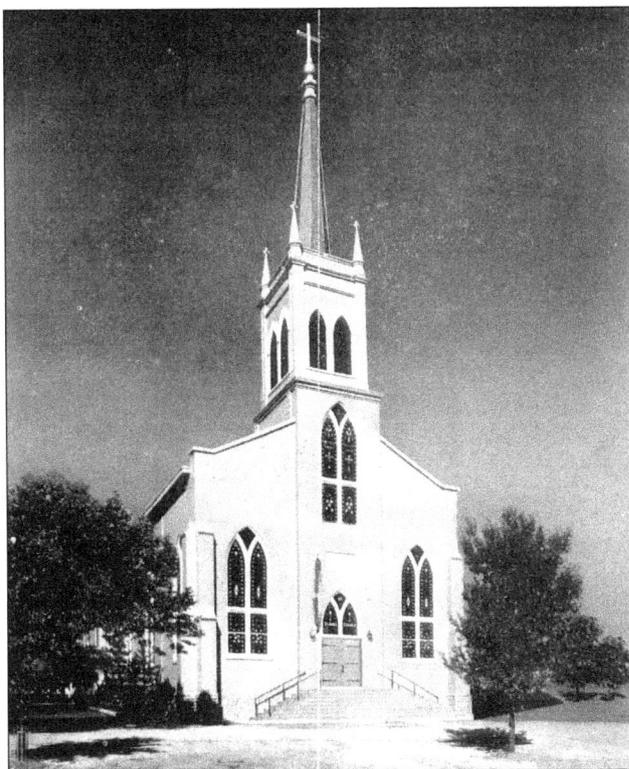

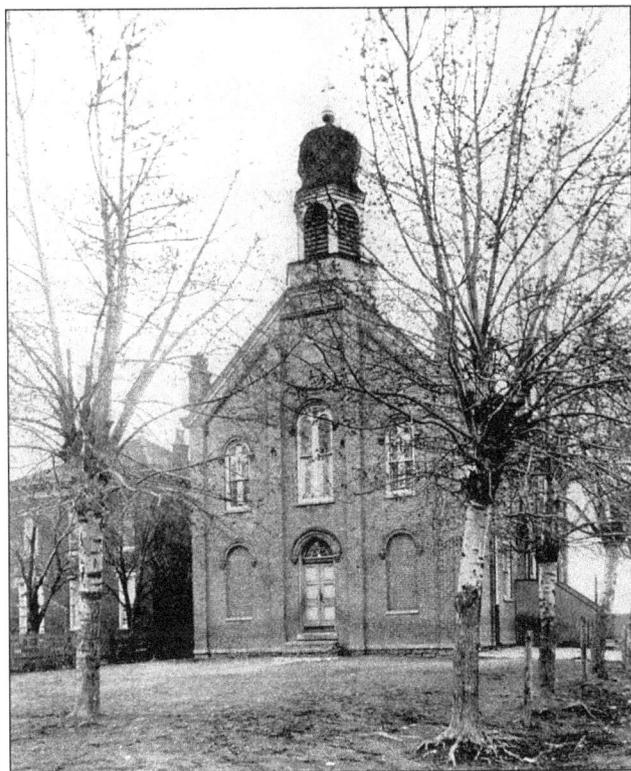

This photograph shows the first St. Aloysius Church built on Cleves Pike, now Bridgetown Road at Fenton Avenue, now Church Lane, in 1867–1868. In the 20th century, continued population growth precipitated the need for new parishes in Westwood and Cheviot. St. Catherine's in Westwood opened in 1904 while St. Martin's in Cheviot opened in 1912. Several other Catholic parishes started in Green Township during the 1900s.

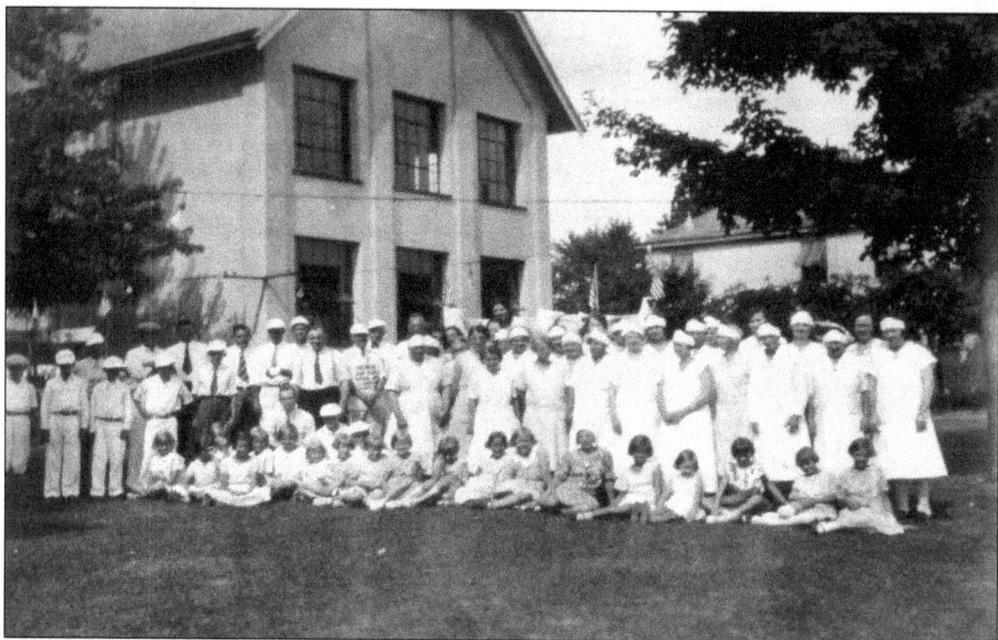

This is the original St Aloysius Church on Cleves Pike. The church was converted to a grade school in 1922. This photograph was taken in 1932 at Lawn Fete. Before this, the building was both church and school.

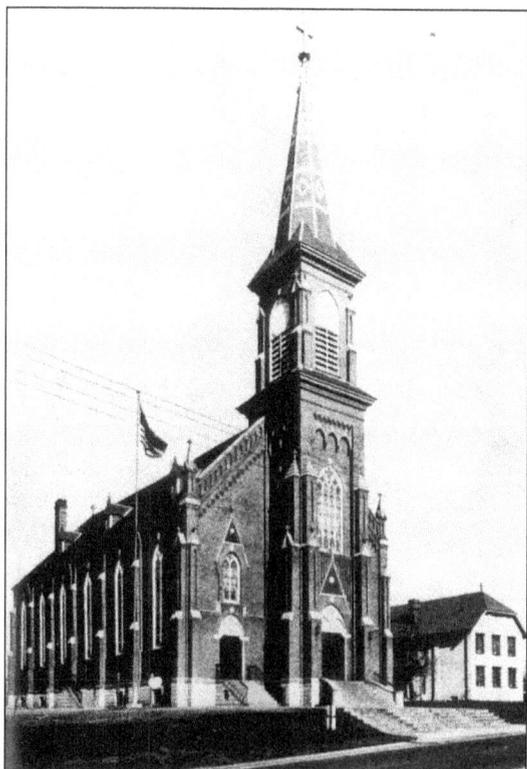

This photograph shows the second St. Aloysius Church built in 1914. The original building at the right was remodeled for school use. In 1960, the second church building was demolished as it was found to be structurally unsafe. The present church, dedicated in 1963, features a circular sanctuary with the altar in the center.

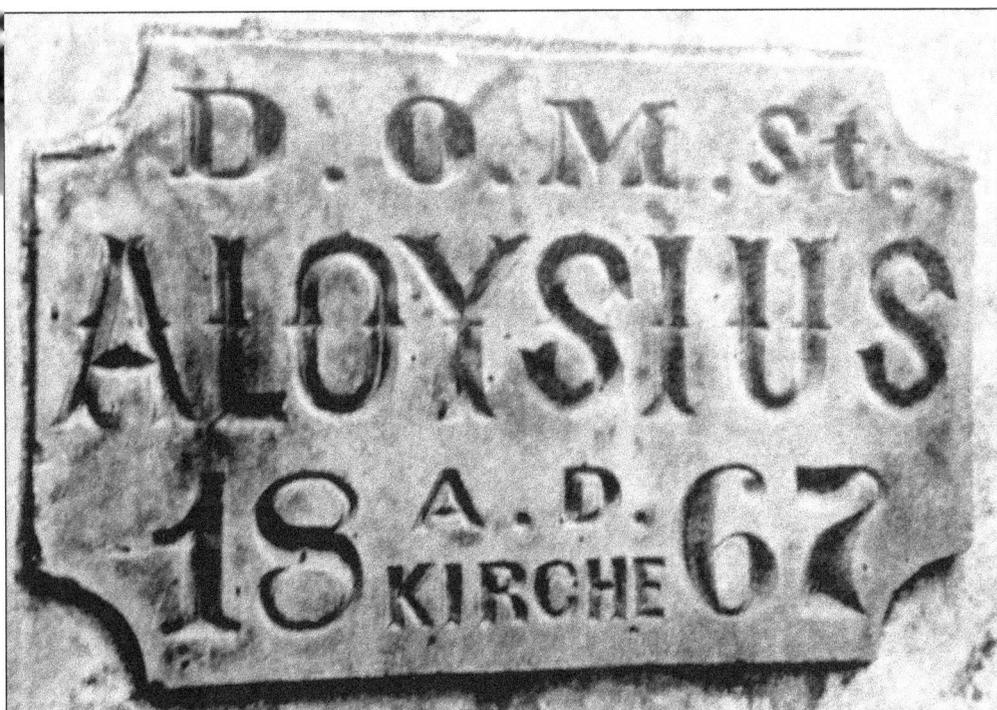

This is a photograph of the original cornerstone of St. Aloysius from 1867. "Kirche" means church.

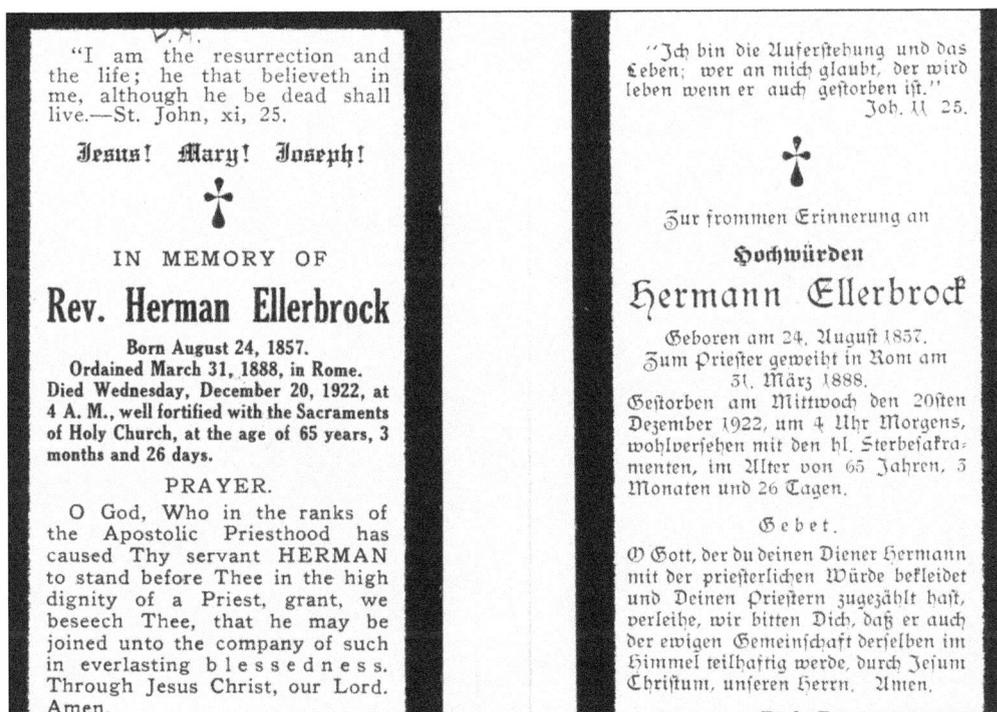

D. M.

"I am the resurrection and the life; he that believeth in me, although he be dead shall live.—St. John, xi, 25.

Jesus! Mary! Joseph!

✠

IN MEMORY OF

Rev. Herman Ellerbrock

Born August 24, 1857.
Ordained March 31, 1888, in Rome.
Died Wednesday, December 20, 1922, at 4 A. M., well fortified with the Sacraments of Holy Church, at the age of 65 years, 3 months and 26 days.

PRAYER.

O God, Who in the ranks of the Apostolic Priesthood has caused Thy servant HERMAN to stand before Thee in the high dignity of a Priest, grant, we beseech Thee, that he may be joined unto the company of such in everlasting blessedness. Through Jesus Christ, our Lord. Amen.

"Ich bin die Auferstehung und das Leben; wer an mich glaubt, der wird leben wenn er auch gestorben ist."
Joh. 11 25.

✠

Zur frommen Erinnerung an

Hochwürden

Hermann Ellerbrock

Geboren am 24. August 1857.
Zum Priester geweiht in Rom am 31. März 1888.
Gestorben am Mittwoch den 20sten Dezember 1922, um 4 Uhr Morgens, wohlversehen mit den hl. Sterbesakramenten, im Alter von 65 Jahren, 3 Monaten und 26 Tagen.

Gebet.

O Gott, der du deinen Diener Hermann mit der priesterlichen Würde bekleidet und Deinen Priestern zugezählt hast, verleihe, wir bitten Dich, daß er auch der ewigen Gemeinschaft derselben im Himmel teilhaftig werde, durch Jesum Christum, unseren Herrn. Amen.

This is a memorial prayer card for Rev. Herman Ellerbrock who served St. Aloysius from 1896 to 1919. He died in 1922. The prayer card is in English on one side and German on the other.

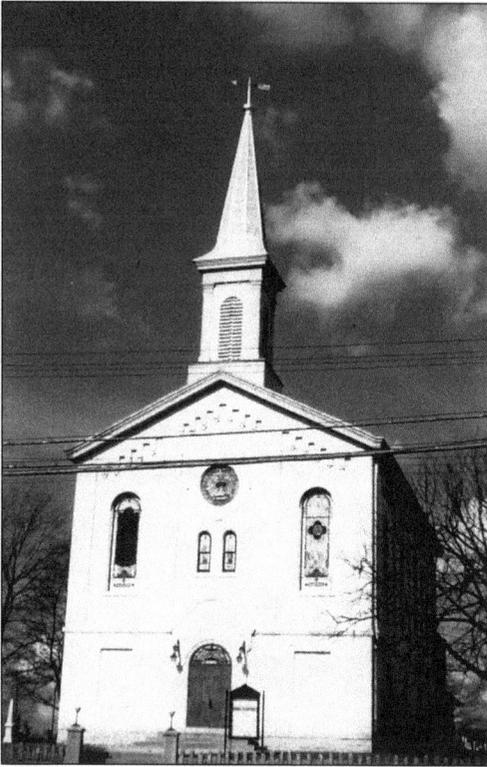

The First Evangelical Congregational Church began in 1870 on land donated by Bridgetown Cemetery and its founders. Stone was carried from the creek beds of the Ruebel Quarry at Race and Reemelin Roads by Christian and Mary Ruebel, charter church members, and other faithful workers. The church was on Cleves Pike, now Bridgetown Road. The first minister was the Reverend A. Schroeder. Pictured here is the church in 1953. (Courtesy of Les Brenner.)

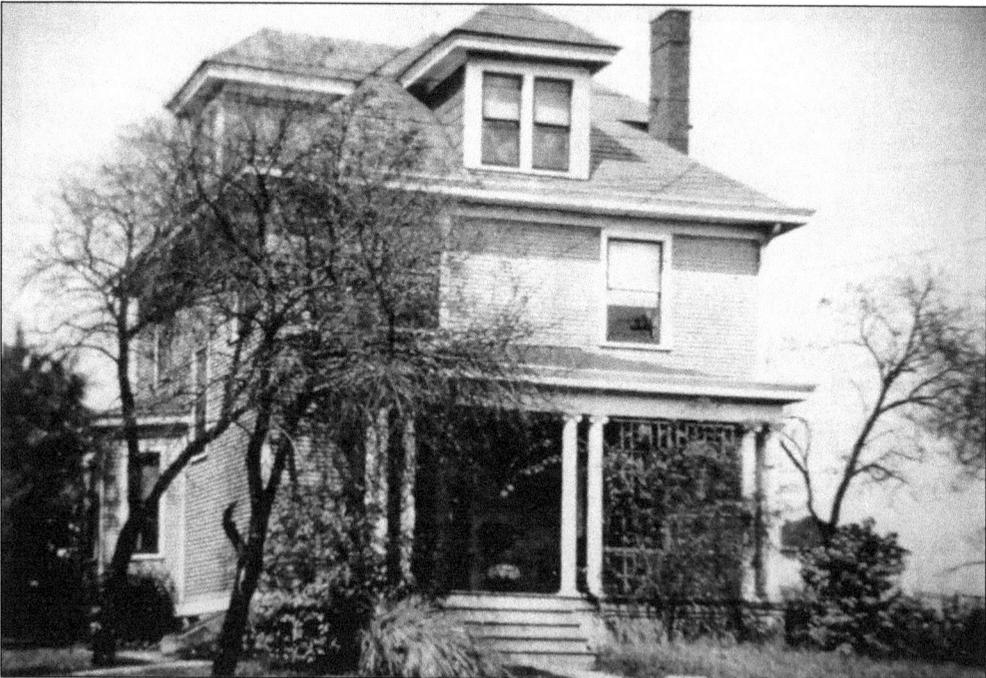

Here is the parsonage for the First Evangelical Congregational Church built in 1904–1905. It was torn down in 1961 when a new church was constructed. In 1960, at the church's annual meeting, the church became Pilgrim United Church of Christ.

100

The new Pilgrim United Church of Christ was designed by architect Fred Betz and was dedicated on Sunday, March 24, 1963. The first services in the new church were held on December 2, 1962, the first Sunday of Advent. The following Sunday, the cornerstone was placed at the base of the tower.

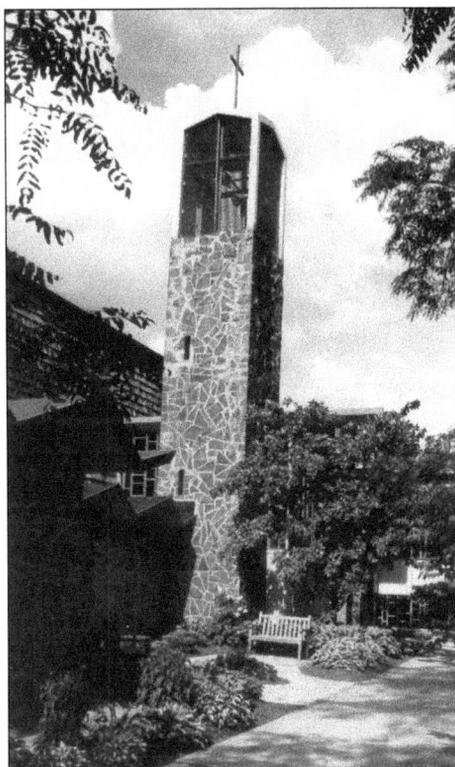

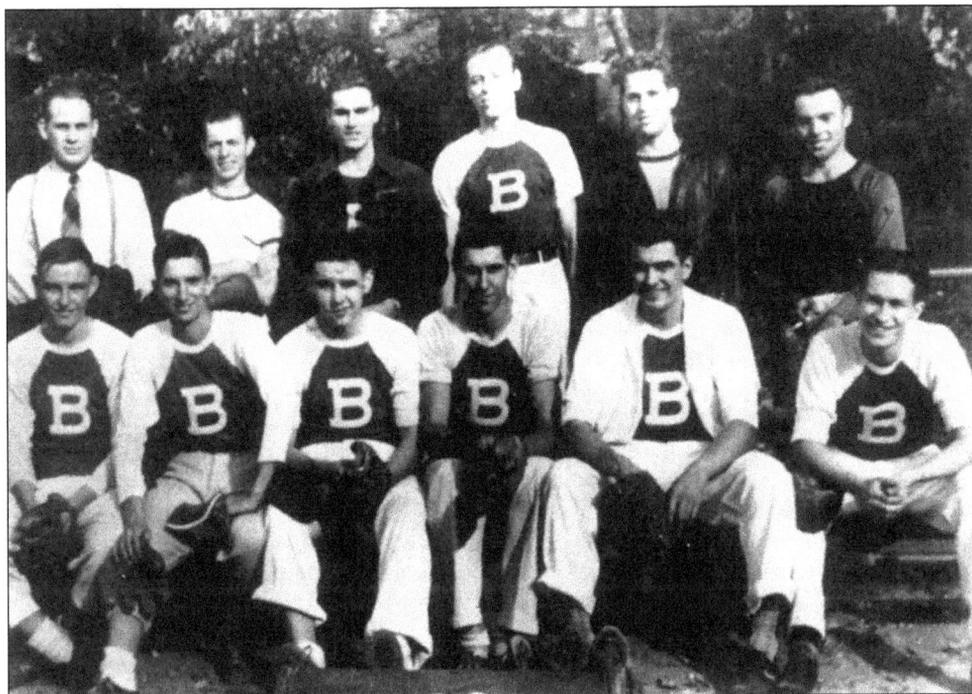

Members of the Pilgrim United Church of Christ's baseball team are pictured in 1940.

The Curd family at Bridgetown Church of Christ is seen here around 1927 or 1928. Mabel and Ed Curd are pictured in back with children Betty Curd (now Geiger), Jim Curd, and Mabel's mother, Alma Eck, in front getting ready for church. Mabel and Ed Curd were founding members of Bridgetown Church of Christ. Ed Curd and Clarence Breuer had been elders in the Westwood-Cheviot Church. In the beginnings of Bridgetown Church of Christ they accepted the duties of a pastor, preaching in turn. Each Sunday, the one who did not preach would teach the Sunday school class. Ed and Mabel Curd and their kids, Betty and James, were all charter members of Bridgetown Church of Christ.

Bridgetown Church of Christ first met in the basement of this house on June 11, 1933. The house belonged to parishioner Al Farrell, a developer and builder whose name is perpetuated in Farrell Drive off Montana Avenue. Optimistically they organized a church that would eventually be called Bridgetown Church of Christ. The church had 87 members but no meetinghouse, little money, not even any detailed plans but a lot of faith. Once the church was established they moved to the loft of the Cheviot Town Hall over the fire station on Harrison Avenue in November 1933. However, the rapidly growing congregation needed more space.

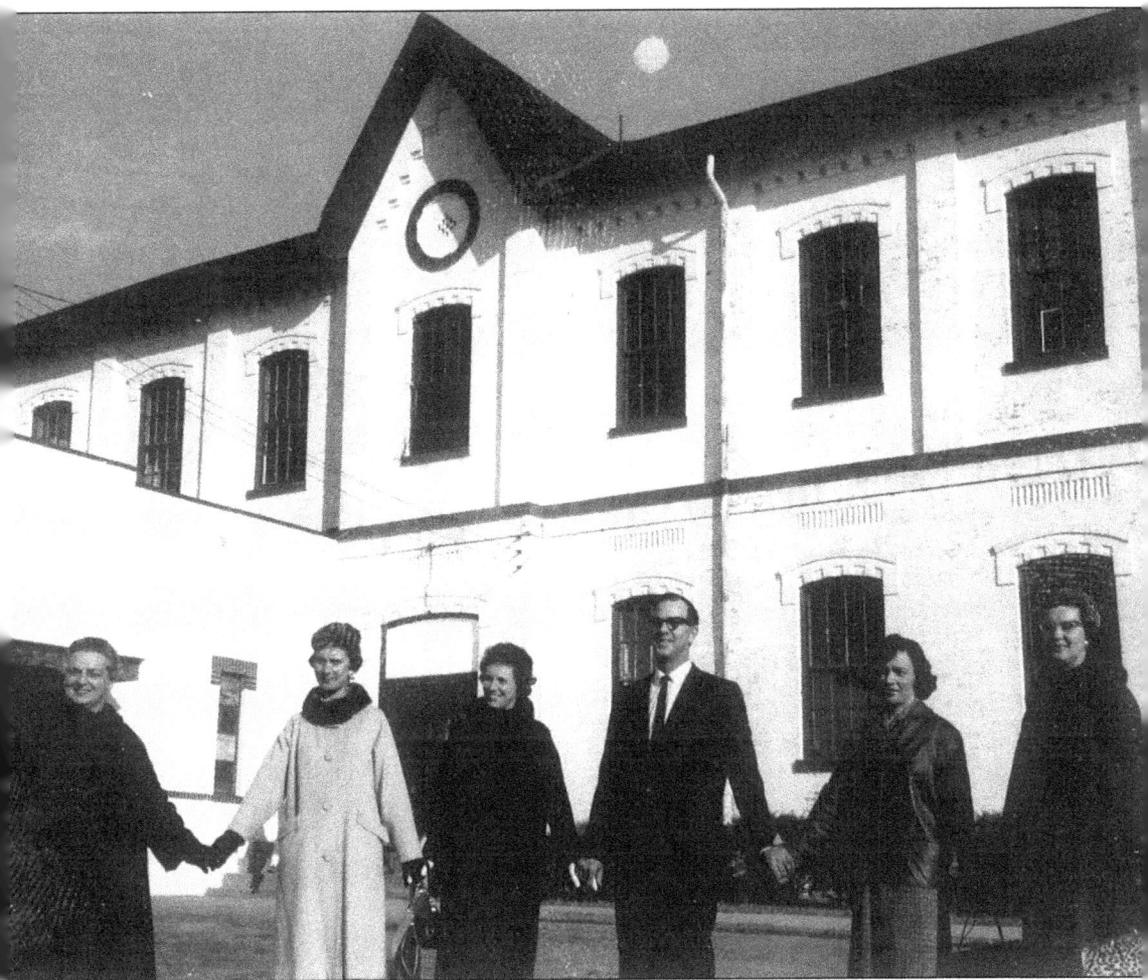

On July 6, 1940, the congregation of Bridgetown Church of Christ purchased the old Bridgetown School on Race Road for church services. The price, set by the Bridgetown School Board, was $4,250. By the grace of God and with careful bidding, Ed Curd was able to buy it for exactly the amount allowed. This was a great acquisition as it had a choice location on Race Road near Bridgetown Road with ample parking for the congregation and a spacious tree-shaded lawn for the annual picnic. The building was constructed solidly of brick after the fashion of many old schoolhouses. It had four huge rooms, two downstairs and two upstairs, plus a big basement so the men's class no longer had to crack their heads on the furnace pipes. In 1948–1949, a concrete sanctuary was added to the front of the building to accommodate the growing congregation. Shortly before demolition in 1963, a few members hold hands for solidarity. A few members and old students from Bridgetown School who attended classes in this building say goodbye to the old building. It had served them as both a church and school. They are, from left to right, Virginia Ruskaup, Dot May, Marian Massmann, Frank Hartman, Joan Hartman, and Betty Geiger. (Courtesy of Roger Miller.)

Bridgetown Church of Christ took a great leap of faith as the congregation continued to grow and in 1964 completed the existing sanctuary. By 1981, a new education wing and fellowship halls were added. Bridgetown Church of Christ is an independent church and voluntarily cooperates with about 5,000 other Churches of Christ in the United States.

Seven

OTHER COMMUNITY SCENES

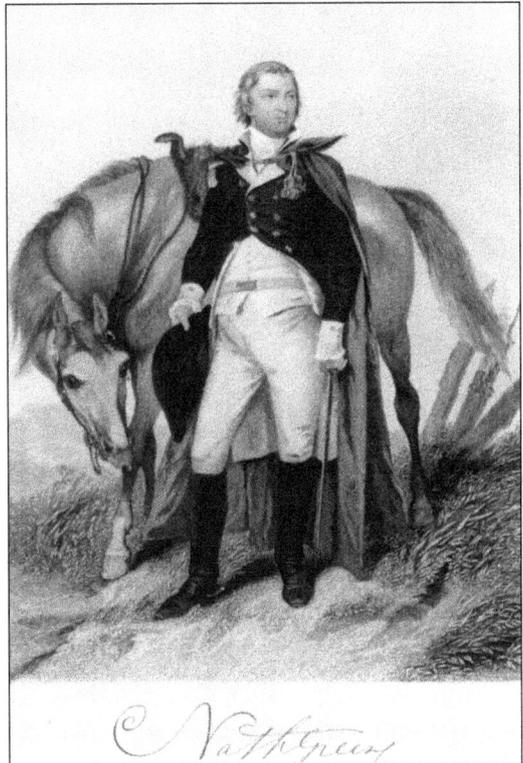

Green Township was named for Maj. Gen. Nathanael Greene, a Revolutionary War hero. Greene was one of Gen. George Washington's most trusted generals during the Revolutionary War and one of Washington's closest friends. He was considered by many to be the best military strategist of the American Revolution and a great military mind. For his service to his country, North Carolina, South Carolina, and Georgia honored Major General Greene with gifts of estates, including a plantation called Mulberry Grove on the Savannah River in Georgia, where he retired after the war. (Courtesy of Cincinnati Historical Society.)

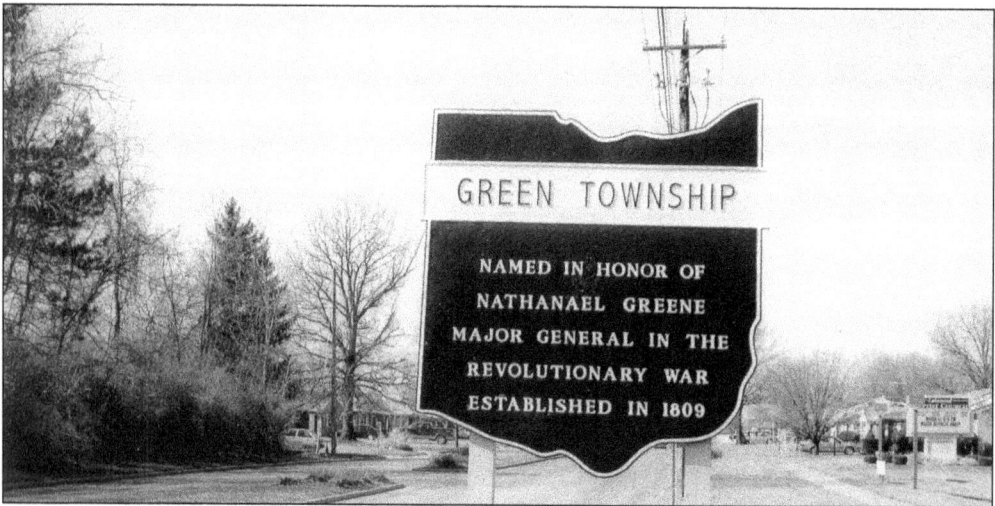

This sign on Westwood Northern Boulevard honors Maj. Gen. Nathanael Greene. Green Township was named after Greene, but the *e* was dropped sometime over the years. Green Township is home to the communities of Bridgetown, Covedale, Dent, Mack, Monfort Heights, and White Oak. Each lies, in whole or in part, in Green Township. Each community is a neighborhood with its own identity, but all are part of Green Township. In the 1800s, the village of Westwood and part of Mount Airy were in Green Township until annexed by Cincinnati. Cheviot remained in Green Township until 1966.

The Nathanael Greene Lodge on Wesselman Road in Green Township was built in 1999 and named after Revolutionary War major general Nathanael Greene. All of the rooms in the lodge are also named in honor of Greene. The Continental Ballroom, the Concord Board Room, the Mulberry Room, and the West Point Room honor places and events, which occurred during the life of Maj. Gen. Nathanael Greene.

This is an 1881 map of Hamilton County showing Green Township. The source is the *History of Hamilton County Ohio* by Henry Ford and Kate B. Ford, 1881. One can see where the Cincinnati and Westwood Railroad terminates in Bridgetown. Old community names include Dry Ridge (Mack), St. Jacobs (White Oak), and Wisenburg (Monfort Heights). Sheartown in the far northwest corner is Taylor Creek today and is now considered a Colerain Township community. Green Township was a full 36 square miles—a square, six miles long on each side. Today it is 29 square miles. The villages of Westwood, part of Mount Airy, and Cheviot were still in Green Township.

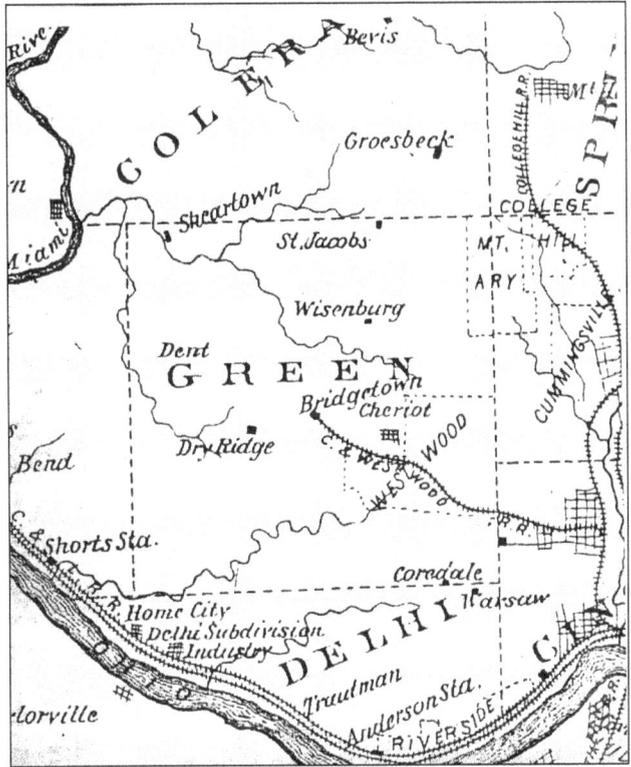

This Green Township flag reads, "Kuliga," a Shawnee Indian word describing the general Green Township area. The popular version says Kuliga means "the Pretty Land." A second version is given by Charles Reemelin. He said he was told this by the sons of one of the township's first settlers who had first-hand knowledge of the Shawnee, "The Indians were coming up the western slope of Green Township from the Great Miami River and saw in Taylor Creek and its branches the figure of an open left hand, palm up, pointing eastward . . . and they named the area 'Kuliga,' meaning Pretty Hand."

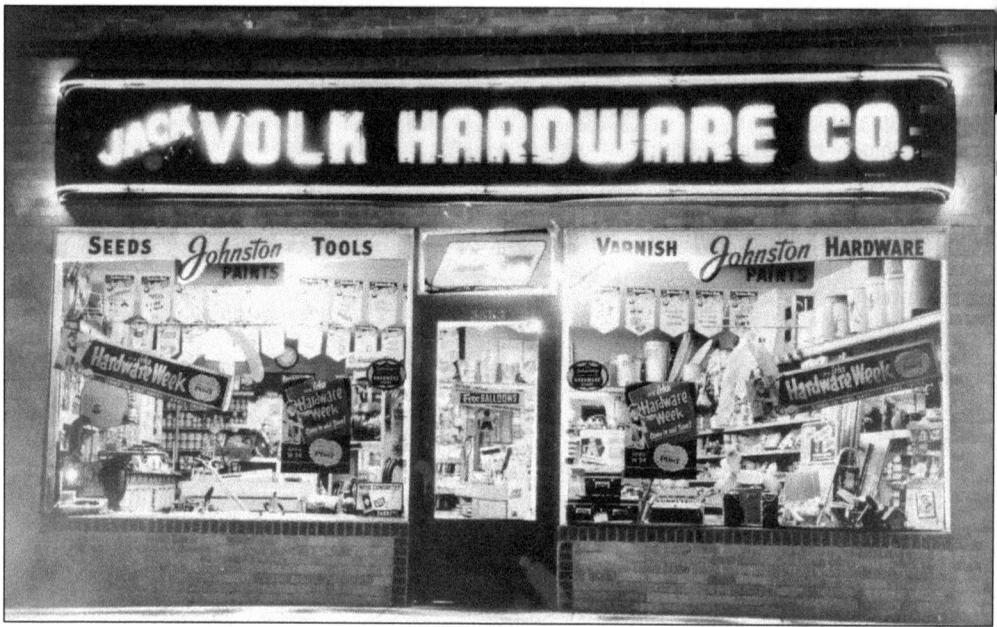

Bridgetown is the community at the geographic center of Green Township. The name most likely came from a pioneer family that settled in the area around 1820, the Fifthian family. They came here from Bridgeton, New Jersey. The Bridgetown name was in use as early as 1847, many years before the C&O Railroad trestle was built in the early 1900s. Jack Volk Hardware opened years ago on Bridgetown Road, west of Glenway Avenue. Today it is Bridgetown Hardware.

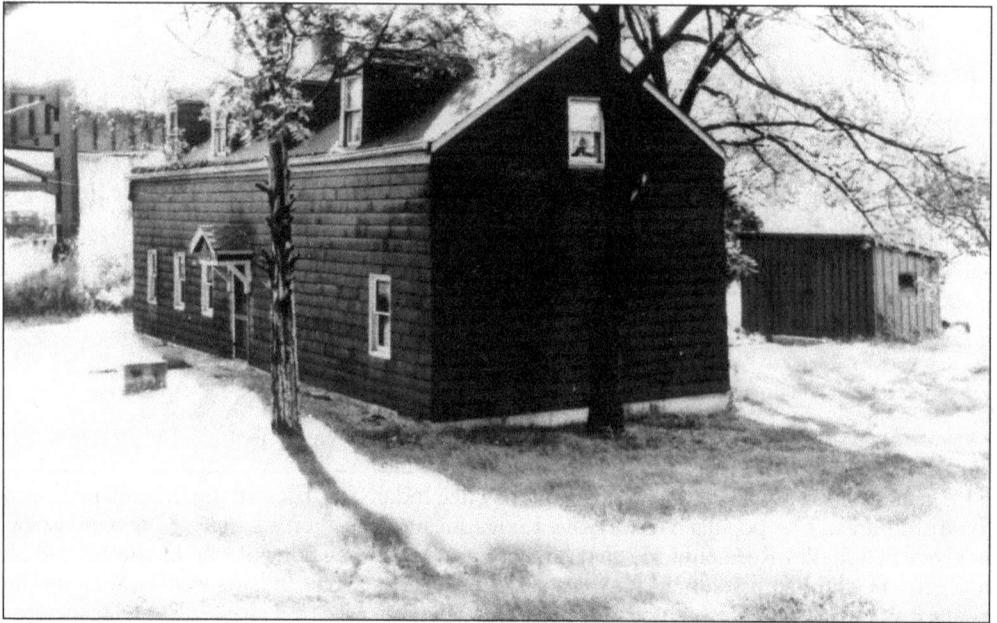

This photograph is of the Fischer house at Glenway and Bridgetown Road, southwest corner. The year is unknown. A paint store occupies the site today.

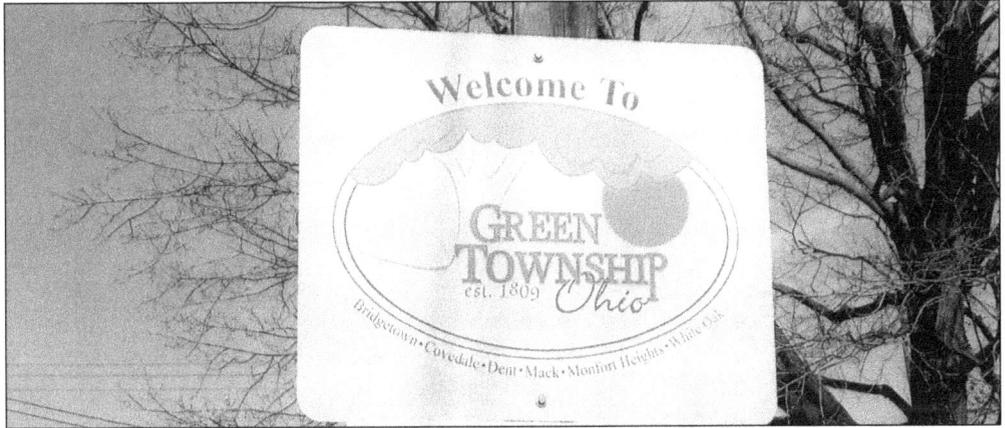

Here is one of many border signs in Green Township honoring the six communities of Bridgetown, Covedale, Dent, Mack, Monfort Heights, and White Oak.

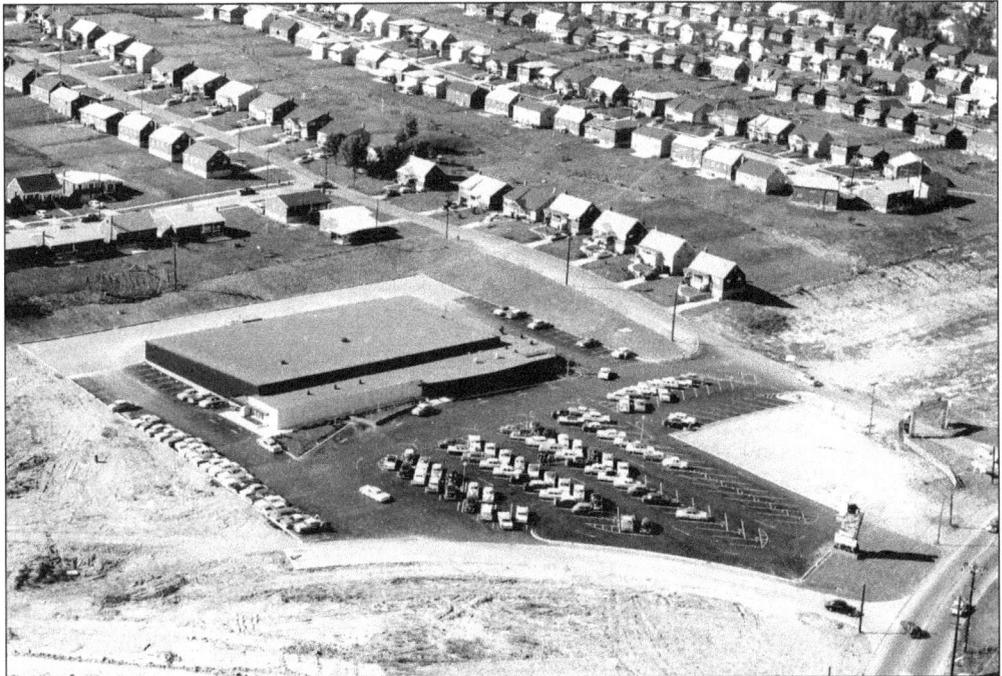

This aerial view shows Western Bowl in Bridgetown in the 1960s. Western Bowl opened in 1958. Note the open land around Western Bowl that is now occupied by houses, stores, and Westbourne Drive.

This photograph shows the interior of Western Bowl shortly after it opened in the 1960s.

Western Bowl today has great landscaping, a restaurant, and hundreds of bowling leagues. The Hoinkes estimate more than 100,000 people travel to and from Western Bowl each year, and they host more than 50 bowling leagues. There are high school bowling leagues, and high schoolers from Oak Hills, Elder, Seton, and Western Hills get donated free bowling, shirts, and balls. Middle school children get picked up for after-school bowling programs.

The Welcome Center today features all the amenities a bowler could want, including 68 lanes and computer scoring. Founder Ervin C. Hoinke Sr. originated the Hoinke Classic in 1943 during World War II, originally to assist the patriotic endeavor of the war and to promote bowling. Hoinke Lanes was the first venue. The prizes in the early years were war bonds and stamps. The singles format as it is today began in 1950 with 532 entries and a $1,000 first prize. Growth over the past 50 years has resulted in 22 consecutive payoffs of over $1 million. The Hoinke Classic draws competitors from around the United States and is sanctioned by the American Bowling Congress. It is billed as the largest non-professional, privately owned bowling tournament in the world. Seventy-four-year-old Erv Hoinke Jr. now heads up the Hoinke Classic, a 64-year-old tournament held from January to November each year for more than 28,000 participants. The Hoinke family under Erv Hoinke are the owners, including son Russell, tournament director, and daughter Jennifer Klekamp, treasurer. Tracy is vice president, and Chris is secretary.

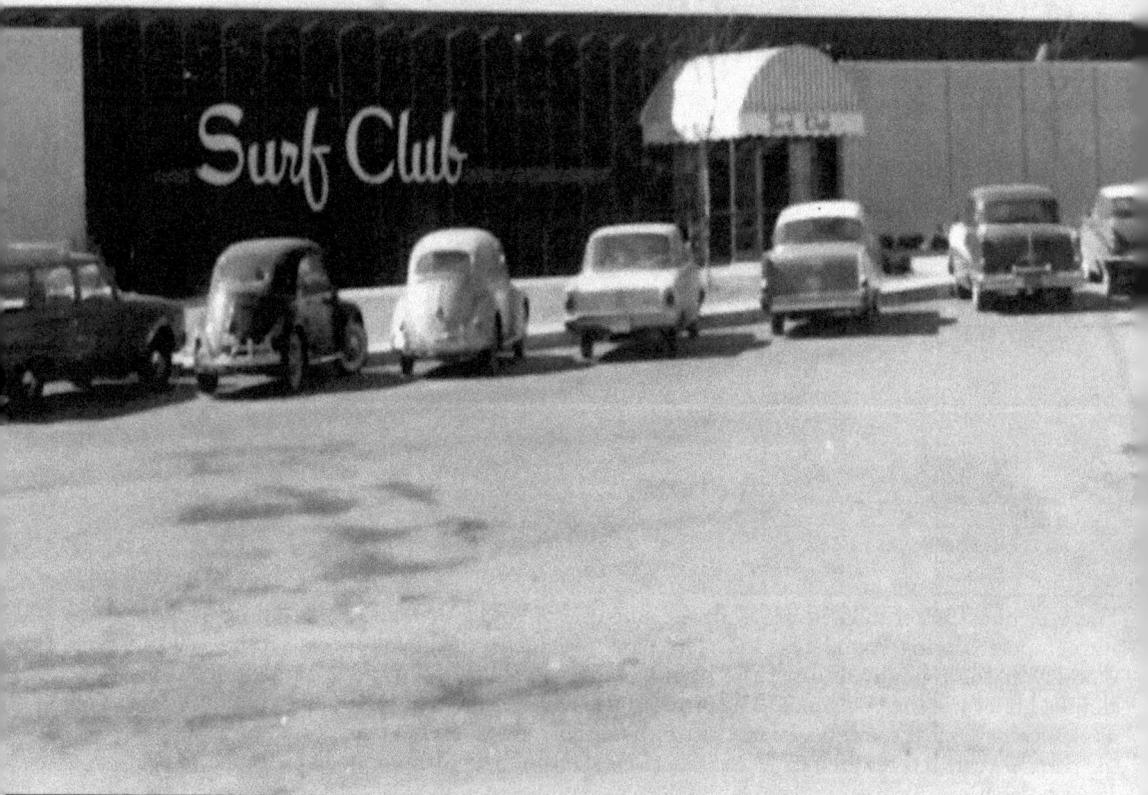

In the late 1950s and early 1960s, Western Bowl had a nightclub called the Surf Club. It featured top recording artists, well-known musicians, television celebrities, and other artists with national and international reputations. Plush and relaxed facilities made for enjoyable entertainment.

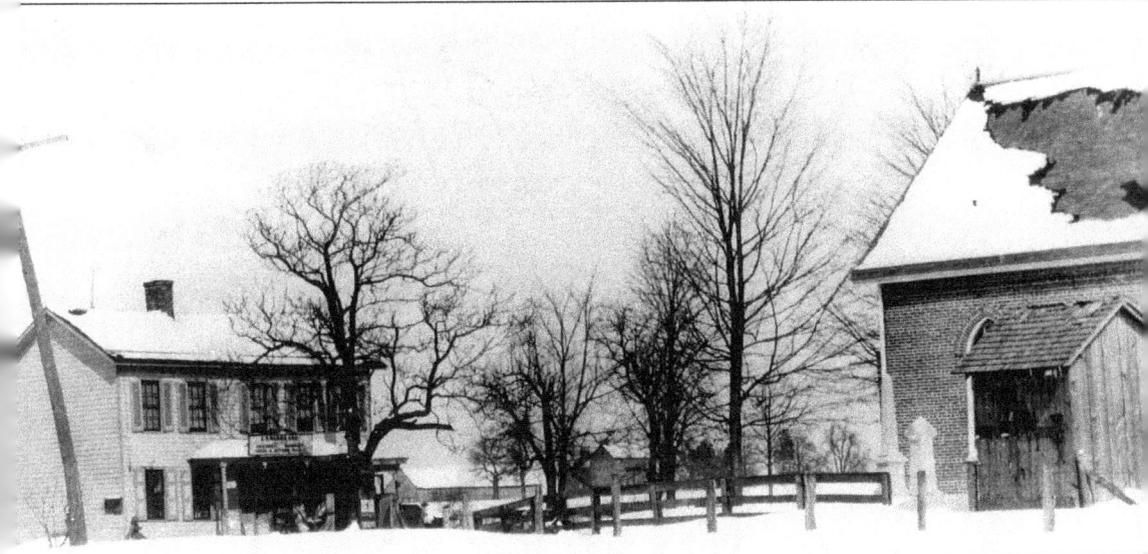

This photograph is of the Markland Store in Mack, opened in 1850 on Bridgetown Road by William Markland. Thomas Markland, his father, settled in Green Township in 1805 on Fiddlers Green Road. It was a general store dealing in food and hardware. Over the years it was operated by several generations of Marklands including William, Avery, Cleves, Les, and Marlan. Mack, along Bridgetown Road just west of Bridgetown, has a five-points intersection of Bridgetown, Ebenezer, and Taylor Roads. The area was known as Dry Ridge until the 1880s. The Mack name came from the post office established in the Markland Store in 1892. As the story goes, Mack was the name of Avery Markland's hound dog. The old store was torn down in 1949, and a new store was built in 1950. It closed permanently in 1972, and a Marathon Station is currently on the site.

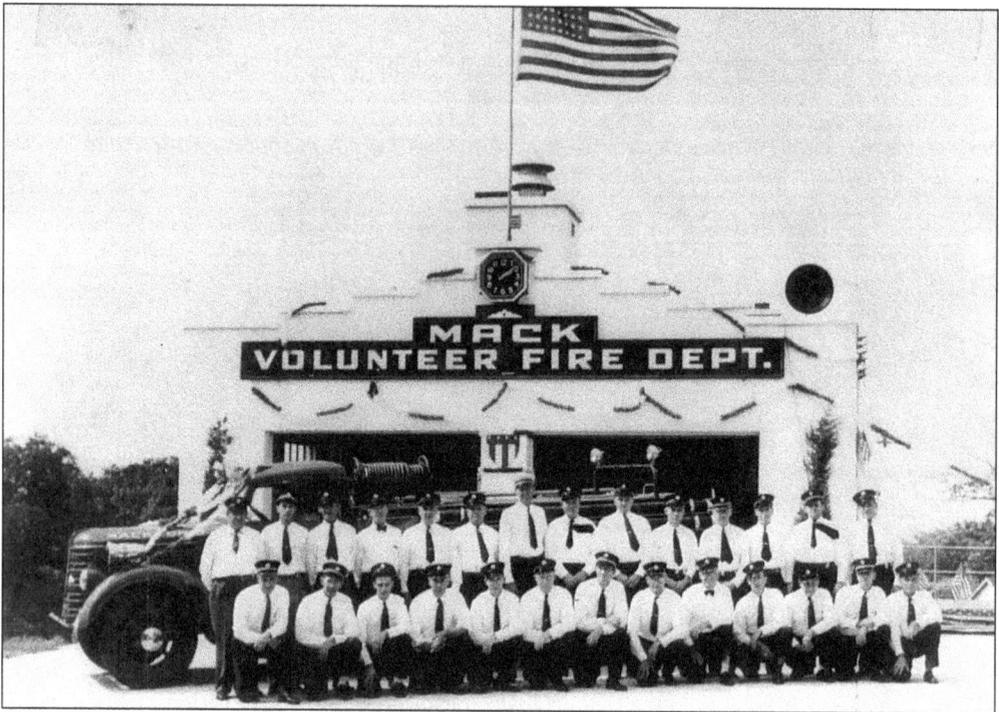

Here is a photograph of the 1947 Mack Volunteer Fire Department. It served portions of the Green Township from 1944 until the township took over fire and emergency medical services in 1984. Today the Green Township Department of Fire and EMS provides first-class service to township residents and businesses.

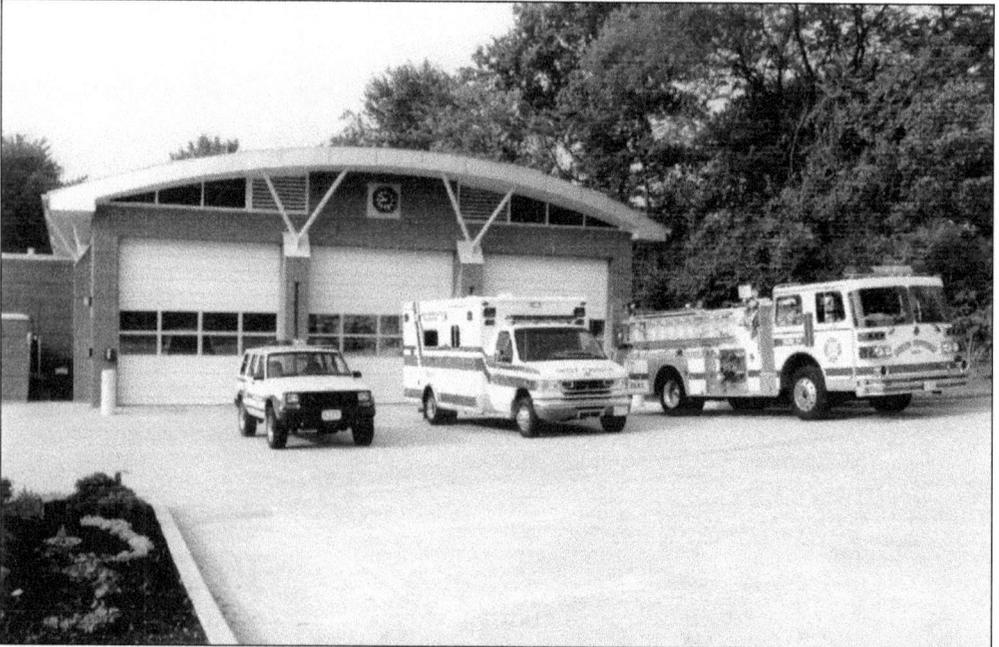

This photograph is of the new Green Township firehouse in Mack. With over 29 square miles and a growing population, four firehouses are a necessity in Green Township.

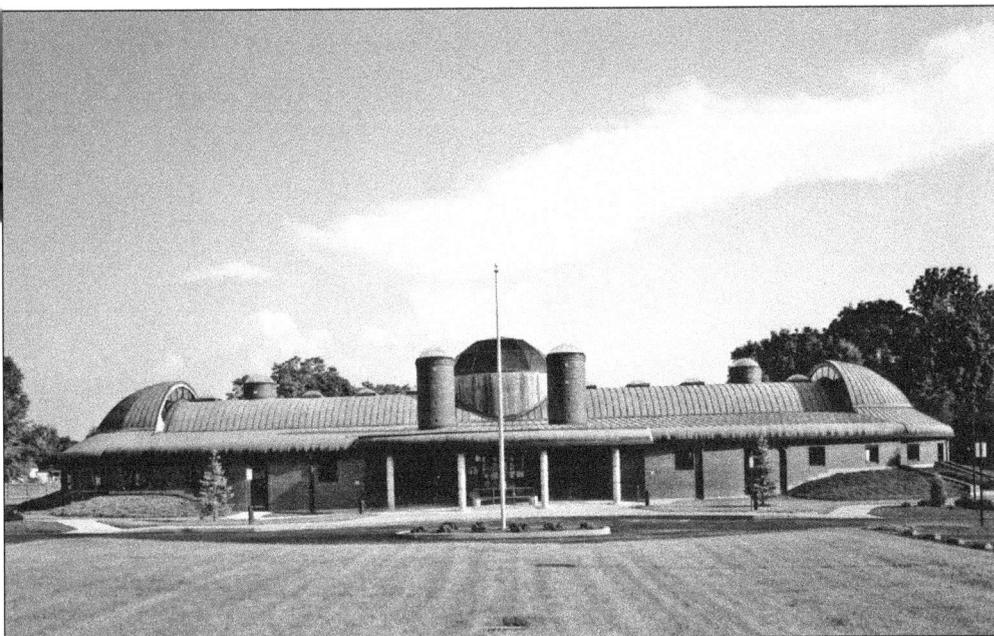

Built on a five-acre site in the heart of rapidly growing Green Township, the library is located on Bridgetown Road, approximately one mile from the Five Points intersection in Mack. A fairly large parking lot accommodates library patrons. The library offers programs for adults, teens, and children.

The Green Township Library opened for service in January 1990. The striking copper central dome is flanked by two smaller domed structures, designed to reflect the silos and barns of the farms that once were so prevalent in Green Township.

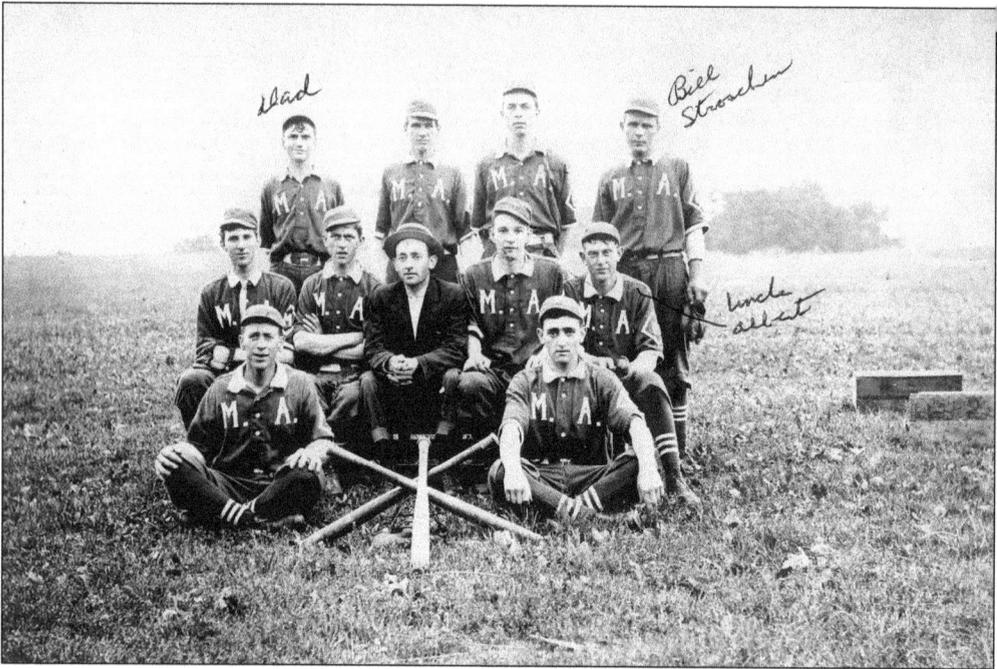

In this photograph, the Mack Merchants Baseball Team is shown. The kids look to be 16 to 17 years old. Bill Scheidt is in the upper left-hand corner, back row, of the photograph, while teammate Bill Stroschen is far right in the back row. Far right in the middle row is Al Vollmer, whose son later played for the Cincinnati Reds in 1941.

Here is a photograph of a gathering at Rose Point on Taylor Road in Mack. In the early 1920s, moonshine was sold out of the barn seen in the photograph. Evidently the first owner wanted to start a dairy farm, but his herd got sick and died. A new owner then bought the property in 1926, and it was a speakeasy and gambling establishment.

The living room and parlor to the left of the entrance to the house were used by big-time gamblers. The old barn seen in the photograph was the main gambling and bar portion of the establishment. Rose Point then became a nightclub after Prohibition ended. The nightclub finally closed around 1937.

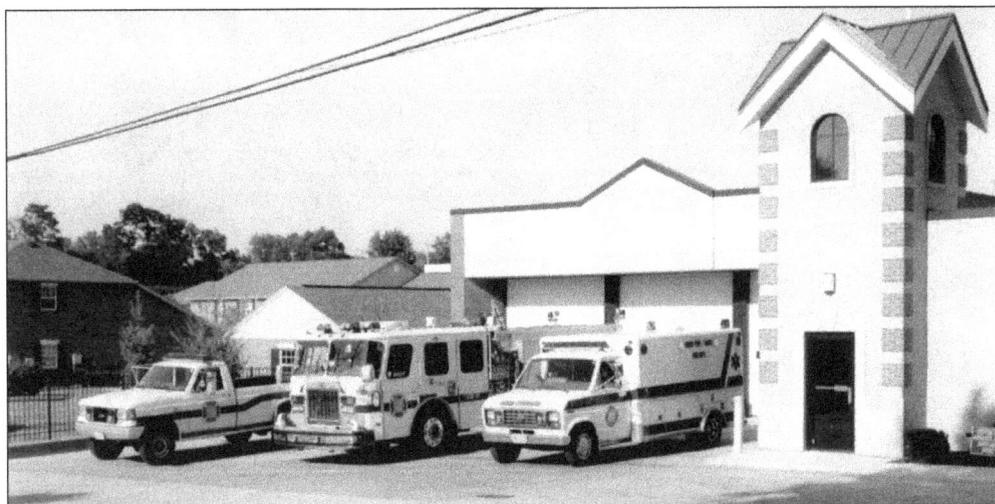

This photograph shows the Green Township Firehouse on Sylved Drive near Covedale. When many Cincinnati westsiders hear the name Covedale they think of the Cincinnati neighborhood along Glenway Avenue near the Covedale Theater and Covedale Branch Library. Until about 1930, this was still Green Township before annexation by Cincinnati. Today the residential part of Covedale "spills over" into Green Township, roughly west of Covedale Avenue along Sydney Road and north of Cleves Warsaw Pike.

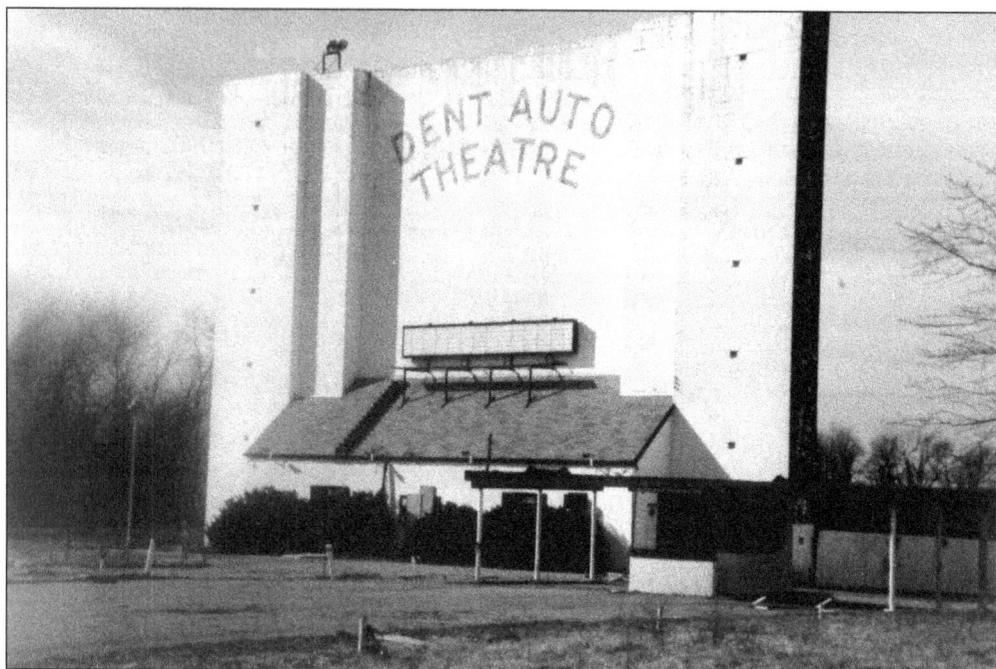

The Dent Auto Theatre on Harrison Avenue in Dent was around for about 40 years. Children, teenagers, and adults have fond memories of the drive-in. It was torn down in 1989.

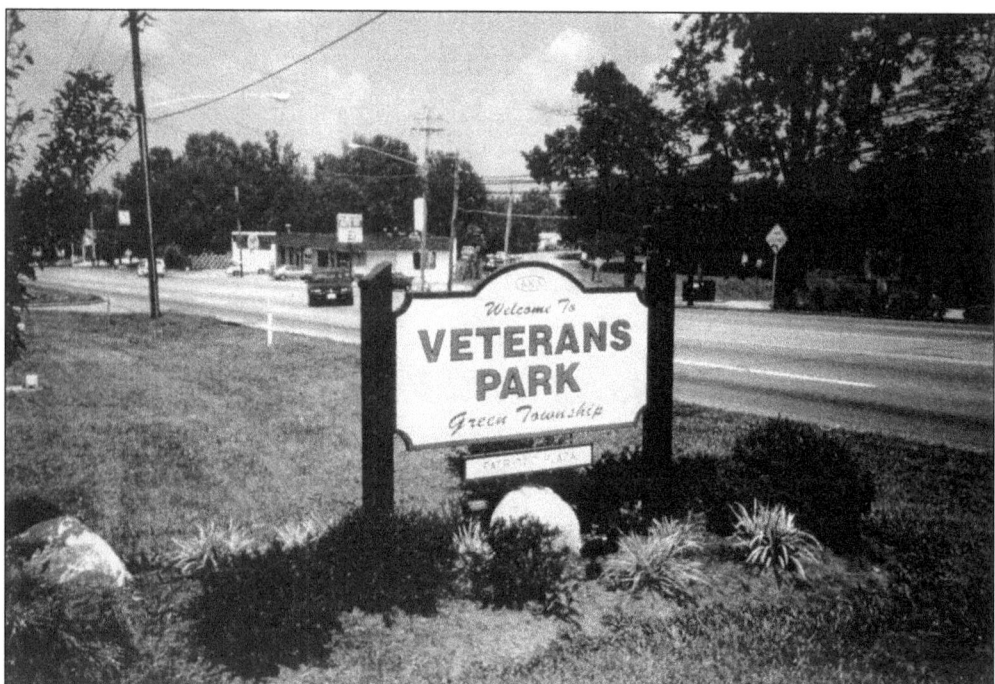

Veteran's Park is now on the site of the old Dent Auto Theatre. It opened in 1992. The Green Township administration building and maintenance office, as well as the police and fire department, are next to Veteran's Park.

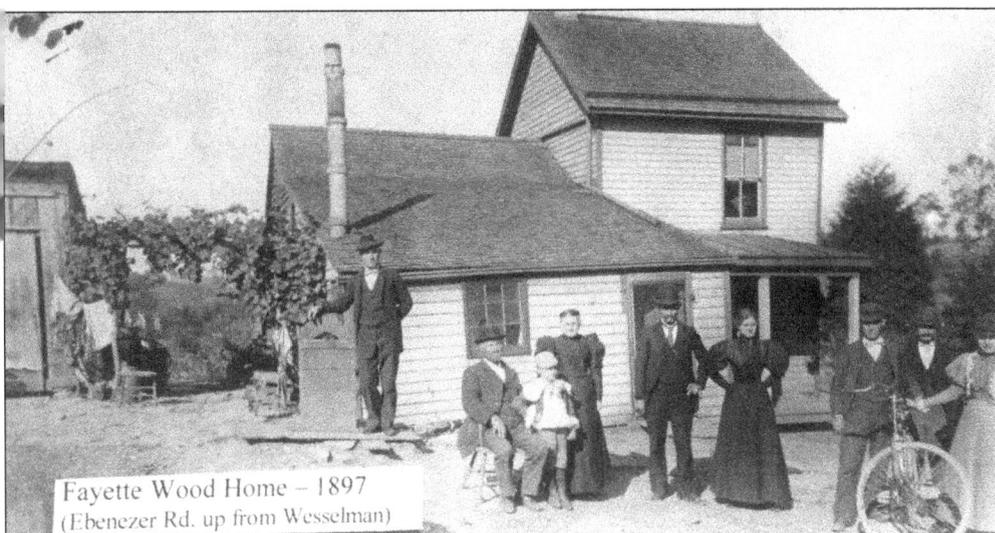

Fayette Wood Home – 1897
(Ebenezer Rd. up from Wesselman)

Dent, another Green Township community, is along Harrison Avenue a few miles northwest of Bridgetown. Its main intersection is Harrison, Johnson, and Wesselman Roads. In the early years the area was called Challensville after a local minister. Charles Reemelin gave the community its current name, Dent. He thought it appropriately described the topography, a large depression or valley in the area. This 1897 photograph is of the Fayette Wood home in Dent. Fayette's son, George, was a teacher at the old Dent School on Harrison Avenue.

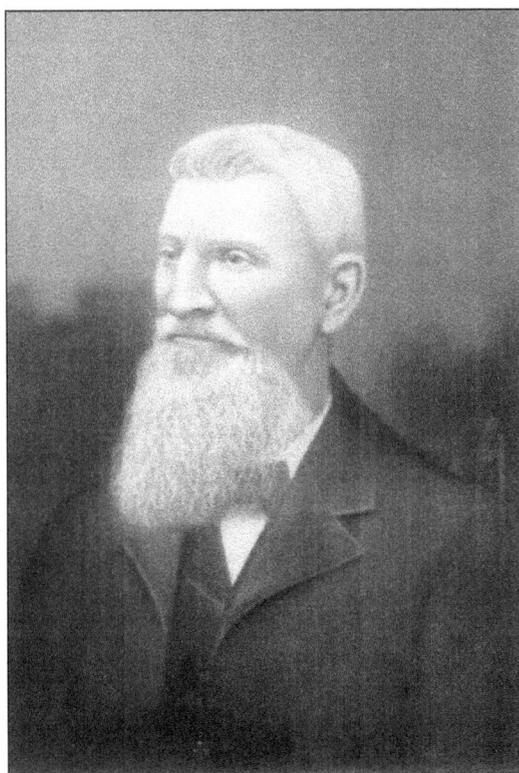

Andrew Neidhard was the founder of A. Neidhard and Sons Funeral Home in 1860. The funeral home was located at the site of the family's residence on Harrison Pike near the far northwest boundary of Green Township. Andrew Neidhard would make solid walnut coffins for the price of $15.

119

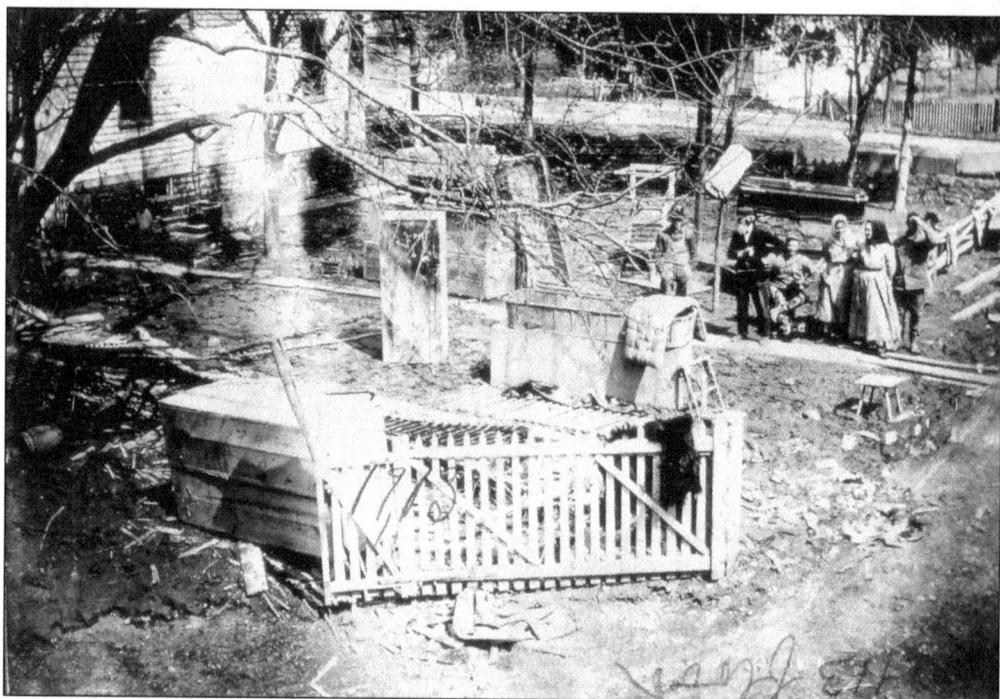

This photograph shows Neidhard Funeral Home on Harrison Avenue in Taylor Creek near the northwest border of Green Township. The funeral home was flooded in 1913, and one can see empty wooden caskets.

Neidhard Class "C" Knothole baseball team won the championship in 1945.

Green Township Firehouse in Dent today is seen here. The complex also houses the Green Township administrative offices and includes the police and maintenance departments.

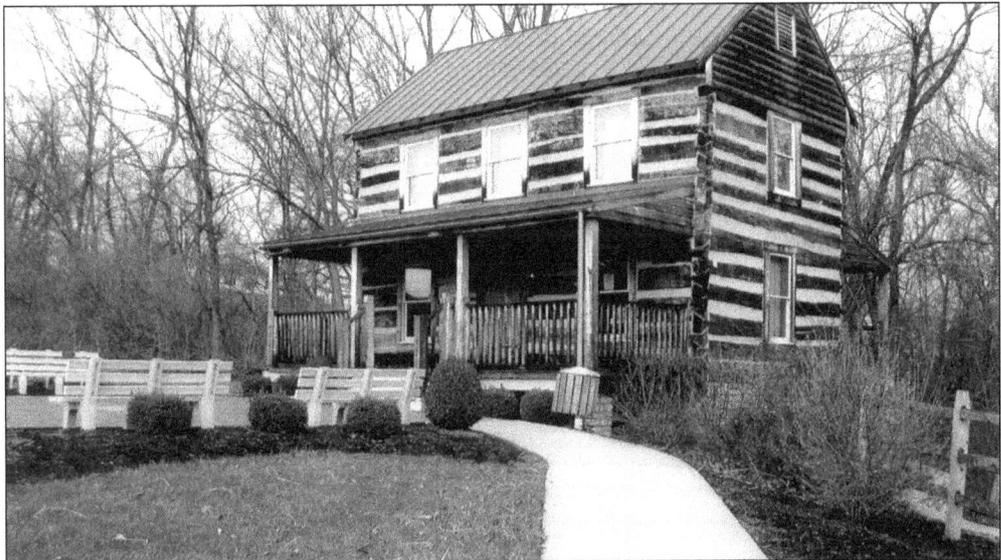

In 1995, the descendents of Philip Feist's family of Delhi Township approached the German-American Citizens' League offering to give their family homestead to the league. It is estimated that the original log home was built around 1840. The league decided that making a museum out of the log house would preserve the house and create a place to preserve the general German heritage of Cincinnati. The house was disassembled and brought to West Fork Park in Monfort Heights for visitors to enjoy. The German Heritage Museum became a welcome addition to Monfort Heights.

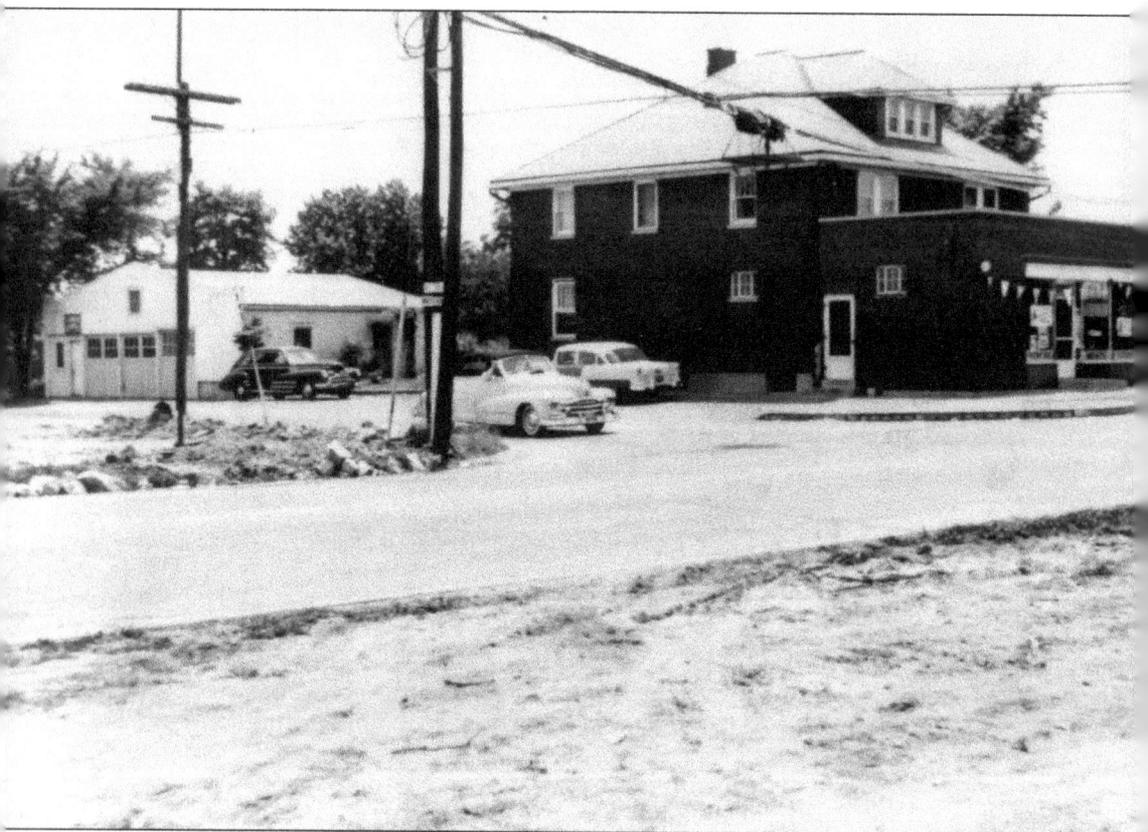

Monfort Heights runs along North Bend Road with its heart at the intersection of West Fork and North Bend Roads. In the 1800s, it was named Wisenburg (Weisenburgh), reflecting the German farmers who settled there. In 1900, Frank Lumler became the postmaster of a new post office on Burnt School House Road, now Cheviot Road. He named the branch "Monfort" for Civil War captain E. R. Monfort, postmaster of Cincinnati at the time. The branch closed in 1905, and the name was dropped and almost forgotten until the consolidation of three area district schools in the late 1920s. The new school district needed a name, and the "Monfort" name was revived. "Heights" was added to reflect the high hilltop altitude of the area. The photograph depicted here is of the Martin Frey Grocery Store on the southeast corner of North Bend Road and West Fork Road. Built in 1924, the store remained until about 1956. The building remained until about 1968 when North Bend Road was widened and I-74 was being constructed. (Courtesy of Jim Wilz.)

The West Fork Branch Library, known as the branch between two cornfields when it was built on part of the farm of Rosie Beyer of Monfort Heights, opened on March 1, 1971. It is located on West Fork Road, a half mile west of the intersection of North Bend Road.

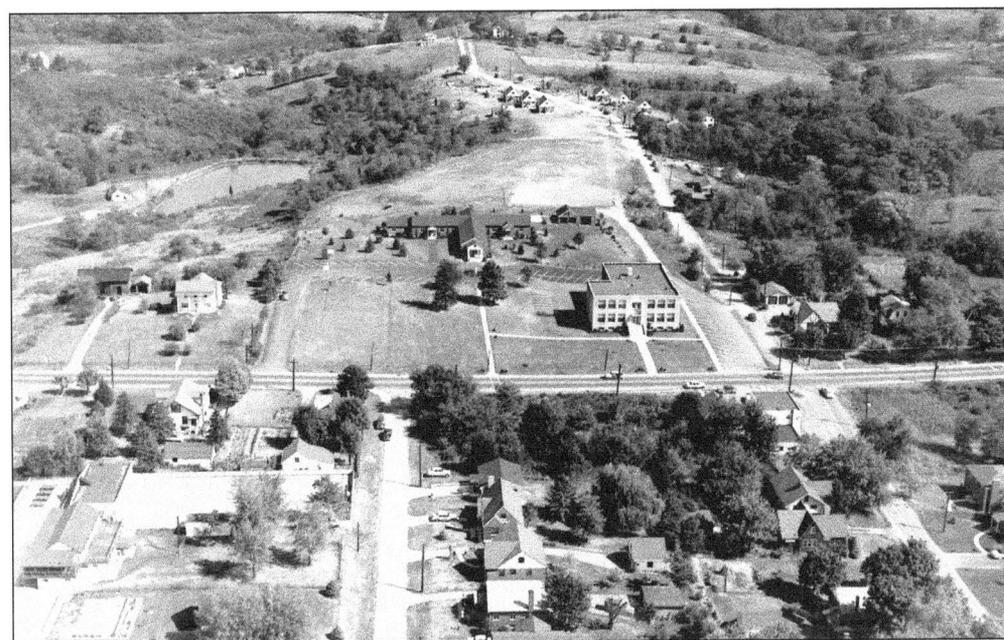

This aerial photograph, taken in the 1950s, is of North Bend Road at St. Ignatius Church in Monfort Heights, before I-74 was constructed. In the center are St. Ignatius School and the original church building, which became Hilvert Hall. Today I-74 would run diagonally across the upper left. In the lower left is the old Airy Hills swimming pool house. (Courtesy of Jim Wilz.)

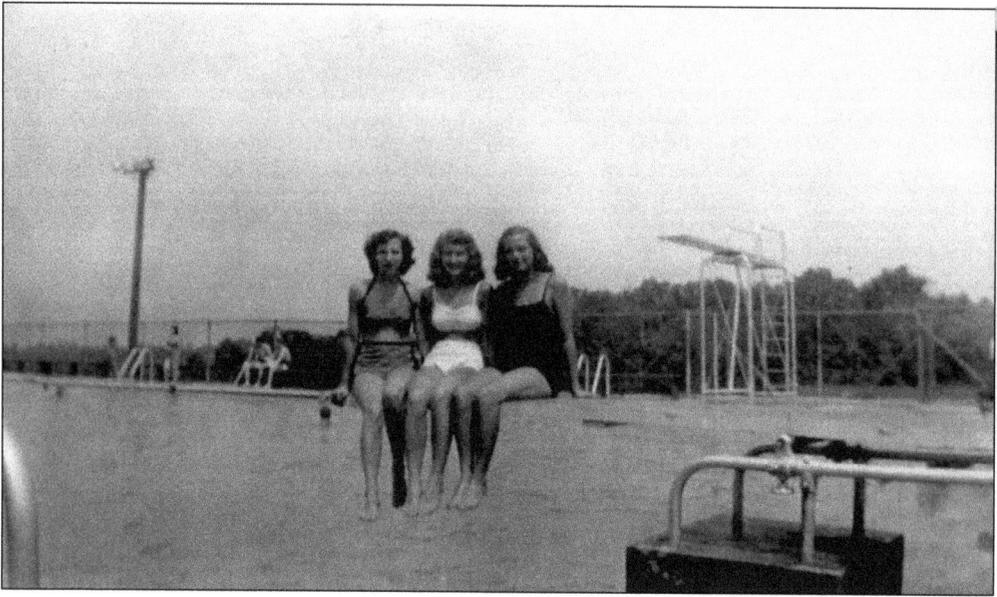

This is a photograph of the Airy Hills pool in Monfort Heights in the 1950s. It was located on North Bend Road opposite St. Ignatius Church, behind today's Bob Evans Restaurant. A few bathing beauties pose on the pool's diving board.

A new Green Township Firehouse in Monfort Heights on West Fork Road accommodates a growing population.

White Oak is along old Burnt School House Road, now Cheviot Road, centering along the stretch from Jessup Road to Blue Rock Road. White Oak lies in both Green Township and Colerain Township. On early maps, the area was known as St. Jacobs, named after St. James Church (Jacob being the German version of James). In the late 1800s, the area was called Creedville after the Creedville postal station at Blue Rock and Banning Roads. By the 1920s, the name White Oak was being used for the area, a name that goes back to the early settlement years when huge white oak trees grew in the area. A Creedville canceled postage stamp is shown from 1898.

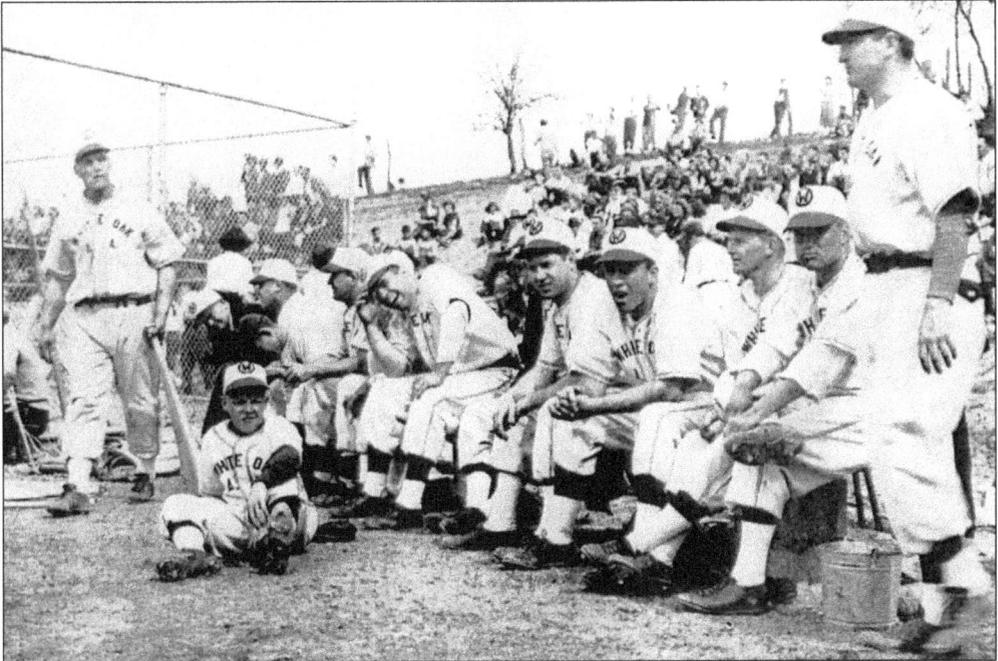

Opening day at Haubner Field in White Oak shows activities and a dedication ceremony in 1950. The field was built on land owned by the Haubner family. In 1960, the field was sold to the White Oak Athletic Association and rededicated.

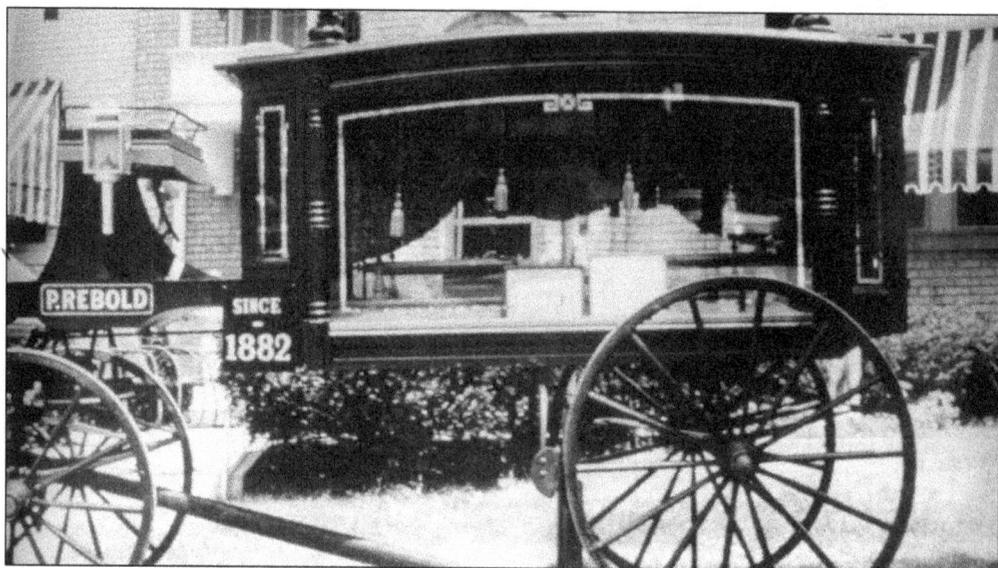

Here is the Rebold Funeral Home horse-drawn hearse on display for the 1959 Green Township Sesquicentennial. The Rebold Funeral Home opened in 1882 as a funeral and livery business in South Fairmount. Peter Rebold was the founder along with his son, Mike Rebold. It was passed on to Peter G. Rebold and then Peter M. Rebold, rounding out four generations. This continued until 2000, when the Rebold family transferred operations to longtime friends and associates, Jerry Rosenacker and Mike Sexton.

Here is a photograph of Rebold Funeral Home as it looked around 1923. It is at its present location on Glenmore Avenue in Cheviot, still in Green Township at the time. The funeral home has gone through several renovations since the photograph was taken.

Tom Wernke stands outside his barbershop in front of a "Mack" sign. He is a member of the Green Township Historical Association and was a major contributor of photographs for this book.

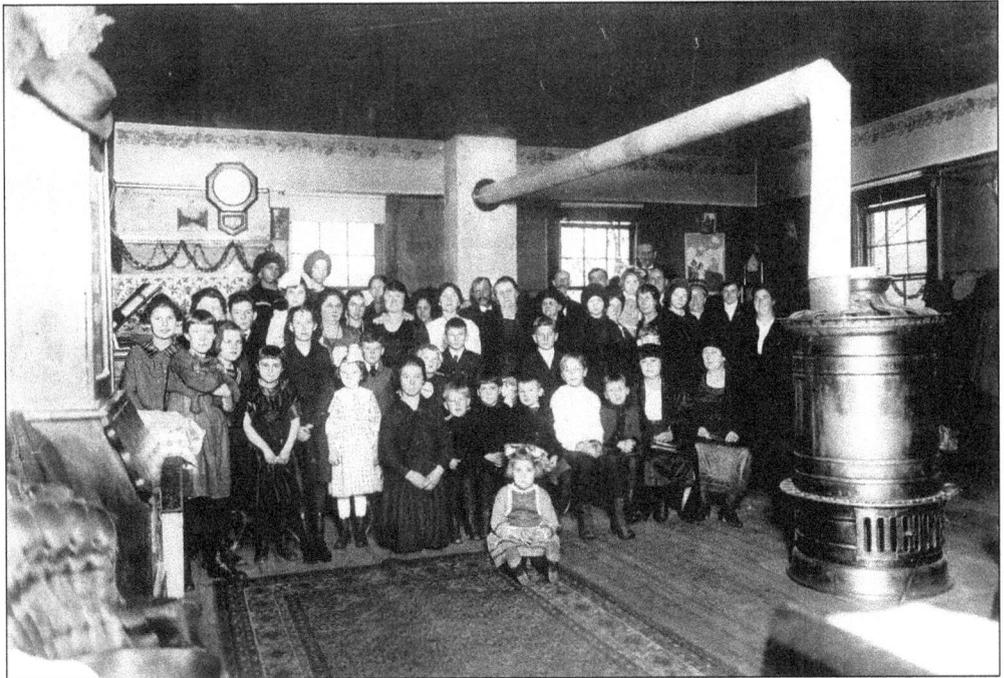

Here is a photograph of the students and staff at Dent School about 1925–1930. The heating system and interior are readily visible. This photograph marks the end of the collection of sights and scenes in Green Township. Class dismissed!

Visit us at
arcadiapublishing.com

www.ingramcontent.com/pod-product-compliance
Lightning Source LLC
Chambersburg PA
CBHW050630110426
42813CB00007B/1763